Picturing
Edited by Rachael Z. DeLue

With essays by
Michael Gaudio, Ulla Haselstein,
Matthew C. Hunter, Elizabeth W. Hutchinson,
and Robin Kelsey

Terra Foundation Essays
Volume 1

Terra Foundation for American Art
Chicago | Paris

Distributed by
University of Chicago Press

Terra Foundation Essays

The history of American art is a history of objects, but it is also a history of ideas. The Terra Foundation Essays illuminate and explore a selection of ideas that have been particularly salient within the production and consumption of art in the United States over three centuries. They present original research by an international roster of established and emerging scholars who consider American art in its multiple, trans-geographic contexts. The essays in each volume expand the conceptual and methodological terrain of scholarship on American art by offering comparative models and conceptual tools relevant to all scholars of art history and visual culture, as well as other disciplines within the humanities.

Terra Foundation for American Art
Elizabeth Glassman, *President and Chief Executive Officer*
Amy Zinck, *Executive Vice-President*
John Davis, *Executive Director for Europe and Global Academic Programs*

Terra Foundation Essays
Rachael Z. DeLue, *Series Editor*
Francesca Rose, *Terra Foundation for American Art, Program Director, Publications*
Veerle Thielemans, *Terra Foundation for American Art, European Academic Program Director*

Picturing
Edited by Rachael Z. DeLue
James Goggin and Shan James, Practise, *Series Design Direction & Volume Design*
Kelly Finefrock-Creed, *Copy Editor*

Published by the
Terra Foundation for American Art
120 East Erie Street, Chicago, Illinois, 60611, USA
121 rue de Lille, 75007 Paris, France
terraamericanart.org

Francesca Rose, *Program Director, Publications*
Rebecca Park, *Publications Assistant*

Printed by Die Keure, Bruges, Belgium
Color separations by Prographics, Rockford, Illinois
Distributed by The University of Chicago Press
press.uchicago.edu

Library of Congress Cataloging-in-Publication Data

Names: DeLue, Rachael Ziady, editor. | Terra Foundation for American Art, issuing body.
Title: Picturing / edited by Rachael Z. DeLue.
Description: Chicago : Terra Foundation For American Art, 2016. | Series: Terra Foundation essays ; Volume 1
Identifiers: LCCN 2015041671 (print) | LCCN 2015042225 (ebook) | ISBN 9780932171573 (paperback) | ISBN 9780932171580 (ebook)
Subjects: LCSH: Art, American. | Image (Philosophy) | Art and society—United States. | BISAC: ART / History / General.
Classification: LCC N6505 .P53 2016 (print) | LCC N6505 (ebook) | DDC 709.73—dc23
LC record available at http://lccn.loc.gov/2015041671

Front cover: Mason Chamberlin, *Benjamin Franklin* (detail, see p. 86).

Contents

PICTURING

AN INTRODUCTION

Rachael Z. DeLue

Picturing:
An Introduction

In the early 1880s, the American artist Winslow Homer (1836–1910)
sketched a tragic scene: a capsized boat foundering near a rocky
shore lined with trees. At least one figure appears to be floating in
the water while others clutch at the overturned boat or take refuge
on a rock. The hand of a drowning man claws the air, straining against
the ocean's relentless heave and pull (fig. 1). The graphite sketch,
a study for Homer's watercolor *The Ship's Boat* (1883), is rough
and summary, supplying just enough detail to communicate the bare
facts of the event.[1] The brusque, stuttering strokes of the pencil that
delineate the swirl of the water and the broken snapping of sailcloth,
along with the spiking slashes of graphite that designate the trees
along the rocky ridge, broadcast the panic and chaos of the wreck.
Sweeping pencil strokes in the sky that take the form of funnel clouds
suggest the violence of the storm that overtook the boat; together
with the wind-whipped trees, these cyclones evoke the destructive
force of a hurricane.

Homer's sketch of a shipwreck reflects the sharp seaward turn his
art took in the 1880s, after living nearly two years in Cullercoats, an
English fishing village on the North Sea, and then settling for good in
Prout's Neck, Maine, a peninsula about ten miles north of Portland.
Fishermen bravely pursuing their catch, wives stoically mending
nets and tending to the day's haul, calamitous storms, dramatic rescues,
outsize waves crashing against rocky shores and exploding skyward
before making their retreat: Homer's pictures during this period
celebrated the raw beauty and power of the ocean and the resolute

Winslow Homer,
The Fog Warning
(detail, see fig. 5).

10

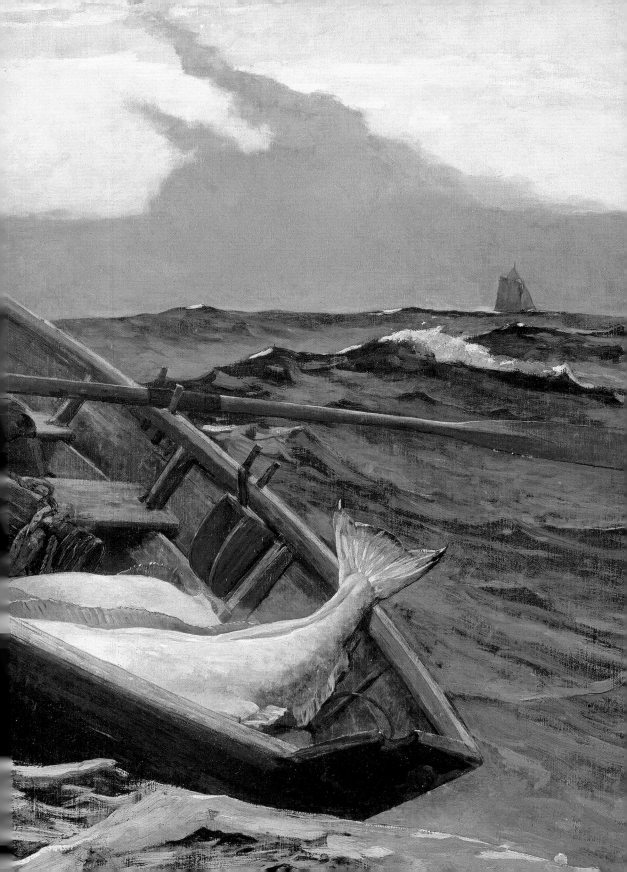

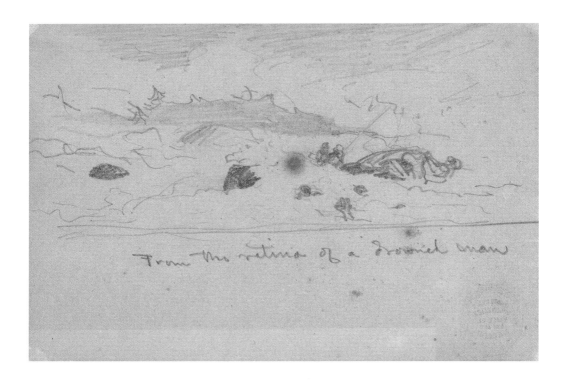

1
Winslow Homer,
*From the Retina of a
Drowned Man*, 1881–82.
Graphite on wove
paper, mounted in an
album, 3 ⅜ × 4 ⅞ in.
(8.5 × 12.4 cm). Cooper-
Hewitt, National Design
Museum, New York.
Gift of Charles Savage
Homer Jr., 1912-12-253.

will of the men and women who made their lives by the sea. Yet in
comparison with the most gripping of his major seascapes, including
those that feature bodies in extremis, such as *The Life Line* (1884),
Undertow (1886), and *After the Hurricane, Bahamas* (1899) (figs. 2–4),
the shipwreck sketch feels unrestrained, even indulgent in its depic-
tion of destruction and death. The clawing hand provides one tipping
point, and Homer's annotation of the sketch provides another.
Horizontal lines separate the shipwreck scene from the rectangle of
bare paper beneath it. Immediately beneath these lines Homer
added a short, explanatory text: "From the retina of a drowned man."

Presumably Homer meant with his caption to suggest that anyone
looking at his sketch should first and foremost imagine occupying
the point of view of a person in the water, a perspective compelled by
other of Homer's seascapes from the 1880s and 1890s, including
Undertow. In *The Fog Warning* (1885) (fig. 5), Homer puts his viewer
at sea, at the oars of another boat or set adrift, imperiled either way.
Homer rendered the waves at the front of *The Fog Warning* with coarse
strokes of white. Given their large scale, these rough marks register
as close-up and brutely material, as if proximally graspable, thereby
suggesting a viewpoint of watery immersion rather than one sited on

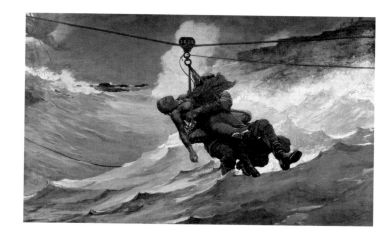

2
Winslow Homer,
The Life Line, 1884.
Oil on canvas, 28 ⅝ ×
44 ¾ in. (72.7 × 113.7 cm).
Philadelphia Museum
of Art. The George
W. Elkins Collection,
1924, E1924-4-15.

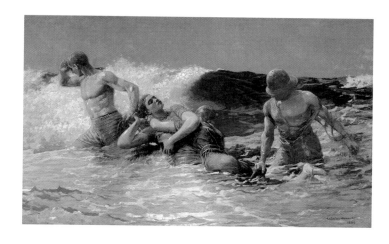

3
Winslow Homer,
Undertow, 1886.
Oil on canvas,
29 ¹³⁄₁₆ × 47 ⅝ in.
(75.7 × 121 cm).
Sterling and Francine
Clark Art Institute,
Williamstown,
Massachusetts, 1955.4.

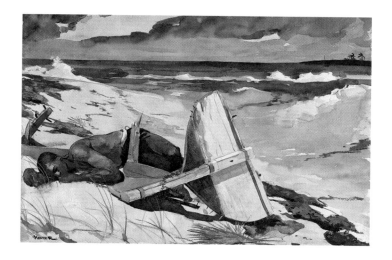

4
Winslow Homer,
*After the Hurricane,
Bahamas*, 1899.
Watercolor and
graphite on ivory wove
paper, 15 × 21 in.
(38 × 54.3 cm).
The Art Institute of
Chicago. Mr. and
Mrs. Martin A. Ryerson
Collection, 1933.1235.

An Introduction

a boat. The complex weave among strokes of white, gray, black, and blue green in this area of the canvas calls to mind a section of excavated and cross-sectioned earth as much as it does the variegated hue and sheen of water moving in time and space. This effect of unearthed terrain underscores the sense that the viewer occupies a submerged, if not subterranean, point of view, a perspective induced even more emphatically by the two cliff-like swells encasing the fishermen in Homer's *Kissing the Moon* (1904).[2] The halibut stacked in the dory occupy a similar position, one counter to their natural state. Wedged at the bottom of the boat and partially obscured by the port side, the hauled-in halibut are out of their element, fatally buried in air. In this way, their submerged condition is conversely analogous to that of the water-bound viewer, whose fate is equivalently sealed by his watery confines. As a result, Homer in his painting offers up as the viewer's closest surrogate the fish, rather than the fisherman, who would be the more obvious or conventional choice. The tail fin of one of the fish breaches the boundary between boat and water — not unlike the clawing hand in Homer's shipwreck sketch — suggesting a straining effort to escape the death trap of the boat and plunge back safely into the sea.

Homer's shipwreck sketch mirrors the desperation of *The Fog Warning*, and then raises the stakes. The viewer of the sketch must

5
Winslow Homer,
The Fog Warning, 1885.
Oil on canvas, 30 ¼ ×
48 ½ in. (76.83 ×
123.19 cm). Museum
of Fine Arts, Boston.
Anonymous gift with
credit to the Otis
Norcross Fund, 94.72.

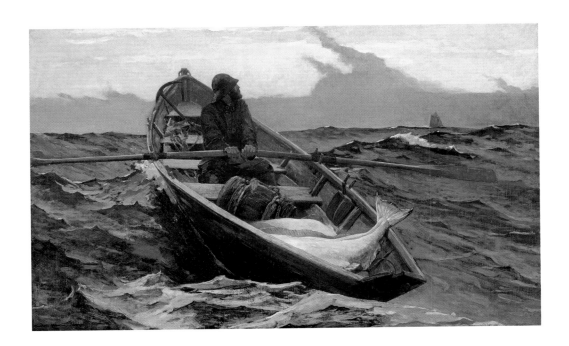

Rachael Z. DeLue

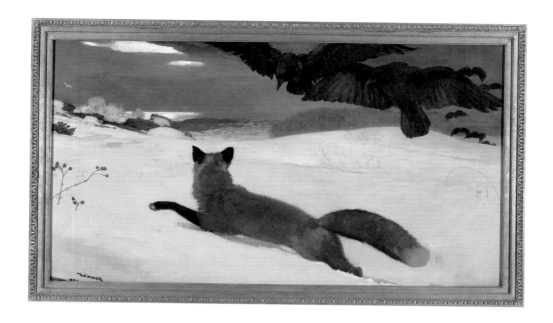

6
Winslow Homer,
The Fox Hunt, 1893.
Oil on canvas, 38 ×
68 ½ in. (96.5 × 174 cm).
Pennsylvania Academy
of the Fine Arts,
Philadelphia. Joseph E.
Temple Fund, 1894.4.

imagine seeing the summarily rendered scene while struggling in the water, but also as if dead. "From the retina of a drowned man," Homer wrote, positing not just a stricken point of view, but also an impossible one, for of course a drowned man cannot see anything from any point of view. This, like the water-bound point of view, feels in keeping with many of Homer's most striking pictures from this period, including those that compel the viewer to assume the perspective of an animal. In *The Fox Hunt* (1893) (fig. 6), a fox slinks through the snow, alert to potential danger but apparently oblivious to the crows circling behind him. His back turned toward the viewer, he adopts the classic pose of the *Rückenfigur*, a figure in a picture seen from behind and contemplating an expanse of terrain. Because his stance is analogous to that of a beholder contemplating the picture, such a figure serves as that beholder's surrogate. Thigh-deep in snow, the partially submerged body of the fox recalls other of Homer's surrogate figures, including both the drowning man of Homer's sketch and the trapped halibut of *The Fog Warning*. Homer also links the snowbound fox to himself, by way of his signature, at left, which he rendered at an angle so that it echoes the diagonal slope of the body of the fox. He then buried the signature up to its midpoint—or waist—in snow, underscoring the correspondence between the picture's snowbound animal protagonist and the human that painted him. This human-fox exchange exists alongside the many transpositions that occur within Homer's pictures, either

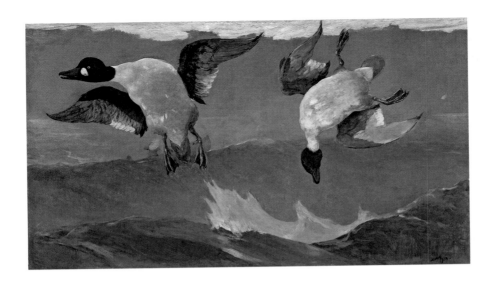

7
Winslow Homer,
Right and Left, 1909.
Oil on canvas,
28 ¼ × 48 ⅜ in.
(71.8 × 122.9 cm).
National Gallery of
Art, Washington, DC.
Gift of the Avalon
Foundation, 1951.8.1.

within a single painting or across several works: between, for instance, the smothering sea in *The Fog Warning* and the obdurate snow in *The Fox Hunt*, or the drowning man in the shipwreck sketch and the imperiled fox. Homer's transpositions among entities and between paintings serve as emblems for surrogacy's substitutions more generally, and in combination with the visual analogy drawn between Homer and the fox, they drive home the idea that *The Fox Hunt* compels the viewer to adopt a fox's-eye-view. That viewer, then, both sees and does not see with the fox, seeing the landscape but not spying the birds. And of course that viewer does neither of these things, having no capacity at all to see as an animal does, especially one that consists merely of paint.

I would not dwell on these characteristics if *The Fox Hunt* represented an anomaly in Homer's body of work, but it does not. More than a few of his pictures ask their viewers to exchange subject positions with an animal, and to identify with animal protagonists. *Right and Left* (1909) (fig. 7), one of Homer's last major works before his death in 1910, is exemplary. Similar to Homer's watercolors depicting hooked fish at close range, such as *A Good Pool, Saguenay River* (1895) (fig. 8), *Right and Left* depicts two ducks as they are shot midair by a hunter armed with a double-barreled shotgun. Hence the painting's title, which refers to the two barrels of the gun and the two shots they fire in quick succession, first one barrel and then the other. Homer registers the effect of the gunfire in several ways: through the water pulled along with the bird as it is blasted out of the sea,

Rachael Z. DeLue

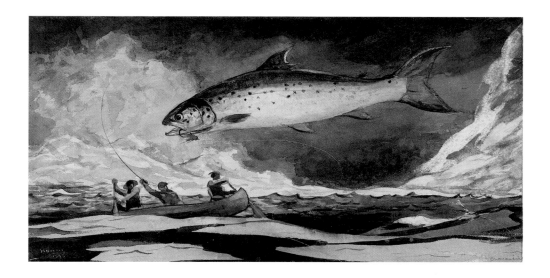

flapping its wings in distress; through an errant, drifting feather at right; and through the frozen-like quality of the birds that communicates their demise but perhaps also their destiny as stuffed specimens on display in the hunter's trophy room. Homer renders the left-hand bird midkill, its orange eye widening in violent surprise, but the bird on the right has already expired, as evidenced by its limp neck and downward trajectory, with the drifting feather toward the canvas's right edge proffering a poignant visual eulogy. As does *The Fog Warning*, Homer's *Right and Left* positions the viewer in the water, alongside the animal protagonists, from whose point of view he or she is meant to experience the scene. Homer underscores this animal surrogacy by adjusting his signature, at lower right, so that it parallels the downward slant of the dead, falling bird, much as he established the interchangeable identity among the fox, himself, and the human viewer in *The Fox Hunt*. Of course in *Right and Left*, the viewer may choose between two surrogates — between the two ducks — but the link between Homer's signature and the right-hand duck suggests that it is the dead one whose point of view the viewer should imagine embodying and through whose eyes he or she should see. This puts the beholder in a position analogous to that compelled by the shipwreck sketch, of seeing through the eyes of a corpse, a correspondence reinforced by the tip of the dead bird's uppermost wing, which breaches the boundary between a distant bank of thickening fog and the sunset-streaked sky, much like the reaching tailfin of the slain halibut in *The Fog Warning* and the hand that breaks the surface of the water in the sketch marking

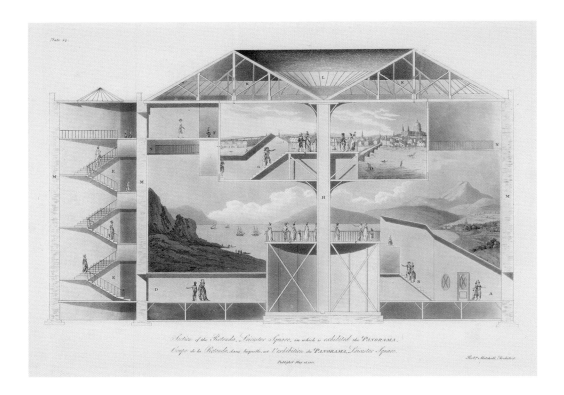

Section of the Rotunda, Leicester Square, in which is exhibited the PANORAMA.
Coupe de la Rotunde, dans laquelle, on l'exhibition du PANORAMA, Leicester Square.

Published May 26 1801.

Rob.t Mitchell, Architect.

9
Robert Mitchell,
"Section of the Rotunda,
Leicester Square, in
Which Is Exhibited
the Panorama," from
Robert Mitchell, *Plans,
and Views in Perspective,
with Descriptions of
Buildings, Erected in
England and Scotland*
(London: Wilson & Co.,
1801), plate 14. Etching,
aquatint, 12 ½ × 18 in.
(32.2 × 46.7 cm).
British Museum, London,
1875,0710.4485.

the futile clutching at air of a drowning man struggling to save himself. So, once again, in *Right and Left*, Homer asks his viewer to see in an impossible manner, from the point of view of a body bereft of life.

Homer's insistence on a death's-eye-view in this and other pictures becomes especially interesting when considered in relation to his caption for the shipwreck sketch: "From the retina of a drowned man." Homer's use of the term "retina," not a particularly obvious choice of words, conjures the morbid perspective from which the scene was putatively viewed or recorded. Yet what I described as the lack of restraint or the macabre indulgence of this scene comes in part by way of Homer's invocation through his caption of something worse than a drowned man, more like a corpse coming apart at the seams, its outer layers peeling away so that its innards are revealed. "Retina" conjures just such an image of a body no longer intact, one the inside surfaces of which can be seen. More specifically, "retina" as a term calls to mind medical science in addition to graveyard rot, thus invoking the perspective of the anatomist and summoning thoughts of dissection to the viewer's experience of the scene. This is the case because of course one way to see this particular anatomical part, lodged as it is

Rachael Z. DeLue

within the organ of the eye, is to disassemble a body through a series of cuts. The emphatic line Homer drew beneath the scene that slices the page in two evokes such cutting. It also transforms the bottom portion of the page into a platform for viewing, calling to mind something like the elevated platform on which a nineteenth-century viewer would have stood in order to view a panorama painting installed in a rotunda (fig. 9) or, more broadly, the space of the audience situated before any entity made or meant to be seen, be it painted, performed, or otherwise. Such a conspicuously theatrical positioning of the beholder in the sketch, right at the foot of the stage, in combination with that same beholder's breach of the fourth wall—as dead or drowning alongside the shipwrecked crew—reinforces Homer's intent to make viewing itself manifestly at issue in this work. The blank rectangle of the bottom half of the page that supports the wrecked boat and floating bodies also emphasizes the status of the sketch as a scene of imagined dissection, complete with a dissection table in the form of the line that cuts across the page and the trappings of an anatomical theater as evoked through the picture's stagelike configuration. Of course by the time Homer made his sketch, an anatomist or physician did not have to cut in order to see a person's retina, for the ophthalmoscope, invented by Hermann von Helmholtz in 1851, allowed for the examination of the internal structures of the eye without dissecting the head. Yet the force of Homer's sketch suggests that even with the idea of the ophthalmoscope in mind, the viewer, obliged through Homer's invocation of the retina to visualize an internal tissue in the raw, wound up confronting the idea of a body turned inside out.

"Retina" also suggests that Homer may have been familiar with an idea circulating among scientists and popular audiences in Europe and the United States in the second half of the nineteenth century and into the twentieth: that an image of the last thing seen before death remained on the dead person's retina, available for scrutiny by others.[3] The notion, which had originated in the first half of the nineteenth century, gained traction with the discovery in the 1850s of a reddish purple pigment, later named rhodopsin and often referred to as "retinal violet," in the photoreceptor cells of the retina known as "rods." By the 1870s, it was observed that this pigment turned a much lighter hue, or bleached, in response to light, and stayed bleached for an extended period before regenerating. Because this discovery posited the retina as a screen rather than a window, a material receptacle for light rather than something through which light simply passed, almost immediately the effect was likened to photography.[4] Scientists

hypothesized the retina as a biological camera that registered light as would a photographic plate and that ultimately yielded through a chemical developing process an image on the retinal surface of the thing that had been seen by the eye. Dubbed "optography," the phenomenon generated a culture of scientific experimentation, mostly involving the beheading and dissection of animals for the purpose of identifying and verifying the existence of a retinal picture. Optography also captivated the imagination of the public, chiefly through journal and newspaper accounts as well as encyclopedias meant for general audiences. Optograms found their way into the plots of both popular and literary fiction; among others, Rudyard Kipling, Jules Verne, and James Joyce featured optograms in their narratives (Joyce did so ironically), and the notion persisted in the popular imagination long after it was discredited in the scientific community. In keeping with the emerging evidentiary paradigm in the period, criminal investigators in some police departments took up the practice of photographing at close range the eyes of murder victims in order to identify the person or persons who had done the deed; this included the murdered Annie Chapman, believed to be one of Jack the Ripper's victims, whose eyes were examined for traces of her killer's visage.[5] Some murderers, in turn, wised up, and either covered their targets' eyes before striking or pitted the eye sockets of the deceased so no retinal evidence could be gathered.

It would be incorrect to count Homer's shipwreck sketch among the experimental and anecdotal evidence offered up in the 1870s and 1880s to support the validity of the optogram hypothesis. His picture shares next to nothing with the sensational newspaper reports of killers identified and caught by dint of their retinal headshots. But having a sense of the larger discursive context of Homer's directive to imagine seeing from the point of view of a drowned man's retina helps illuminate the dynamic complexity of his image, in particular the fluid and elusive identity and status of the "picture" itself within the network of seeing and not seeing he constructs through it. For what *is* the status of the picture we see here? What exactly, as a visual expression, *is* it, given the complexity of the fiction of its creation as well as the conditions of its existence and its availability to us as viewers as bequeathed by Homer through his caption? Homer prevents an easy answer by putatively obscuring both the origin of the drawing and the means by which it comes to be perceived after its creation: he drew it, and we see it, but according to the fiction of his caption, neither he nor the viewer could have envisioned the scene, either as a waterborne

Rachael Z. DeLue

dead person or through an image etched in light on that person's retina. Of course one could imagine the sketch as meant to be that very retinal picture, extracted from the corpse by way of dissection, or through the speedy employ of an ophthalmoscope—a retinal image that rendered the interior of the eye visible to an external observer who then transferred the view to paper. But such a scenario has its own problems, for it stipulates an improbable chain of reproduction, from retinal picture to pencil sketch, one that necessarily brings photography into the mix as a possible source for what we see in Homer's picture, which could be the image "photographed" by the retina and observed on that tissue or, just as easily, a photograph *of* the retinal image, translated from anatomical membrane to photographic plate and then to photographic print. Of course Homer's sketch is not literally a retinal picture. This goes without saying, as does the futility of any attempt to figure out what the picture "really" is or what it "really" shows. That effort would involve falling headlong under the sway of the fiction of realism and a consequent search in vain for the external cause responsible for producing the pictorial effect.[6] But the caption does introduce, if hypothetically, the possibility that Homer's sketch *could* be just such a retinal image. And this would mean that what we are seeing is something that we did not view, that we never could, and that never existed in the first place—or, alternately, that what we see is visual data available only to something we are not: a corpse, an animal, an optical or reproductive technology, and so forth. What *is* a picture, after all, the sketch ultimately asks, a boldfaced but urgent question for those who earn their keep by making pictures or by assaying their meaning. That Homer posed such a question across a diverse array of his work, and pinned it to another query—along the lines of *who* or *what* generates the appearance and operations of a picture—suggests an abiding concern on his part for the nature and capacity of visual form, pictures in particular, and for the problems and possibilities and also the pleasures and potential dangers that attend any act of pictorial representation.

Art history as a discipline is conventionally if not exclusively preoccupied with what pictures mean: with the process of decoding a work of art's iconography and formal vocabulary and identifying the socio-historical sources and intended recipients for the meanings conveyed through form and subject matter. *Picturing* considers the very ground

for such inquiry, the fact of a picture itself: as a thing that exists in the world as the result of a series of manual and imaginative operations and to which is attributed certain and various properties and conditions, actual, desired, or otherwise. "Picturing" as the organizing term for this collection of essays thus refers to the particular exigencies of the production and consumption of visual representation. The term understood in such a manner also and more pointedly refers to picturing as a concept: as a cohort of ideas and hypotheses that collectively generate visualization *as* an available act, a thing that people can and choose to do. This idea is key to the volume's intentions and its contribution to the scholarly discourse: that is, that a picture is first and foremost an idea, rather than a thing that simply exists in the world a priori, and is made available *as* an idea and extant option through material, cultural, and social contingencies. This hypothetical availability goes hand in hand with hypothetical productivity, that is, with the sense that a picture might be made with an outcome in mind. For this reason, "picturing" as a term also refers to how a given culturally and chronologically contingent cohort of ideas and hypotheses theorizes the conditions of the production of a visual representation both locally, for an individual maker, and more generally, for a particular historical moment. *Picturing* considers such conditions alongside a range of thinking by artists, writers, and others about the production of visual form brought to bear on the making, viewing, and analysis of pictures in the United States. The result is an account of salient episodes in America's rich history of thinking and theorizing about the nature of pictorial existence (to borrow a phrase from one of the contributors to this volume) that attends to a series of seemingly basic yet essentially complex historical and conceptual questions: What is a picture? Why make a picture? What do pictures do? How do pictures communicate? When do pictures fail? How is picturing like or unlike bringing something into sight through the operations of vision? These questions, similar to those formulated in paint by Winslow Homer in the 1880s, have been raised persistently by makers and viewers in the past and into the present, and they are this volume's chief queries as well. It is hoped that by putting such queries front and center, *Picturing* will serve as a foundation for further research and writing in art history and other disciplines concerned with the history and theory of visual representation as both a phenomenon and an idea in the United States and beyond.

 Picturing of course shares certain concerns formulated in scholarly writing about the arts across the humanities and the social sciences

Rachael Z. DeLue

that highlight fundamental questions about visual art. A rough sketch of this body of literature would yield three primary terms essential to such inquiry and, also, to the project of *Picturing*: (1) "ontology," the nature of being of a work of art, (2) "epistemology," the grounds for knowing that subtend visual production, and (3) "modality," what a work of art does or demands. Other terms would of course rise to the surface, including *Bildwissenschaft*, "visual studies," "visual culture," and "material culture." Indebted as this volume is to the methodological breakthroughs of these areas, it is worth elucidating how these realms of inquiry and the concerns of *Picturing* compare—not to position *Picturing* as counter to the study of the visual writ large as it has been articulated theoretically and institutionally in Europe and the United States, but in order to articulate precisely from the outset the specific intentions and predilections of *Picturing* as outlined above.

Rooted in part in the study of the history and theory of culture associated with the work of the German art historian Aby Warburg (1866–1929), in particular Warburg's expansion of the purview of art history to include nonart imagery, *Bildwissenschaft*, roughly translated as "image theory" or "image science," encompasses a diversity of methodologies and scrutinizes a wide range of material. The scholar Horst Bredekamp, who published a seminal account of *Bildwissenschaft* in 2003, highlighted two key characteristics: an embrace of "the whole field of images beyond the visual arts," including photography, film, video, scientific illustration, and mass media images, and an insistence on taking "all of these objects seriously."[7] Importantly for Bredekamp, *Bildwissenschaft* does not exclude or exist as distinct from the study of fine art. As he points out, this mode of inquiry originated from within the discipline of academic art history, with figures such as Erwin Panofsky, Hermann Grimm, and Heinrich Wölfflin whose study of visual art included consideration of reproduction technologies like photography and slide projection; it follows that art history, for a figure like Bredekamp, is always *Bildwissenschaft*. His version of it involves elucidating the structures of images so as to characterize how they, rather than simply recording visual experience or data, construct the visual and how images generate and disseminate knowledge through this construction.[8] This differs somewhat from the *Bildwissenschaft* of two other key figures in Germany, Gottfried Boehm and Hans Belting, who each represent a distinct approach. Yet all three concern themselves with the question "What is an image?" and thus with the matter of ontology, and all three conceive of visual expression as operating and acting according to a logic distinct from the systems that

govern other forms of representation, such as language and text. Essential to this formulation is the anthropologically inflected understanding that images possess forms of agency, and also a sense that images, given the thickness of their presence and their potential to act or operate in the world, may not be reduced to the catchall rubric "representation."[9]

As Bredekamp points out, the distinction between the English-speaking world's version of visual studies, properly termed "visual culture," and the historic trajectory of *Bildwissenschaft* in Germany and Austria hinges on the fact that visual culture is not an iteration of art history but an approach formulated partly in opposition to it.[10] Arising in part from cultural studies, the study of visual culture took shape in the United States and Britain primarily if not exclusively as a mode of ideology critique that treats the visual sphere as a social and ideological formation and aims to articulate the political stakes and effects of the circulation of images in the public sphere. So while *Bildwissenschaft* commonly asks questions about the fundamental nature of visual expression and attends to the divergent properties and capacities among different types of visual artifacts, visual culture in the Anglo-American tradition tends to focus, if not exclusively or uncomplicatedly, more on the visual as a medium for the production and circulation of sociopolitical meaning, endeavoring to document what happens *after* an image finds its way into the realm of culture. The term "image," which predominates in writing about visual culture, signals a major intervention, one shared with *Bildwissenschaft*, namely, the insistence that categories of visual expression other than fine art demand and deserve scholarly attention and analysis, alongside and commensurate with the study of "high" culture. For visual culture, this includes, in addition to photography and film, other visual forms based in media and information technology such as television, the Internet, social media, fashion, popular entertainments, the built environment, and advertising.[11] "Image" as an organizing term also serves to differentiate visual culture studies from *Bildwissenschaft*. Although scholars and critics of visual culture recognize that images occur within multimedia contexts, opticality fundamentally drives inquiry. That is, the forms and modes of address and consumption that receive the lion's share of scrutiny within analysis are those that address the visual sense.[12] Accordingly, the concept of visuality provides a fundamental paradigm for understanding the status of visual expression within society, meaning that scholars of visual culture attend to images but also to how they are seen: specifically, to the

social construction and cultural constraints of vision, what Hal Foster has termed a "scopic regime," that is, not "how we see" but "how we are able, allowed, or made to see."[13] Consequently, visual forms of widely diverse types are subject to a common set of methodologies as well as to the assumptions about identity, meaning, and power that come along with and underpin those methodologies. Additionally, objects of analysis remain within the register of the visual for the duration of interpretation, persisting from start to finish as "image" largely apart from their physical existence and the matter of their material production, aspects of an object that *Bildwissenschaft* subjects to rigorous scrutiny. Each object considered by visual culture thus contributes alongside a multitude of other images under examination to the formulation of a sense of the world and one's experience of it as insistently spectacular and optically mediated.

"Picture" as the default descriptor for this volume registers the expanded historical, material, and methodological terrain of *Bildwissenschaft* and visual culture while responding in particular to the structuralism of the latter. Matthew C. Hunter describes in his essay a tussle over terminology in late eighteenth-century England marked by worry that the French word *peintre*, when translated into English as "painter," lost its specificity and wound up referring equally to artists and to other slingers of paint, including men who painted houses to earn their keep. The loss occurred because the English word "painter" collapsed into a single term two French words distinct in their meaning, *peintre* and *coleurs* (the latter, a noun, is French for "paint"), resulting in the elimination of the all-important distinction between an artist and the artist's materials, the creative act and dumb matter. But of course any work of art, as with any image, exists as a material object in three dimensions within a larger network or matrix of other objects and forms of matter. What is conventionally taken to be the gist of a painting, for example, is simply and only the visible and privileged uppermost surface or skin. Even a digital image subsists within a complex of material parts and occupies three dimensions by virtue of the screen or physical surface through which it must manifest in order to be seen. The perceived threat of the banal connotations of "painter" to fine art in eighteenth-century England hinged on the same unsustainable fantasy of visual form's pure exteriority implicit in more recent studies of visual culture that suppress distinctions among materials and transform diverse visual artifacts into so many equivalent and interchangeable scrims. As evidenced by the subjects and objects considered by the contributors to this volume, *Picturing*

embraces the study of visual culture as vital and necessary, urgently so. But it insists on the material, social, sensorial, and epistemological specificity of visual expression within history and resists the idea that all images everywhere may be collectively theorized such that their nature and operations may be collectively understood: not picture theory, but picture *theories*, one could say, or even picture *biographies*. Put another way, a "picture" is thick in a way that an "image" is not, and it is that thickness, physical as well as intellectual and historical, that "picturing" as the governing concept of this collection of essays intends to mark and explore.

"Picturing" also reflects the manner in which thinking about pictures transpired in the historical period under discussion, from the eighteenth century forward. Grammatically speaking, as both a transitive verb (indicating an action that has a direct object) and the present participle of "to picture" (a verb form that fashions a continuous tense, as in "I am thinking" or "I am picturing the scene"), the word "picturing" produces a threefold effect most useful for the purposes of this volume: it implies action, it refers to something other than itself, and it embodies temporality. Svetlana Alpers in her seminal *The Art of Describing: Dutch Art in the Seventeenth Century* provides a precedent for such a formulation. According to Alpers, "picturing" as a verb better suits the task of dealing with the nature of northern European images than the noun "picture" for three reasons: "it calls attention to the *making* of images rather than to the finished product; it emphasizes the inseparability of maker, picture, and what is pictured; and it allows us to broaden the scope of what we study since mirrors, maps, and . . . eyes also can take their place alongside of art as forms of picturing so understood."[14] Alpers's consideration of a line of thinking about vision descending from Johannes Kepler, which posits seeing itself as a form of picturing and the processes of finding and making as inseparable within art, also provides a useful model for this volume's expanded view of what it was "to picture" in America.[15] Thus *Picturing* considers things that are pictures in a conventional sense, visual representations such as paintings, photographs, drawings, and prints ("picture" as a noun), as well as the materials, processes, and procedures that led to their creation, that is, to their picturing (taking the verb "to picture" as implying time as well as the network of entities activated and produced within the time of an object's creation). But the five essays gathered herein also make clear that other modalities and mediums of picturing—such as verbal description, the formation of a mental image or impression, the arraying of data, the idea of

Rachael Z. DeLue

likeness, or natural and physical operations such as atmospheric phenomena, sedimentation, and chemical reaction—are equally if divergently part of period discourse on the nature and limits of visual production. Consequently, while nouns are not banished from the core terminology or the conceptual scheme of this collection of essays—"picturing," after all, can also be a gerund, the noun form of the verb "to picture"—the volume puts pressure on the manner in which terms like "image" but also "object," "artifact," or "thing" condition interpretation by unduly restricting or localizing analysis. The essays, then, collectively offer "picturing" as a more flexible and historically adequate category of inquiry, one that in encompassing multiple possible forms of visual matter or phenomena understands those forms as produced and consumed in duration. The volume also argues against the explicit or implicit privileging of any categorical term or explanatory idea, opticality included, and insists that any account of picturing in America must resist the impulse to identify theoretical or structural continuities across myriad practices as a means by which to offer a theory or taxonomy of the image in America as such. In other words, *Picturing* makes a methodological intervention not by saying how pictures in America should be conceptualized and thus approached within interpretation (as images, as agents, as social matrices, and so forth), but by marking historical manifestations of picturing and thinking about picturing as demanding serious and sustained scholarly attention commensurate with the attention direct-ed at picturing by cultural producers in the past. By necessity, then, each contributor draws on the material and ideas of multiple disciplines in pursuing his or her analysis, while the connections and comparisons each makes across various media illuminate the sheer richness and range of visual expression and the ideas that shaped visual expression in the American context.

 Picturing thus makes clear that the questions raised by Winslow Homer's paintings and sketches with which I began this introduction— What is a picture? What is being pictured? How do we know?—were serious ones for historical practitioners and thus should be taken just as seriously by present-day scholars. By formulating the idea of picturing broadly and eccentrically, this volume demonstrates how deliberation about pictures and picture making in America included but also extended beyond institution-based or art-critical writing, manifesting in expressions as diverse as scientific writing, survey photography, crime reporting, travel narratives, popular fiction, and experimental literature. But even more importantly and insistently, *Picturing* marks

just how particular and specialized thinking about pictures was at different historical moments, in varying conditions, and for a diversity of makers and viewers. Accordingly, the essays included in this volume consider a diverse range of material, from eighteenth-century Anglo-American portraiture and pictures of Pacific coast fog to the poetry of Gertrude Stein and the photography of Jeff Wall. But they converge in illuminating the centrality and significance of the problematic of picturing within American visual practice and in arguing for the historicity of picturing as a concept and an operation. And they proceed always with the understanding that works of art and other kinds of pictures actively theorize their own nature and limits, at times in excess of their makers and viewers or in ways not fully explicable solely through recourse to contemporaneous discourse or sociopolitical context.

In this way, *Picturing* in its approach draws on the methods and insights of the field commonly called material culture or material culture studies. As defined by the historian of American art Jules Prown, material culture undertakes to study through artifacts "the beliefs — values, ideas, attitudes, and assumptions — of a particular community or society at a given time."[16] As a mode of inquiry, material culture treats such artifacts as a unique form of evidence for use in historical analysis, distinct from the written word and from other types of historical documents. All five contributors to *Picturing* situate their objects of study prominently in their analyses and offer thick descriptions of these objects; they also recognize that objects, no matter how privileged they are within historical investigation, never transparently reflect or embody history and ideology. The essays also challenge the prevailing assumption that thinking about pictures in the United States always hewed closely to the precepts of European art treatises, the derivativeness of art theory in America thus not warranting close or sustained analysis. This volume pays particular attention to the transit of ideas across the Atlantic while also revealing the unexpected complexity and, in some instances, the sheer strangeness of thinking about picturing in the American context. And for the purposes of *Picturing*, that context necessarily encompasses the geographic area now known as the United States as well as the international fabric of which "America" and American pictures have always been a part. In this way, the concept of picturing as explored by this collection of essays might be understood as equally pictorial or theoretical and *transactional*, as both the process and product of exchange among different cultures and geographies.

Rachael Z. DeLue

⚡

Picturing is the first installation in a series of volumes published by the Terra Foundation for American Art that identify and explore ideas, categories, and concepts that have been particularly salient and generative within the history of American art and visual culture. Other volumes in the series address scale, circulation, experience, color, and intermedia. While not arbitrarily selected, these concepts of course exist among many other possible points of focus, and future installations might consider concepts such as violence, evidence, abstraction, models, blindness, or prophecy. Specially commissioned for the series, the essays in each volume attend rigorously to specific objects, as much of the best scholarship on American art always has, but they also zoom out onto a range of historically significant and presiding conceptual and theoretical concerns so as to integrate thinking about visual expression in the American context more substantially into a larger and richer history of ideas. Consequently, the material under discussion in each essay serves as a portal to the bigger picture of art making in the United States. Prospective in orientation, rather than retrospective, the series aims to support the field of American art history by mapping new historical and interpretive terrain and by doing so in relation to but not *as* a review of methodology or historiography. In this way, the series aims to entice non-Americanists to engage with American art by offering comparative models and conceptual tools relevant to all scholars of art and visual culture from a variety of art-historical subfields as well as disciplines other than art history. By including a diverse roster of authors whose essays consider material from multiple continents, the series also facilitates much-needed connections in print among the work of scholars in the United States and those based elsewhere, thereby providing a model of intellectual exchange and collaboration for future work and situating American art and visual culture in a more rigorously transnational discourse. The essays in *Picturing* embody this impulse, for they consider American art in certain of its transatlantic and transpacific contexts, with particular attention to England, France, and China. In this way, *Picturing*, framed as it is by scholars and methodologies hailing primarily from France, Britain, Germany, and North America, also signals just how much work there is left to be done, and just how rich future scholarship on the international conditions of American art and visual culture can be.[17]

All of this of course begs the question: Why American art? The concepts considered by *Picturing* and the other volumes in the series

are relevant across multiple areas of art-historical expertise, after all, and in some cases they already have a well-developed scholarly literature (for example, writing about the history and theory of color on the part of scholars of early modern and modern European art). It should be stated outright, then, and with especial emphasis, that these volumes are not at all interested in narratives bound up with claims for the exceptional nature or distinctiveness of American art and culture. This series treats with healthy suspicion all versions of the question "What is American about American art?" save for instances when such a question might have been raised within historical discourse. Instead, the series treats American art as one category of artistic production among many and possesses relatively little patience for the idea that art must be understood as constitutively linked to nation and, consequently, that considerations of American art must necessarily address matters of national identity or the question of Americanness. This does not mean that "America" winds up a hollowed-out term of analysis, a mere placeholder for art-historical inquiry that could easily and without complication direct its attention to and adjudicate just about any object, American or otherwise. It is simply that American art, as a category of artistic production, and, yes, as the product of specific (if not wholly exceptional) histories and experiences, *invites* attention to certain themes and concepts that the art of other nations and regions may not, or not as urgently, and, also, that certain questions, when asked of American art, give us impressively interesting and compelling answers that illuminate history and contribute to art-historical discourse in significant and distinctive ways. The fact that artistic production was largely decentralized in the American context, at least in comparison to art making in Europe, might serve as one example of a difference that proves intellectually generative for scholarly inquiry. The lack of a dominant, institution-based discourse on art and the consequent proliferation of multiple and multidisciplinary discourses, from the idiosyncratic to the outright strange, might be another. And the fact of being bounded by vast oceans on the east and west and terra incognita to the extreme north and south, creating, for instance, conditions of existence and spaces of transaction that have been termed the transatlantic and transpacific, could be yet another still—as long as such qualities do not predetermine scholarly outcomes by pitching inquiry from the outset in the direction of exceptionalism. The line that this series walks between exceptionalism and generality is consequently a very fine one, but it walks that line with conviction. And such conviction comes from the belief that neither an insistence

Rachael Z. DeLue

on the characteristically American nor the superficial and too-easy application of the terms and approaches of other areas of inquiry will yield substantial historical insight or new grounds for approaching and understanding American art and visual culture.

For these reasons, a great deal of thought went into the commissioning of the essays for *Picturing*. Each author invited to write for the volume has in previous scholarship substantially addressed historical and conceptual concerns regarding the nature and limits of pictorial and visual expression, from the capacity of pictures to capture the otherness of new terrain and populations (the New World, the West, the "native") to the ways of seeing and knowing that adhere in diverse visual practices and the cognitive properties attributed to media such as printmaking, painting, drawing, and writing.[18] Responding to my formulation of *Picturing* as a new research project rather than a showcasing of extant work, each author agreed to write something new for the volume. Diversity served as a criterion for the subject matter and scope of the essays, which address various media, time periods, audiences, practitioners, disciplines, and modes of display. But history necessarily trumped diversity, for each author selected his or her subject because it demanded to be understood in terms of the idea of picturing, and those demands in turn established the preoccupations of the volume as a whole. Thus all five essays purposefully constellate and respond to a set of common concerns generated by the concept of picturing as I have articulated it here, beginning with the very existence of "picture" as a term of period discourse, one generated by and subject to multiple and at times contradictory demands and desires. And each author follows period cues in refusing take the idea of a "picture" for granted, making instead that idea the very subject of his or her analysis. Following this, each author insists on what Robin Kelsey in his contribution to the volume characterizes as the plasticity of the term "picture" for period practitioners, and each argues for what the essays collectively articulate as the need to account for picturing as it unfolds in an expanded field of actions, agents, and entities. There thus exist common threads—the materiality of pictures, nonhuman interventions in the process of picturing, the nonopposition of painting and photography, the electrochemical as a template for picture making, substitution as the key operation of picturing, picturing as experiment, picturing as failure—as well as striking divergences in content and approach among the five essays written for *Picturing*.

In the first essay, Matthew C. Hunter discusses a May 1773 open letter to London's *Morning Chronicle* that lodged a striking complaint

with Sir Joshua Reynolds, then president of Britain's recently opened Royal Academy of Arts. This anonymous critic charged that by dint of an excessively literal translation of certain French words, among them *peintre*, pigmented ooze, or paint as such, had come to disfigure and corrupt conceptions of pictorial art current among English-language speakers. By taking the *Morning Chronicle*'s peculiar critique seriously and using it alongside Reynolds's notorious chemical experiments with materials as an entry point into a discussion about period conceptualizations of pictures and, also, period theorizations of just what *makes* a picture, Hunter recasts conventional scholarly accounts of picture theory in the Anglo-American world. Namely, he considers how Reynolds and contemporaries in Britain and early America understood the interface between paint and image, between unstable work on canvas and its multimedia replication, and through his account, he shows how ideas about picturing in the eighteenth century were in significant ways continuous with those of the modern period, especially as regards the question of making pictures by mechanical or otherwise nonhuman means.

The second essay, Michael Gaudio's, lingers in the eighteenth century and in the domain of scientific experimentation. Gaudio looks closely at a portrait of Benjamin Franklin, created in 1762 by the London portraitist Mason Chamberlin, in order to consider painting in the eighteenth-century Atlantic world as a practice that happens at the limits of rational understanding. While Chamberlin pictures Franklin as a sober scholar in his study, Gaudio's essay focuses on how the thunderstorm raging outside the scientist's window offers a commentary on the excessive potential of Enlightenment picturing. In his account, Gaudio draws on Franklin's own picture theory, or the closest thing to such a theory: Franklin's description of his experiment that involved an electrified portrait of the king of England, a performance he called the "magical picture."

The third essay, Elizabeth Hutchinson's, also considers the limits of picturing as a form of knowing. As Hutchinson points out, scholars have long recognized the Western habit of representing unfamiliar landscapes using conventions developed for other locales. This practice traces across mediums: maps insert the iconography of exoticism developed for East Asia into representations of South America; topographical renderings of Australia depict local scenery in a picturesque style developed for the British countryside; and so forth. The habit dates even to early photographers who, while they could not distort the contours of the landscape, used strategies of composition and framing

to make what was depicted match their viewers' expectations. Through a focus on the work of Eadweard Muybridge, Hutchinson's essay explores what happens when the limits of such practices are reached. When Muybridge photographed the Pacific coast of North America, he confronted a geographic region whose geological history resulted in a topography that was difficult to fit into pictorial conventions, not only because of the shape and height of the coastal mountains that trace down the continent, but also because of their meteorological effects. In particular, the fog trapped by this mountainous ridge challenged any artist hoping to make an accurate rendering. Interrogating Muybridge's responses to this challenge and comparing his work to that of other artists who sought to negotiate the novel and the familiar, Hutchinson illuminates the challenges confronted in giving both pictorial form and cultural meaning to newly encountered landscapes and, like Hunter in his essay on Reynolds, offers an account of picturing as a network among human and nonhuman entities and agents.

The fourth essay, contributed by Ulla Haselstein, discusses Gertrude Stein and Paul Cézanne, focusing on certain of Stein's remarks on Cézanne in her lecture "Pictures" and in her verbal portrait of the painter. Haselstein explores how Stein's encounter with Cézanne's paintings changed her idea of writing and paved the way for her modernist innovation. Stein's portrait of Cézanne, Haselstein demonstrates, is particularly interesting as a *paragone*, for Stein clearly wished to demonstrate the superiority of writing over painting, the limits of which could be surpassed by literary portraiture. Yet, as Haselstein shows, Stein also through the specific form of her writing acknowledged Cézanne's profound impact on her work. For Haselstein, Stein thus offers a way into considering period conceptualizations of the relationship between writing and painting at a moment of experimentation across multiple representational registers. Stein also serves as a case study of a theory of picturing that unfolds within literature and fiction, much as picture theory arises from the discursive and experimental contexts of science as described by Gaudio and Hutchinson.

The fifth and final essay, by Robin Kelsey, returns to the history of photography. Kelsey examines the dynamic moment around 1900 when American photographers of aesthetic ambition staked their claim to photography as art on the basis of a new concept of the *picture*. In an effort to shoehorn photography into the fine arts, these practitioners construed the picture as a vital aesthetic category independent of medium or genre. This effort required a subtle negotiation of the line separating photographs that qualified as *pictures* from those that did

not, and the resulting criteria bore a latent theory for what distinguished pictorial art in other media. In his essay, Kelsey considers the dialogue between writing and photography through which Alfred Stieglitz and others associated with pictorialism fashioned this assertive new concept of aesthetic validity. He also makes clear that, in light of Jeff Wall's influential postmodern use of the term "picture" to introduce large-format photography into the place of painting, now is a propitious time for recalling this crucial but neglected aspect of pictorialist practice as one among numerous examples of formulations of the term "picture" that have been overlooked or marginalized in scholarly accounts of the history and use of the term. Calling on figures as diverse as Stieglitz, Wall, Frederick Douglass, and Jacques Lacan, Kelsey demonstrates how photography's radical redefinition of "picture" as a concept disrupts conventional narratives of its constancy from the eighteenth century through the 1930s. In so doing, he returns to a line of inquiry introduced by Hunter's essay concerning the fraught migration of theories of picturing from the past to the present.

The closest Homer ever came to rendering a retinal picture of the sort postulated in late nineteenth-century popular and scientific literature came in a letter he wrote in 1896 to his friend George C. Briggs, which recalled the time Homer spent at the siege of Yorktown, Virginia, during the Civil War. Homer went to war at the behest of *Harper's Weekly*, charged with providing illustrations of life on the front lines for the journal's readership. He was in Yorktown for about two months in 1862, embedded with Lieutenant Colonel Francis Channing Barlow and his troops.[19] In his letter to Briggs, he described an encounter with Union sharpshooters and illustrated his recollection with a sketch (fig. 10). "I looked through one of their rifles once when they were in a peach orchard in front of Yorktown in April 1862," Homer wrote, penning the sketch before continuing his account. "This is what I saw. I was not a soldier but a camp follower and artist. The above impression struck me as being as near murder as anything I ever could think of in connection with the Army and I always had a horror of that branch of the service." One of Homer's earliest paintings of the front, *Sharpshooter* (1863) (fig. 11), depicted a sharpshooter from the Union side. The cropped composition, tilted perspective, and tense poise of the gunman, here perpetually on the verge of taking a shot, together create a scene thick with the anticipation of violence and death.

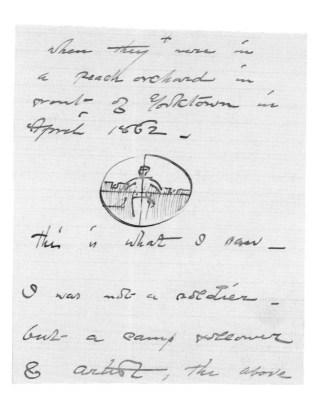

Homer obscures the sharpshooter's features in order to underscore
the anonymity of this type of warfare, commonly characterized by
soldiers on both sides as cold-blooded and inhuman.[20] Homer's sketch
in his letter to Briggs succinctly and efficiently registers the murderous-
ness of sharpshooting. It brings the soldier's body into close range
for the reader, pinning the target between the crosshairs of the scope
and the flatness of the page. The crosshairs slice the body into quarters,
figuratively anticipating the zip of a bullet through air and into flesh
and calling to mind more generally the disfigured bodies and missing
limbs of soldiers wounded in battle, which Homer also illustrated for
Harper's (fig. 12).

But Homer's riflescope sketch offers more than a document of
his response to the incident at Yorktown, a record of what happened
and how it made him feel. I say this because of the pictorial amputation
Homer stages through slicing effects in his drawing for Briggs: a split-
ting off of limbs that resonates with the dissection underway in his
shipwreck sketch and, like his injunction to see by way of a dead man's
retina, infuses a scene of seeing with danger and dread. The riflescope
sketch also conjures Homer's invocation in the shipwreck scene of

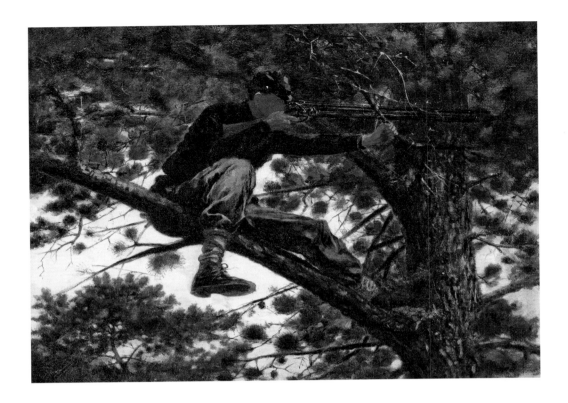

11
Winslow Homer,
Sharpshooter, 1863.
Oil on canvas, 12 ¼ ×
16 ½ in. (31.1 × 41.9 cm).
Portland Museum
of Art, Maine. Gift of
Barbro and Bernard
Osher, 1992.41.

a pictorially captured retinal image: the riflescope picture presents a record of Homer, who has been lent a rifle by a sharpshooter, seeing as would another man — not just stepping into his shoes and adopting his point of view, but seeing and registering an image of that man's victim before the trigger is pulled, a scenario identical in reverse to that of a victim of murder seeing and then retinally photographing his killer, with the resulting image available for scrutiny by others as the riflescope sketch was for Briggs. The riflescope sketch mirrors the conventional circular shape of the images passed off in the nineteenth century as optograms, but only by coincidence does this reinforce the idea that Homer's riflescope drawing, like his shipwreck sketch, has something to say about the insistent and tense exigencies of picturing. It is the urgency with which Homer rendered a picture *of* picturing in the Briggs letter that makes plain how pressing such concerns were for him. Prompted by Homer's caption, a viewer can imagine the shipwreck sketch as an image generated by a mechanical process such as photography (as in a photograph-like retinal image or the photograph *of* a retinal image) or a mechanical device such an ophthalmoscope. The riflescope sketch, however, *insists* on its status as an image

Rachael Z. DeLue

of picturing, and not simply its existence as a picture, because it depicts not only a view seen but a view produced by a machine, in particular, a telescopic lens, an image translated from the real through selection, cropping, and distortions of distance and scale, like a photograph. "This is what I saw," Homer wrote immediately beneath his sketch, in the form of a caption—"this" being at once the imperiled soldier and the picturing generated by the riflescope as depicted in Homer's sketch.

When taken together as a cohort, Homer's animal pictures, his shipwreck sketch, his riflescope view, and his paintings of the sea offer up a portrait of an artist intensely curious about the nature and limits of pictures and picturing, one whose remarkable interlacing of picturing and acts of violence demands further scrutiny, both within Homer's oeuvre and alongside other pictorial practices and theorizations of the period. This body of work also proffers itself as a collection of concepts and questions for use in fathoming not just the impulses of Homer's art but also the grounds for picturing more generally in the period: what it was understood to be, what it strove to do, and why it happened at all. Mining Homer not just for meaning, but for methodology—for a sense of the questions one might ask of his work or for direction in charting new approaches to visual expression in the period—illuminates just how much might be gained by approaching the history of American art as a history of picturing as well as just how much Americans have had to say about the pictures they theorized, created, and consumed.

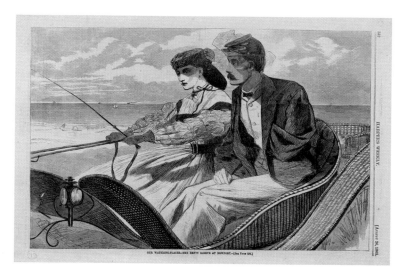

12
Winslow Homer,
*Our Watering Places—
The Empty Sleeve at
Newport*, from *Harper's
Weekly*, vol. 9, August
26, 1865, p. 532.
Wood engraving on
newsprint, 9 3/16 × 13 11/16 in.
(23.4 × 34.7 cm).
Sterling and Francine
Clark Art Institute,
Williamstown, Massachusetts, 1955.4447.

I extend my thanks to the Terra Foundation for American Art for its support of the Terra Foundation Essays. Veerle Thielemans and Francesca Rose deserve especial gratitude for their stewardship of the project. Thanks also go to the two anonymous peer reviewers of *Picturing* who provided critical guidance and advice, to Kelly Finefrock-Creed for her thoroughgoing editing, and to James Goggin and Shan James for their superb design work.

1 Kathleen A. Foster, *Shipwreck! Winslow Homer and "The Life Line"* (Philadelphia: Philadelphia Museum of Art, 2012), 60–63. Both Foster and Nicolai Cikovsky Jr. identify Homer's sketch as a study for *The Ship's Boat*, which depicts five fishermen struggling in the water near their capsized dory. Nicolai Cikovsky Jr., "Good Pictures," in *Winslow Homer*, ed. Nicolai Cikovsky Jr. and Franklin Kelly (Washington, DC: National Gallery of Art, 1995), 372. Foster's book, which accompanied an exhibition of the same name, offers the most thorough account to date of Homer's shipwreck and rescue scenes, including those I discuss in this essay. See also Sophie Lévy, ed., *Winslow Homer: Poet of the Sea* (Giverny: Musée d'art américain/Terra Foundation for American Art; London: Dulwich Picture Gallery, 2006). For further discussion of *The Ship's Boat*, see Charles Colbert, "Winslow Homer, Reluctant Modern," *Winterthur Portfolio* 38, 1 (Spring 2003): 37–55. *The Ship's Boat* is in the collection of the New Britain Museum of American Art, New Britain, Connecticut.

2 *Kissing the Moon* is in the collection of the Addison Gallery of American Art, Phillips Academy, in Andover, Massachusetts.

3 The account that follows relies on the following sources: Arthur B. Evans, "Optograms and Fiction: Photo in a Dead Man's Eye," *Science Fiction Studies* 20, 3 (Nov. 1993): 341–61; Véronique Campion-Vincent, "The Tell-Tale Eye," *Folklore* 110, 1–2 (1999): 13–24; Andrea Goulet, "Retinal Fictions: Villiers, Leroux, and Optics at the Fin-de-siècle," *Nineteenth-Century French Studies* 34, 1–2 (Fall–Winter 2005–2006): 107–20; Craig Monk, "Optograms, Autobiography, and the Image of Jack the Ripper," *Interdisciplinary Literary Studies* 12, 1 (Fall 2010): 91–104; Douglas J. Lanska, "Optograms and Criminology: Science, News Reporting, and Fanciful Novels," in *Progress in Brain Research*, vol. 205 of *Literature, Neurology, and Neuroscience: Historical and Literary Connections*, ed. Anne Stiles, Stanley Finger, and François Boller (Amsterdam: Elsevier, 2013), 55–84. See also Neal J. Osborn, "Optograms, George Moore, and Crane's 'Silver Pageant,'" *American Notes and Queries* 4 (Nov. 1965): 39–40; and, from the period under discussion, "Photographing the Eyes of Murdered Persons," *Humphrey's Journal of Photography*, May 1, 1864, 11–12; "German Correspondence," *Philadelphia Photographer* 14, 161 (May 1877): 149–51; "Permanent Pictures on the Retina," *Philadelphia Medical Times*, Apr. 23, 1881, 479; and R., "Brain Pictures: A Photo-Physiological Discovery," *New York Tribune*, Jan. 15, 1888, 6. Thanks go to Tanya Sheehan for her assistance with period sources. In "Winslow Homer, Reluctant Modern," Colbert discusses the connection between Homer's caption and period discussion of retinal images (41–44). Yet as Foster points out in *Shipwreck!* (108n177), Colbert mistakenly attributes the caption to another study for *The Ship's Boat*, a pen and ink sketch in the collection of the New Britain Museum of American Art.

4 Goulet, "Retinal Fictions," 109–10.

5 Alan Sekula, "The Body and the Archive: The Use and Classification of Portrait Photography by the Police and Social Scientists in the Late 19th and Early 20th Centuries," *October*, no. 39 (Winter 1986): 3–64; Evans, "Optograms," 343; Monk, "Optograms," 91; Lanska, "Optograms," 76–78.

6 For a succinct and lucid critique of this realist fiction, see Michael Fried, *Realism, Writing, Disfiguration: On Thomas Eakins and Stephen Crane* (Chicago: University of Chicago Press, 1987), 10–11.

7 Horst Bredekamp, "A Neglected Tradition? Art History as *Bildwissenschaft*," *Critical Inquiry* 29, 3 (Spring 2003): 418.

8 See, for example, Horst Bredekamp, *The Lure of Antiquity and the Cult of the Machine: The Kunstkammer and the Evolution of Nature, Art, and Technology*, trans. Allison Brown (Princeton, NJ: Markus Wiener Publishers, 1995); Horst Bredekamp and John Michael Krois, eds., *Sehen und Handeln* (Berlin: Akademie Verlag, 2011); Horst Bredekamp, *Theorie des Bildakts* (Berlin: Suhrkamp, 2010); and Horst Bredekamp, *Darwins Korallen: Frühe Evolutionsmodelle und die Tradition der Naturgeschichte* (Berlin: Klaus Wagenbach, 2005).

9 For Belting, Boehm, and Bredekamp, see, for example, Hans Belting, *An Anthropology of Images:*

Rachael Z. DeLue

Picture, Medium, Body, trans. Thomas Dunlap (Princeton, NJ: Princeton University Press, 2011); Hans Belting, *Likeness and Presence: A History of the Image before the Era of Art* (Chicago: University of Chicago Press, 1997); and Gottfried Boehm, ed., *Was ist ein Bild?* (Munich: W. Fink, 1995). Because these scholars claim visual expression's own, particularized logic, their work may be understood in part as a response to the pervasive analogizing of the visual and the textual inspired by semiotics and exemplified by Roland Barthes's influential essay "Rhetoric of the Image," in *Image, Music, Text*, ed. and trans. Stephen Heath (New York: Hill and Wang, 1977), 32–51. Other major contributions to the scholarly conversation on the nature and capacity of visual form, which has generated a bibliography far too extensive to render fully here, include David Freedberg, *The Power of Images: Studies in the History and Theory of Response* (Chicago: University of Chicago Press, 1989); Norman Bryson, Michael Ann Holly, and Keith Moxey, eds., *Visual Theory: Painting and Interpretation* (New York: HarperCollins, 1991); Michael Podro, *Depiction* (New Haven, CT: Yale University Press, 1998); James Elkins, *The Domain of Images* (Ithaca, NY: Cornell University Press, 1999), the first of several book-length studies by Elkins on the subject; Joseph Leo Koerner, *The Reformation of the Image* (Chicago: University of Chicago Press, 2004); Georges Didi-Huberman, *Confronting Images: Questioning the Ends of a Certain History of Art*, trans. John Goodman (University Park, PA: Penn State University Press, 2005); W. J. T. Mitchell, *What Do Pictures Want? The Lives and Loves of Images* (Chicago: University of Chicago Press, 2005), which followed his equally relevant *Picture Theory: Essays on Verbal and Visual Representation* (Chicago: University of Chicago Press, 1994); and Barbara M. Stafford, *Echo Objects: The Cognitive Work of Images* (Chicago: University of Chicago Press, 2007). The classic text from anthropology is Alfred Gell, *Art and Agency: An Anthropological Theory* (Oxford: Clarendon Press, 1998). My own consideration of art and agency appears in "Dreadful Beauty and the Undoing of Adulation in the Work of Kara Walker and Michael Ray Charles," in *Idol Anxiety*, ed. Josh Ellenbogen and Aaron Tugendhaft (Stanford, CA: Stanford University Press, 2011), 74–96; and *Arthur Dove: Always Connect* (Chicago: University of Chicago Press, 2016).

10 Bredekamp, "A Neglected Tradition?," 419–22.

11 For the foundational study of mass media, see Marshall McLuhan, *Understanding Media: The Extensions of Man* (New York: Signet Books, 1964).

12 W. J. T. Mitchell considers the privileging of the visual in the study of visual media in "There Are No Visual Media," *Journal of Visual Culture* 4, 2 (2005): 257–66. It goes without saying that such an optical bias has roots in the art criticism of Clement Greenberg, a subject addressed in Caroline Jones, *Eyesight Alone: Clement Greenberg's Modernism and the Bureaucratization of the Senses* (Chicago: University of Chicago Press, 2005).

13 Hal Foster, ed., *Vision and Visuality*, Dia Art Foundation Discussions in Contemporary Culture, no. 2 (New York: New Press, 1999), ix; Nicholas Mirzoeff, "On Visuality," *Journal of Visual Culture* 5, 1 (2006): 53–79. See also Jonathan Crary's seminal *Techniques of the Observer: On Vision and Modernity in the Nineteenth Century* (Cambridge, MA: MIT Press, 1990), and Whitney Davis's important *A General Theory of Visual Culture* (Princeton, NJ: Princeton University Press, 2011).

14 Svetlana Alpers, *The Art of Describing: Dutch Art in the Seventeenth Century* (Chicago: University of Chicago Press, 1984), 26.

15 Alpers, "'Ut pictura, ita visio': Kepler's Model of the Eye and the Nature of Picturing in the North," ch. 2 in *The Art of Describing*.

16 Jules David Prown, "Mind in Matter: An Introduction to Material Culture Theory and Method," *Winterthur Portfolio* 17, 1 (Spring 1982): 1. For recent examples of writing about American visual and material culture relevant to *Picturing*, among many other examples that could be cited (including recent cultural histories of materials such as cotton and mahogany), see Jules David Prown and Kenneth Haltman, eds., *American Artifacts: Essays in Material Culture* (East Lansing: Michigan State University Press, 2000); David Morgan and Sally Promey, eds., *The Visual Culture of American Religions* (Berkeley: University of California Press, 2001); Bernard L. Herman, *Town House: Architecture and Material Life in the Early American City, 1780–1830* (Chapel Hill: University of North Carolina Press, 2005); Sandy Isenstadt, *The Modern American House: Spaciousness and Middle Class Identity* (Cambridge: Cambridge University Press, 2006); Wendy Bellion, *Citizen Spectator: Art, Illusion, and Visual Perception in Early National America* (Chapel Hill: University of North Carolina Press, 2011); and Sally Promey, ed., *Sensational Religion: Sensory Cultures in Material Practice* (New

Haven, CT: Yale University Press, 2014). See also Ian Hodder, *Reading the Past: Current Approaches to Interpretation in Archaeology* (Cambridge: Cambridge University Press, 1991), for a relevant account of the role of material artifacts in historical interpretation.

17 For recent writing about American art and the transnational (with emphasis on transatlantic exchange between Europe and America), see, for example, Barbara Groseclose and Jochen Wierich, eds., *Internationalizing the History of American Art: Views* (University Park, PA: Penn State University Press, 2009); David Peters Corbett and Sarah Monks, eds., "Anglo-American: Artistic Exchange between Britain and the USA," special issue, *Art History* 34, 4 (Sept. 2011); and Andrew Hemingway and Alan Wallach, eds., *Transatlantic Romanticism: British and American Art and Literature, 1790–1860* (Amherst: University of Massachusetts Press, 2015).

18 Ulla Haselstein, "Gertrude Stein's Portraits of Matisse and Picasso," *New Literary History* 34, 4 (Autumn 2003): 723–43; Robin Kelsey, *Archive Style: Photographs and Illustrations for U.S. Surveys, 1850–1890* (Berkeley: University of California Press, 2007); Klaus Benesch and Ulla Haselstein, eds., *The Power and Politics of the Aesthetic in American Culture* (Heidelberg: Winter, 2007); Michael Gaudio, *Engraving the Savage: The New World and Techniques of Civilization* (Minneapolis: University of Minnesota Press, 2008); Elizabeth Hutchinson, *The Indian Craze: Primitivism, Modernism, and Transculturation in American Art, 1890–1915* (Durham, NC: Duke University Press, 2009); Michael Gaudio, "At the Mouth of the Cave: Listening to Thomas Cole's *Kaaterskill Falls*," *Art History* 33, 3 (June 2010): 448–65; Roman Frigg and Matthew C. Hunter, eds., *Beyond Mimesis and Convention: Representation in Art and Science* (New York: Springer, 2010); Matthew C. Hunter, *Wicked Intelligence: Visual Art and the Science of Experiment in Restoration London* (Chicago: University of Chicago Press, 2013); Elizabeth Hutchinson, "A 'Narrow Escape': Albert Bierstadt's *Wreck of the 'Ancon*,'" *American Art* 27, 1 (Spring 2013): 50–69; Robin Kelsey, *Photography and the Art of Chance* (Cambridge, MA: The Belknap Press of Harvard University Press, 2015).

19 Nicolai Cikovsky Jr., "The School of War," in Cikovsky and Kelly, *Winslow Homer*, 20.

20 Ibid., 39–40.

DID JOSHUA REYNOLDS

PAINT THIS PICTURES.

Matthew C. Hunter

Did Joshua Reynolds Paint His Pictures?
The Transatlantic Work of Picturing in an Age of Chymical Reproduction

Joshua Reynolds,
*Diana (Sackville),
Viscountess Crosbie*
(detail, see fig. 5).

In the spring of 1787, King George III visited the Royal Academy of Arts at Somerset House on the Strand in London's West End. The king had come to see the first series of the *Seven Sacraments* painted by Nicolas Poussin (1594–1665) for Roman patron Cassiano dal Pozzo in the later 1630s. It was Poussin's *Extreme Unction* (ca. 1638–1640) (fig. 1) that won the king's particular praise.[1] Below a coffered ceiling, Poussin depicts two trains of mourners converging in a darkened interior as a priest administers last rites to the dying man recumbent on a low bed. Light enters from the left in the elongated taper borne by a barefoot acolyte in a flowing, scarlet robe. It filters in peristaltic motion along the back wall where a projecting, circular molding describes somber totality. Ritual fluids proceed from the right, passing in relay from the cerulean pitcher on the illuminated tripod table to a green-garbed youth then to the gold flagon for which the central bearded elder reaches, to be rubbed as oily film on the invalid's eyelids.

Secured for twenty-first century eyes through a spectacular fund-raising campaign in 2013 by Cambridge's Fitzwilliam Museum, Poussin's picture had been put before the king in the 1780s by no less spirited means. Working for Charles Manners, fourth Duke of Rutland, a Scottish antiquarian named James Byres had Poussin's *Sacraments* exported from Rome and shipped to London where they were cleaned and exhibited under the auspices of Royal Academy President, Sir Joshua Reynolds (1723–1792).[2] If less flashy than his

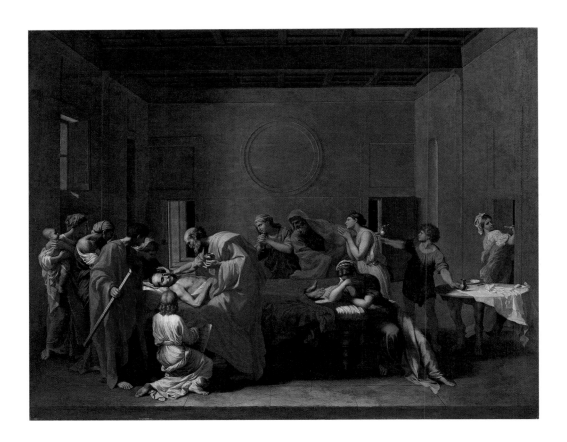

earlier sale of the Portland Vase to Sir William Hamilton, Byres's coup is worthy of note nonetheless.[3] On the pretense of having the Poussin *Sacraments* cleaned in Rome, Byres removed the pictures from the Boccapaduli Palace one by one. Surreptitiously replacing them with replicas painted by a Fleming named André de Muynck, he shipped the originals off to the president in London. Anticipating receipt of those canvases, Reynolds assured Rutland that Byres's scheme was just as time-tested as it was readily replicable: "It is very probable [that] those copies will be sold again and other copies put in their place. This trick has been played with Pictures of Salvator Rosa by some of his descendants . . . who pretend that the Pictures have been in the family ever since their ancestor's death."[4] In an age that would soon see the removal of the Parthenon sculptures and their installation in the British Museum as the "Elgin Marbles," Reynolds was unmoved by any talk of pictorial malfeasance. As he put it to Rutland: "I have not the least scruple about sending copies for originals."[5]

SIR JOSHUA REYNOLDS HELPED TO PIRATE OLD MASTERS

Our Lady of the Rocks
By Leonardo da Vinci

Sir Joshua Reynolds
First President of the Royal Academy

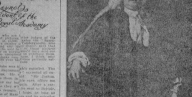

Sir Robert Walpole by J. B. Van Loo
© Walker & Cockerell

"The Small Cowper Madonna"
By Rachael
by permission of Braun & Co.

His Letters, Just Found, Show He Was Involved in Substituting Copies for Originals.

LETTERS which have just been uncovered in the British Museum show that Sir Joshua Reynolds and other artists had a sort of loosely organized "ring" which made a practice of substituting copies for originals of famous paintings owned in Italy and other Continental countries, the originals then being brought to England and sold there.



(Continued on Page 6.)

Rediscovered in the early twentieth century, however, the Reynolds-Rutland correspondence was viewed differently by American readers. Writing in 1914 from the epicenter of an exploding market for European art driven by J. P. Morgan, Henry Clay Frick, and other "robber baron" collectors, a screaming headline from the *New York Times* named the crime: "Sir Joshua Reynolds Helped to Pirate Old Masters." Poised above the newspaper's horizontal fold, a bespectacled Reynolds gazes out from a ground of lithographic striations, his nervously hatched body plotted among those Italian masterpieces he had purportedly helped traffic (fig. 2).[6] For the *Times'* unnamed writer, such familiar comportment forced "two questions to be called to mind in 1914. How many scores of canvases now in Continental galleries which are acclaimed as old masters are really copies from English brushes? How many scores of reputed old masters, bought at vast figures by Americans from reputable and innocent sources in Europe, are really substitutions made by coteries of English forgers in the days of long ago?"[7]

Asked amid the transatlantic politics of art on the cusp of the First World War, this essay's titular question might thus have been interpreted as an inquiry after property and propriety. Was Reynolds involved somehow in a shady business of painting and dealing pictures not truly his own?[8] In fact, queries after Reynolds's fair dealing are not only older but more vexingly intricate. In his period biography of the president, critic Edmond Malone dismissed as "too ridiculous and absurd to be gravely confuted" the charge that poet Dr. Samuel Johnson (1709–1784) had written the famous *Discourses on Art*, which Reynolds delivered semiannually at the academy's prize-giving ceremony.[9] Nevertheless, Malone then went on to quash a different rumor, one claiming that politician and theorist Edmund Burke was the *Discourses'* author.[10] And Reynolds hardly did himself any favors in those famous discourses where he positively embraced theft as a Promethean act at the very core of ambitious art. "Borrowing or stealing," as he put it in "Discourse VI" from December 1774, should be regarded with the same lenience among painters "as was used by the Lacedemonians; who did not punish theft, but the want of artifice to conceal it."[11] Indeed, the period's liveliest accusation of the president's light-handed turpitude followed directly on the heels of that 1774 discourse. In the spring of 1775, Irish painter Nathaniel Hone (1718–1784) submitted to the Royal Academy's summer exhibition *The Pictorial Conjuror, displaying the Whole Art of Optical Deception* (fig. 3).[12] Seen here in oil sketch on wood panel, Hone depicts a bearded figure (identifiable to contemporaries as George White,

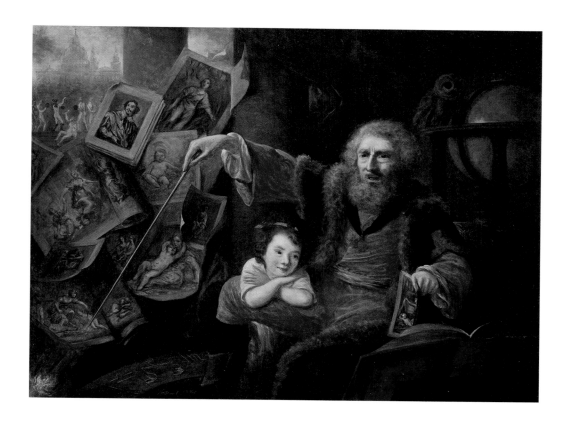

3
Nathaniel Hone, Sketch
for "The Conjuror," 1775.
Oil on wood, 22 ⅝ ×
32 ¼ in. (57.5 × 81.9 cm).
Tate Gallery, London,
T00938.

a model favored by Reynolds) cloaked in a crimson housecoat and
fur-lined vest, a hexagram pendant dangling from his neck. The action
of the picture is directed down the conjuror's wand. Buffeted in by
an arch inscribed with zodiacal symbols, our eyes are guided diago-
nally from the darkened globe and owl at upper right to the site of
combustion at left where fire leaps forth under magical command to
consume a cascade of copperplate prints after Old Master pictures.
Initially accepted for exhibition, Hone's *Pictorial Conjuror* was quickly
rejected once disclosed as a satire variously impugning the virtue of
academician Angelica Kaufman and the borrowing underpinning
Reynolds's emulation of the Old Masters. Where Horace Walpole's
then-recent, fourth installment of *Anecdotes of Painting in England*
(1771) defended the president's numerous references to art's history
as "not plagiarism, but quotation," painter Joseph Farington cast the
scene more darkly.[13] Hone's picture was contrived, he observed, to
show that Reynolds "had no power of invention; that he was a decided
plagiarist; and that his designs for groups of figures, and of attitudes
for his portraits, were *stolen*, as it was termed, from prints."[14]

Passing copies for original pictures and profiting from designs not really his to paint, Reynolds begot still more searching questions on the nature of pictorial existence—of picturing—itself. A year and a half before his "Discourse VI," an anonymous contributor to the *Morning Chronicle and London Advertiser* articulated that problem in an open letter addressed to Reynolds.[15] Paint's unctuous, chromatic ooze, this anonymous critic charged, had come to color British art with an untoward, defacing stain. The issue was partly a linguistic one, since it followed from the practice of denoting British picture makers through an excessively literal translation of French words. In typical English parlance, *Peintre* became "*Painter*, and the materials which ingenious persons of that denomination make use of to display their talents, we have, from that word, called *paint*, which in French is named *coleurs*."[16] Where the French salubriously bifurcated their lexical designation of artist from materials (*Peintre* and *coleurs*), English speakers compressed them together.[17] In the wake of Britain's resounding defeat of the French in the Seven Years' War (1756–1763), the *Morning Chronicle* writer proposed a solution that would throw off Gallic linguistic hegemony and clearly distinguish the fine artist from "he who makes use of paint to cover walls and houses with."[18] Appealing to the antique tastes of Reynolds's classicizing circles, the writer asks: "Why not like sculptors and architects have a peculiar name, Sir Joshua, for your very profession? Why not like these take up at once your classic name? Why not *Pictor*?"[19]

Pictor is from the Latin verb *pingere*, "to paint," a root that yields in turn *pictura*, the act of painting or its product, a picture. What, then, is a picture? And how is it to relate to the paints manipulated by this Pictor? Grounded in Reynolds's milieu but trafficking in far older currents, the *Morning Chronicle* writer's impulse to privilege pictures above their constitutive physical supports forces forward an issue with abiding salience for the interpretation of Anglo-American art.[20] If James Elkins is correct that, for contemporary theorists of all stripes, talk of pictures sustains a dream "that there is such a thing as a purely visual artifact independent of writing or other symbolic means of communication," recognizing the relation between picture and its material thingness as a site of meaning has been crucial to interpreters of the Modernist tradition and its early modern roots.[21] Staring down the incursion of literally shaped canvases into New York School abstraction of the early 1960s, Michael Fried envisioned a complex engagement between picture and painters' materials forced by the opticality of postpainterly abstraction. In the irregular polygons

of Frank Stella (b. 1936) (fig. 4), Fried saw painting surviving the material allure of the shaped canvas by insisting on being pictorial. "By making literalness illusive," Fried wrote in 1966, Stella's paintings triumphed insofar as they dissolved the apparent "conflict between a particular kind of pictorial illusionism—addressed to eyesight alone—and the literal character of the support." [22]

Taking a different approach in his *Languages of Art* (1968), philosopher Nelson Goodman defined pictures by their inexhaustible fullness, their "repleteness." [23] Possessed of potentially infinite gradations within their symbolic markings—pointing to indeterminate targets in the world, or to none at all—pictures for Goodman were syntactically and semantically dense, replete signs wherein everything potentially counts: "any thickening or thinning of the line, its size, even the qualities of the paper—none of these is ruled out, none of

these can be ignored."[24] Recent materialist approaches to Anglo-American art have restaged these modernist debates in a knowingly savvy way. Jennifer Roberts's work on American colonial painter John Singleton Copley (1738–1815) explicitly radicalizes the ambit of Goodman's pictorial conception. "The theorist Nelson Goodman wrote in 1968," she observes, "that 'such properties as weighing ten pounds or being in transit from Boston to New York on a certain day hardly affect the status of a painting in its representational scheme.'"[25] But Roberts expands the envelope of meaning to include those worldly logistics. The pictorial significance of Copley's *A Boy with a Flying Squirrel (Henry Pelham)* (1765) becomes inseparable from the fact that it was designed as a material thing to be sent by ship from Boston to London where it could be seen by viewers including Reynolds: "weight and time and transit pervade Copley's painting not only in its configuration but also in its design and iconography."[26] Although made obliquely, Roberts's engagement with Fried's reading of picture and shape is no less compelling here.[27] Refusing compression with the physical terms of the paint support, modernist painting had survived for Fried insofar as it maintained autonomous self-enclosure in pictorial fiction, a problematic his own subsequent art-historical writing has traced forward from the eighteenth century.[28] In turn, following her first book on Robert Smithson (a deft critic of Fried's modernism), Roberts too has moved to the eighteenth century, but to read pictorial surfaces as effectively swamped by what Smithson had sarcastically called "this 'harrowing' of hellish objecthood [that] is causing modernity much vexation and turmoil."[29]

I will return to these terms of contemporary debate in my conclusion, but the *Morning Chronicle* writer implicitly foregrounds the crucial, historical point: nowhere in eighteenth-century Anglo-American art were issues of pictorial ontology more devilishly complicated than in the works of Joshua Reynolds himself. At once, qua picture, Reynolds's *Diana (Sackville), Viscountess Crosbie* (1777) (fig. 5) could be said to comprise a dense, Goodmanian symbol-system whose syntax describes an infinitude of meaningful marks. By one reading, those marks make for a stunning exercise in portraiture. Gazing cherubically out from the picture plane, Crosbie cinches the train of her shimmering cream dress and steadies herself against a breeze that tousles her voluminous hair into whirling ringlets. Its sylvan frame opening onto an azure pane of sky, this portrait's semantic field denotes as much Diana Sackville as it does Reynolds's earlier *Mrs. Hale as 'Euphrosyne'* (1762–1764), now at Harewood House in Yorkshire.[30] Yet thanks to

5
Joshua Reynolds, *Diana (Sackville), Viscountess Crosbie*, 1777. Oil on canvas, 94 ¾ × 58 in. (240.7 × 147.3 cm). The Huntington Library, Art Collections, and Botanical Gardens, San Marino, California, 23.13.

Matthew C. Hunter

Did Joshua Reynolds Paint His Pictures?

CONDITION OF PAINTING

craquelure

speck w/
associated loss

area of
craquelure

craquelure

paint loss
associated with
loss of varnish
layer

loss
and accretion

∴ =Areas of
craquelure
throughout

tear

hole scratch

brown accretions

6
Repair report on *Diana
(Sackville), Viscountess
Crosbie*, ca. 1990s.
The Huntington Library,
Art Collections, and
Botanical Gardens,
San Marino, California.

his inveterate experiments with paint chemistry, Reynolds's pictures
were frequently menaced by their material existence as objects—
as painted things inclined to fade, to flake, and to alter visibly in time
(fig. 6). Among Reynolds's contemporaries, these volatilities were
the stuff of legend. The Royal Academy president's coloring, so wrote
one French observer in the early nineteenth century, "fades away,
and disappears rapidly;—many of his pictures are now only black

Matthew C. Hunter

and white. He is said to have been fond of trying experiments in colors, and thought he had found the secret of rendering them more lasting."[31] Poet William Mason recalled an infamous episode when Reynolds eagerly bought from "some itinerant foreigner . . . a parcel of what he pretended was genuine ultramarine, which, in point of color, seemed fully to answer its title. Without bringing it to any chemical test, the artist ventured to use it, and by it spoiled, as he assured me, several pictures."[32] A "poetical epistle" addressed to Reynolds in 1777 envisioned those changes as unfolding in real time: "As I thus enraptur'd stand / Before the wonders of your hand, / I see the lively tints decay, / The vivid colours melt away."[33] Modern technical historian Mansfield Kirby Talley has summarized the situation most succinctly. Reynolds's "persistence in following practices which he knew perfectly well would seriously shorten the life of his pictures can only be described as perverse."[34]

Given the searing impression made on Copley, Benjamin West (1738–1820), and other ambitious American artists by what Neil Harris has called the "vast moral function" staked out in Reynolds's fabulously successful art, this essay aims to thematize that "perverse" relationship between the material chemistry of paint and pictorial function—between pigments and picturing—as a key problem for Anglo-American art of the late eighteenth century.[35] To that end, the essay unfolds in two stages. First, building from the *Morning Chronicle*'s lexical query, I use the insights of Dr. Samuel Johnson (eminent linguist of Reynolds's erudite circles) to pose the problem of pictorial ontology against the numerous replicative media through which the president's unstable paintings were then made available to transatlantic audiences. Since pictures in this view cannot be reduced to paint and indeed were imagined to persist long after the unstable material artifact had decayed, a first answer to the essay's titular question is negative. Reynolds did not paint his pictures, and perhaps could not have done so. A second approach to the question then turns the problem around. I will attend to the variety of forces understood to be not only active at the making of Reynolds's images but valued for their ongoing, material evolutions within his works. Seeing the Reynoldsian Pictor as never alone when he painted best enables us to reconcile the president's theory of art set out in the *Discourses* with his experimental facture. Doing so, I will argue, not only foregrounds the centrality of his vexing pictorial problematic to ontological questions now most frequently associated with the art of photography, but it can also help us imagine anew a Reynoldsian legacy in a tradition

of American-born experimental painters including West, Washington Allston, and Albert Pinkham Ryder.[36]

Painting as a History of Metals

Reynolds's former apprentice James Northcote (1746–1831) recounts a tale in his period biography designed to demonstrate Samuel Johnson's ignorance of visual art. Dismayed to see "so much mind as the science of painting requires, laid out upon such perishable materials," the poet asks Reynolds at a gathering in 1771 why painters did not prefer copper to canvas as a pictorial support.[37] Johnson here effectively performs that collapsing of picture into paint materials so displeasing to the *Morning Chronicle* writer. After all, the poet had defined "picture" in his 1755 *Dictionary* as "a resemblance of persons or things in colours." Only in secondary and tertiary definitions did picture appear as a body of knowledge ("the science of painting," then "the works of painters") properly separating intellectual skill from staining matter.[38] And that chromaticist, materialist conception of picture shows through in the 1771 conversation with Reynolds and wealthy brewer Henry Thrale. As Reynolds deflects the poet's promotion of copper supports by gesturing to the difficultly in sourcing sufficiently large plates of metal, Johnson cuts him short: "What foppish obstacles are these! . . . Here is Thrale who has a thousand ton of copper; you may paint it all round if you will, I suppose. It will serve to brew in afterwards: will it not, Sir?"[39]

Paltry though Northcote claims Johnson's knowledge of the visual to be, painting on copper was indeed an art perfected in early modern Europe. As a support, it offered what one recent scholar has called a "smoother and more uniform surface, ideal for working with fine brushes."[40] Variations on that technique were being developed in the early 1770s by Joseph Wright of Derby (like Reynolds, a product of Thomas Hudson's studio) to achieve brilliantly luminous effects. In pictures such as *Two Boys by Candlelight* (ca. 1767–1773) (fig. 7), Wright applied silver leaf onto those areas of the canvas that were to read as most luminous, so that light would reflect off the metal support and show back through the paint layer as the bladder's diffused glow.[41] In so doing, Wright also compromised the integrity of the "science of painting" Johnson had sought to safeguard. Where his collaborator Peter Perez Burdett quickly rendered that chiaroscuro scene in aquatint and exhibited it as "the effect of a stained drawing attempted, by printing from a plate wrought chemically, without the use of any instrument of sculpture" in early 1770s

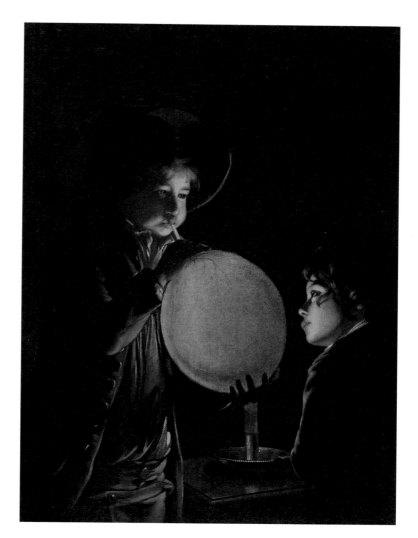

7
Joseph Wright of
Derby, *Two Boys by
Candlelight, Blowing
a Bladder*, ca. 1767–1773.
Oil on canvas, 36 ×
28 ⅜ in. (91.4 × 72.1 cm).
The Huntington Library,
Art Collections, and
Botanical Gardens,
San Marino, California,
58.16.

London, Wright's own intersection of paint chemicals and metal
has fared poorly.[42] His glowing bladder's veinous structure has flaked
into pictorial oblivion.

 If not the practical panacea Johnson imagined, metallic supports
offered Northcote a broader meditation on pictorial ontology. Reynolds's
apprentice chided Johnson for failing to recognize "that the duration
of a picture does not depend on the strength or durability of the canvas
on which is it painted. The canvas can be renewed as often as it
may be found necessary, and the colours will in time become nearly
as hard and as durable as enamel. It is by frequent and injudicious
cleaning, and not by time, that pictures are destroyed."[43] Suggesting

Did Joshua Reynolds Paint His Pictures?

what philosophers call the ship of Theseus problem, Northcote envisions the identity of a picture persisting through time even after aspects of its original, material composition had vanished.[44] Pictorial ontology is reducible neither to the brute longevity of the canvas carrying the paint film nor to the mere endurance of unaltered pigments, binders, and other physical stuff of mark making. Canvas replaces canvas, oil paint becomes like enamel, but picture abides. Writing in the wake of the British Institution's 1813 exhibition *Pictures by the Late Sir Joshua Reynolds*, painter Martin Archer Shee expanded on this distinction between material duration and pictorial durability. Shee acknowledged that "Reynolds at an early period of his practice, painted many pictures, which, from the failures incident to an experimental process, have not preserved their brilliancy."[45] Yet it was a foolish viewer who confused those frailties of experimental pigments with failed pictures. "The magnificent assemblage of his works so lately before the public," Shee observed, "did not indeed . . . excite the idea of 'a chemist's window.' The ambition of Reynolds was to produce fine colouring, not fine colours. His was the chastened glow — the subdued splendor — the 'deep toned brilliancy of the ancients;' which he so elegantly recommends in theory, and so successfully illustrates in practice."[46] Pictorial skill — that elusive, historical commodity convincingly traced by Michael Baxandall rising up through and surpassing the value of material pigments in fifteenth-century Italian painters' contracts — is the criteria by which all but the coarsest philistine would, in Shee's view, evaluate Reynolds's work.[47]

A still more radical implication of this splitting of picture from painted thing was posed by Reynolds himself. According to J. T. Smith: "Sir Joshua Reynolds considered the art of mezzotint as best calculated to express a painter-like feeling. I have often heard him declare, that the productions of M'Ardell would perpetuate his pictures when their colours should be faded and forgotten."[48] That is, James Macardell's "painter-like" mezzotint engravings would not only transmit Reynolds's decaying colors and their unstable canvas supports to posterity, but they would do so precisely by transposing paint into what Smith calls "pictures." In this sense, Joshua Reynolds did not paint his pictures at all for the simple reason that pictures were not — and perhaps could not *be* — painted in the conventional sense. Instead, painted things became pictures when detached from an unstable, autograph materialization and transposed into reproductive, copperplate multiplicity. More than it being

Matthew C. Hunter

Reynolds who painted his pictures, we might say, it was engraver James Macardell who pictured Reynolds's paintings. Further, to return to the *Morning Chronicle* writer's terms, the Anglophone Pictor modeled here appears to have stolen a march on a much-maligned ancestor, the Platonic *zographos*. As Plato had argued in *The Republic*, a carpenter or other skilled craftsman (*demiourgos*) fashions a bed or table by referring back to the idea (*eidos*) of that artifact, which is made by god.[49] The painter (*zographos*), however, makes neither the idea nor its material incarnation. Instead, he copies the craftsman's physical realization of the divine idea, thus placing his work at three removes from the true nature of things (*ton tou tritou apa gennematos apo tes phuseos mimeten*).[50] The Reynoldsian Pictor, by contrast, creates a skillful idealization that outstrips and outlasts its own material frailties precisely as it is perpetuated pictorially by subservient craftsmen.

In this way, the parsing of picturing from painting accords well with the broader academic enterprise promoted under Reynolds. By separating itself from the messy business of paint handling, the Royal Academy's artistic pedagogy had foregrounded appeal to the stable, persistent virtues of Florentine *disengo* over the fugitive, ephemeral allures of Venetian *colorito*—sentiments found frequently in the president's *Discourses*.[51] At the same time, Reynolds's own use of reproductive technologies to disseminate his paintings was as sophisticated as it was vast. Contracting with generations of mezzotint engravers including Macardell (1727/8–1756), Valentine Green (1739–1813), and John Raphael Smith (1751–1815), the president famously "kept a port-folio in his painting-room, containing every print that had been taken from his portraits; so that those who came to sit, had this collection to look over, and if they fixed on any particular attitude . . . he would repeat it precisely."[52] In light of the pioneering research of Waldron Belknap, this panoply of British mezzotints has been described as a focalizing force in shaping American pictorial tradition, "the major factor in transmitting fashion, feeling, art traditions and all the pictorial elements of Old World culture to the New."[53] Yet if it is true that "no other artist was more frequently copied" in the mezzotint printer's copper than Reynolds, I argue in the following section that a novel array of experimental reproductive techniques would equally enfold the president's metallic memorialization into chemical circulation.[54] That is, the chemical arts of lithography, pollaplasiasmos, and enamel can help us rethink the reproductive strategies central to the Anglo-American Reynoldsian Pictor.

8
Benjamin West, *Angel of the Resurrection*, 1801. Lithograph, 12 ⅜ × 8 ⅞ in. (31.4 × 22.5 cm). Yale University Art Gallery, New Haven, Connecticut, 1955.18.22.

Chymical Reproduction

With darkened palm and the shaded sole of an outstretched foot held aloft, Benjamin West's *Angel of the Resurrection* (1801) (fig. 8) stares directly out from the picture plane. Smoke curls in frothy billows from densely hatched darkness at left, its networked intensity of tone answering in counterpoint to the dotted arc and starburst rays of sunlight cresting the sloping hillocks at right. Split down the spine of the image through the licking flames of the angel's unevenly forked locks, West's intent figure appears strangely unsettled. Said better, the angel figures a conspicuous struggle for balance—a pursuit of

Matthew C. Hunter

equilibrium between the resplendent plumage of his proper left wing and its obscured twin, between the plant straining upward to find sunlight at right and the inky void at left. Light versus dark, sprouting life versus curling smoke: the image's various efforts at left-right reconciliation act to call attention to the massive boulder on which the angel sits so awkwardly. With splayed legs taking the stone's broad measure, the angel's perch compels us to tarry over that rock rolled back from the threshold of Christ's tomb to reveal his resurrection accomplished, perhaps. But it also alerts us to the force of stoniness in the making of the image. For, published in Philipp André's *Specimens of Polyautography* (1803), West's print is an early example of the art of lithography, a technique that had been invented by entrepreneurial printer Alois Senefelder between 1796 and 1798.[55]

According to Walter Benjamin, the advent of lithography marked a key contribution to the technological acceleration of the image in the modern age. "The fact that the drawing is traced on a stone, rather than incised on a block or wood or etched on a copper plate," Benjamin observed, ". . . made it possible for graphic art to market its products not only in large numbers . . . but in daily changing forms."[56] Narrated by contemporaries amid what historians of science call the "Chemical Revolution," however, Senefelder's practice was more a matter of chemistry than of *technicshen Reproduzierbarkeit*.[57] "The ink is a chemical preparation," so one writer explained in an 1808 contribution to the *Gentleman's Magazine*, "of which soda, lac, and lamp-black are component parts."[58] Then known in France as *imprimerie chimique*, lithography turns on what one modern historian has called "very simple chemical principles: the antipathy of grease and water, and the attraction of these two substances to their like and to a common porous ground."[59] Given West's enmeshment in the delicious scandal of the "Venetian Secret" during the later 1790s, the lithographic angel might well be seen as embodying a resurrection of chemical hopes and alchemical theology that the American painter shared with leading contemporaries in Britain.[60]

Seen by his leading Victorian biographers, Joshua Reynolds too had to be counted in that chymical cult.[61] "He believed in the *Venetian secret* as ever an alchymist did in the *philosopher's stone*," observe Charles Robert Leslie and Tom Taylor, "and so intense was his love of colour, that he would always hazard the durability of his works rather than give up any chance of attaining its truth and beauty."[62] Reynolds's robust interface with chymical techniques also extended to his replicators and their innovations. One of these is an invention known as

pollaplasiasmos. In the 1780s, portrait painter and entrepreneur Joseph Booth (d. 1797) began a series of bombastic publications trumpeting his replication of grand manner oil paintings by "a mechanical and chymical process, without any touch or finishing by the hand." [63] Offering pollaplasiasmic reproductions of Reynolds's *Girl Leaning on a Pedestal (The Laughing Girl)* (ca. 1775–1782) for pennies on the pound from display rooms of the Polygraphic Society on London's Pall Mall, Booth envisioned positively revolutionary benefits to flow once great art was placed in the hands of a general public through such cut-rate, high-quality reproductions.[64] "By reducing the price of commodities and manufactures," Booth proposed, pollaplasiasmos "multiplies customers, and extends their sale." [65] Drawing a telling analogy with "the invention of cotton mills . . . in Lancashire," he cast his chemo-mechanization process not as an obstacle to the traditional painter's living, but rather as a means of rendering the art-market elastic by working to "cherish and diffuse a general taste for painting." [66]

Public though his process would make the oil painter's products, Booth was highly secretive about his own technique. Replicating works such as Philippe Jacques de Loutherbourg's *A Winter Morning, with a Party Skating* (ca. 1776) (fig. 9), he appears to have fabricated a complex printing matrix for stenciling or stamping oil-painted form onto prepared canvases. Identifying the surprising presence of pumice mixed into Booth's thick priming layers, a recent technical study by David Saunders and Antony Griffiths supports the claims for polla-plasiasmos's chymical *and* mechanical agency. As the authors observe: "If the paint was applied in blocks, using a stencil, block printing or screen printing [technique] . . . the role of this porous pumice-containing layer might have been to absorb some of the oil, so that the paint would be 'touch dry' more quickly, allowing an adjacent block of color to be applied without smudging." [67] Wallpaper-like in its texture, this unusual facture is visible in Booth's rendering of *Winter*'s central figure: the seated gent in an azure coat who gazes cockily out from the picture plane as a servant affixes his ice skates. Guided by his twin thickly outlined, gloved index fingers as they gesture down to the russet ground, we can see a tan margin flanking three sides of his chair-leg. Contrary to the logic of the picture's fiction, this ground reads up through the umber hue of the servant's cast shadow. Like the tree trunk rising up as a tracery of pale-white and blue-grey arabesques from the dun-colored snow, these blocky forms appear to have been stamped out on, and not brushed onto, prepared canvas.

Matthew C. Hunter

9
Joseph Booth,
*"Polygraph" print after
Philippe Jacques de
Loutherbourg's "Winter,"*
1780–1790. Mechanical
oil painting on canvas,
34 ¾ × 49 in. (88.3 ×
124.2 cm). The British
Museum, London, 1982,
0619.2.

However it was achieved, this chymo-mechanical process was advertised as immune to the vulnerabilities besetting the high-status objects it replicated. Pollaplasiasmos was impervious, Booth claimed, "to changing, cracking, peeling, or another other of those inconveniencies, which frequently attend first rate pictures painted in the usual way: so that it will multiply pictures in such a manner as to perpetuate the genius, style, and effect of the most celebrated painters, to the most distant ages." [68] More important still to Reynolds's polychrome perpetuation, though, were his transactions with enamelists including Henry Bone (1755–1834) and William Russell Birch (1755–1834). [69] Trained at porcelain works in Reynolds's native Devonshire, Bone

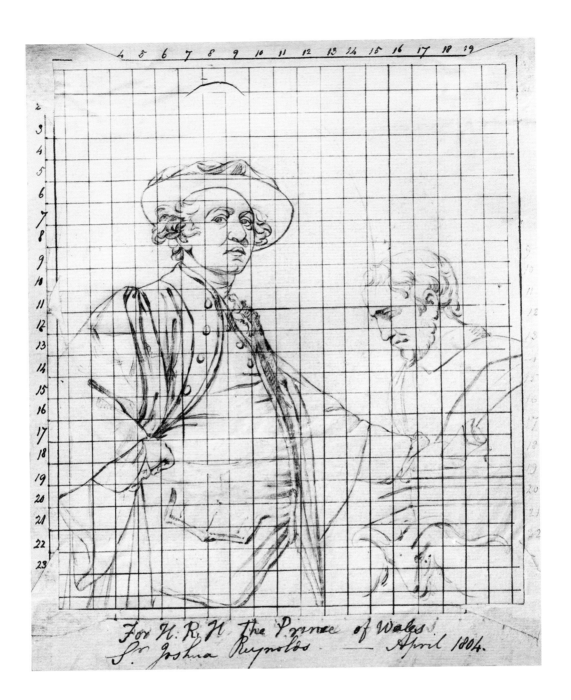

For H.R.H the Prince of Wales. Sr Joshua Reynolds. —— April 1804.

Matthew C. Hunter

began exhibiting at the Royal Academy in 1781 where he showed reproductions of oil paintings in his laborious enameling technique. Demonstrated by the remarkable preparatory study of Reynolds's self-portrait in academic robes (fig. 10) now in the collection of the National Portrait Gallery, London, Bone prepared crisp graphic renderings of the portrait he was to translate into enamel on gridded, numbered sheets. He then applied pigmented metal oxide powders suspended in vegetal oils onto coated metal supports, which were fired at upwards of eight hundred degrees Fahrenheit.[70] Unlike oil painting where pigments could easily be mixed, revised, and otherwise improvised, each chromatic layer of an enamel painting had to be fired independently and in sequence such that the color with the highest melting point was fired first. Bone's reproductive transpositions were further enhanced by the innovative, glossy "flux" he added as a prophylactic fixing layer.[71] Made brilliant and durable by these repeated firing processes, Bone's enamels were recognized by contemporaries as the persisting standard through which subsequent generations could know Reynolds's excellence as a pictorial colorist. J. T. Smith put the point this way: "As much as of the interest of Sir Joshua's pictures is annually lessened by the fading of his colours, the surest means of handing down to posterity that great Artist's fascinating style of colouring, [are] the correct copies which Mr. Bone has made of them in enamel."[72]

Designed to maintain Reynolds's fugitive, florid forms, the enamelist's techniques of chymical preservation were trucked across the Atlantic by William Russell Birch. Arriving in Philadelphia in 1794 bearing a letter of introduction from Benjamin West, Birch met with checkered success in the early United States where he acted as painter, printer, landscape architect, and frustrated advocate for the fine arts.[73] As outlined in his *Life and Anecdotes of William Russell Birch, Enamel Painter* (ca. 1815–1834), enamel was a "chymical practice" ideally suited for pictorial conservation.[74] It is "the Unique art of hightening and preserving the beauty of tints to futurity, as given in the Works of the most celebrated Masters of Painting, without a possibility of there changing."[75] Birch went on to explain to an American readership how his own technical innovations with "calcined Terrovert compounded with the soft well-melted Fluxes from crucibles of the imitative Jewellers' manufactory" enabled him not only to achieve an innovative, brown enamel hue that could simulate Reynolds's rich palette, but how doing so had won him a medal in 1784 from London's Society for the Encouragement of Arts, Manufactures and Commerce.[76] Chymically improved, enamel painting figured among

10
Henry Bone, *Study of Sir Joshua Reynolds*, April 1804. Pencil drawing squared in ink for transfer, 10 × 7 ⅝ in. (25.3 × 19.5 cm). National Portrait Gallery, London, NPG D17345.

the strategies for sustaining the much-bemoaned fragility of life for artists and art objects alike in the early United States.

If less systematic than the experimental enamel panels produced in contemporaneous collaboration between George Stubbs and Josiah Wedgwood, Reynolds's own palette was seen by contemporaries as reciprocally engaged with the materials of his enamelist replicators.[77] Poet William Mason describes how the Royal Academy president's preferred blue smalt pigment was "a highly vitrified substance, that the art of enamelling, and that of making china" had improved industrially to the point of rivaling those found in Asian export porcelain.[78] Thus, whether printed in chymo-mechanical multiples by Booth or fired at blistering temperatures by enamelists like Bone and Birch, Reynolds both encouraged and integrated materials of production from a complex array of reproductive artists able to make durable, chymical pictures from his destabilizing painted things. Yet given the ways in which they pursued the president and vied for rights to reproduce his works, it might be better to say that these chymical practitioners "courted" Reynolds.[79] Courtly models are indeed instructive here. In a perceptive analysis of science at the absolutist court, Mario Biagioli outlines a crucial asymmetry between the high-status patron and aspiring clients. Where such ambitious clients stood to gain much from princely patrons through audacious challenges to their intellectual rivals, those patrons had to take care to position themselves at safe distance from the acrimonious fray. "Great patrons," Biagioli observes, "were as vulnerable as they were powerful. . . . To be powerful meant being fragile, and to be fragile meant being powerful."[80] Tricky as were Reynolds's own relations to George III, court culture's lessons for Britain's leading, knighted painter were clear enough. While Walter Benjamin saw the withering of art's aura in the age of technologized, lithographic reproducibility, Reynolds's entourage of chymical picture makers suggests a different model of artistic power—one where the fragile, chymically unstable masterpiece is surrounded by kindred clients competing for its visibility and propagation.

The acute asymmetries between those fugitive, vulnerable alloys struck by the fabulously wealthy "father of the English School of Painting" and the enduring work of his pictorial technicians, however, also bred bad feelings.[81] Consider again Hone's *Pictorial Conjuror* (see fig. 3). In light of J. T. Smith's claim that Hone was "a fashionable Miniature-painter in enamel" frustrated by Reynolds's stranglehold on the art market, *Pictorial Conjuror* can be read as a pointed critique not only of the president's undue influence on impressionable youth

like the child folded into the conjuror's lap but also of the paint-to-picture transit outlined here.[82] Rather than the enamelist's purifying fire that could render pictures durably brilliant, Hone shows a charlatan's false flame—the "pale fire" that Shakespeare's arrant thief, the moon, snatches from the true, sun-like artist.[83] Equally, Hone is the *Morning Chronicle*'s Socratic gadfly. If classical language could secure artistic timelessness from staining matter for the *Morning Chronicle* writer, Hone visualizes robust resistance from the perspective of the modern, chymical practitioners required to accomplish those paintings' material perpetuation. Picturing, in this view, is a trick, and Reynolds is an alchemical trickster.

Chance, Taken and Tamed

In his influential *Handmaid to the Arts* (1764), London-based chymist Robert Dossie had pledged that "a deeper knowledge of the principles and practice of chymistry *is* requisite" to advancing the enamel painter's practice.[84] Arriving in the early United States at what one recent historian has called "a time of risk, not fixity, when great personal fortunes could be made and lost," William Russell Birch expressed little more confidence in the epistemological foundations of his enamel enterprise.[85] Since enamel painting awaited any standardization of its pigments and required so much delicacy in a master's hand to yield its brilliant hues, Birch concluded: "There is no regular scientific principles laid down for this Art, its practice has hitherto depended upon chance."[86] Yet as much as any artist could do, Birch may have come to Philadelphia in the 1790s exceptionally well prepared for taking precaution against chance's vagaries. Economic historian Jonathan Levy has recently traced a compelling history of freedom under nineteenth-century American capitalism as the terrestrial landing of "risk" from an oceanic world of commodities. "Born on the deep, in the act of maritime voyaging," as Levy puts it, risk was not some amorphous fear of the unknown: "Rather, it referred to something material: a financial instrument for coping with the mere *possibility* of peril, hazard, or danger."[87] In his autobiography, Birch foregrounds his close relationship with and patronage by William Murray (1705–1793), first Earl of Mansfield, a leading jurist of maritime law and one of the major Anglo-American architects of risk's legal grounding.[88] A staunch defender of predictability and certainty in mercantile legislation, Mansfield had doubts about Joshua Reynolds. Birch claimed that only at his prompting did Mansfield finally sit for Reynolds in 1785, having rebuffed the painter for a decade.[89]

Now, whether or not Mansfield's hesitation stemmed from the gamble he knew himself to be taking when commissioning a portrait from the Royal Academy president—a painter who grew up near the major port of Plymouth, who built a crucial client base around Britain's naval officer class—Reynolds seems to have apprehended risk's broad principles. As with the legal doctrine of insurable interest whereby "a merchant could only insure property in which he had a pecuniary 'interest,'" Reynolds recognized that he too should limit his chymical experiments to speculatively produced exhibition works, rather than those painted on commission.[90] Northcote tells us that the president had hoped to confine his "experiments . . . [to] his fancy pictures, and if so, had they failed of success, the injury would have fallen only on himself."[91] If Jennifer Roberts has taught us to see oceanic transit embodied in Copley's *Pelham* portrait, might we not equally find the watery world of maritime risk imported into Birch's transatlantic collaboration with Reynolds as so much pictorial insurance bought against the chance of paint's chymical decay?

However we answer this question, Birch, Hone, and their contemporaries would have confronted a bold meditation on the central role of chymical chance to grand manner art in Reynolds's own publicly delivered discourses. Read less than six months before Hone's *Pictorial Conjuror* was exhibited, Reynolds's "Discourse VI" foregrounded relations among the artist, fire, and what might be called the felix culpa of chymical transformation. In stated aim, "Discourse VI" sought to defend a project of emulative imitation rooted in the works of classical antiquity and the Old Masters—to beat back a rising Romantic tide that would place private cerebration of untutored genius as the necessary and sufficient condition for artistic invention. Contesting the tendency of "those who are unacquainted with the *cause* of any thing extraordinary, to be astonished at the *effect*, and to consider it as a kind of magick," Reynolds's lecture outlines a method by which the studious artist can gather then carefully mix elements from a wide-ranging canon to make new art.[92] As he puts it: "The fire of the artist's own genius operating upon these materials which have been thus diligently collected will enable him to make new combinations, perhaps, superior to what had ever before been in the possession of the art."[93] But the president then takes that combustible fire back to its metallurgical roots within a longer chymical tradition. The artist "will pick up from dunghills what by a nice chymistry, passing through his own mind, shall be converted into pure gold; and, under the rudeness of Gothick essays, he will find original, rational, and even

Matthew C. Hunter

sublime inventions."[94] Art is Art, in this view, because its innovative, dazzling effects are nonetheless grounded in a capacious command of the past bent to intended causes, inaccessible and mystified though those may appear to an ignorant public.

Yet as Joseph Wright had then recently done when dramatizing the chance discovery of artificial phosphorous in his *The Alchymist, in Search of the Philosopher's Stone, Discovers Phosphorous, and prays for the Successful Conclusion of his operation, as was the custom of the Ancient Chymical Astrologers* (first shown in London in 1771), Reynolds also models invention as accident in "Discourse VI." The creation of artistic novelty from a serried, pictorial assemblage of past exemplars unfolds through serendipity, a term itself coined by Horace Walpole in 1745 "to describe the making of unexpected yet insightful discoveries 'by accident and sagacity.'"[95] By this second view, innovation occurs "as in the mixture of the variety of metals, which are said to have been melted and run together at the burning of Corinth [in 146 BC], a new and till then unknown metal was produced, equal in value to any of those that had contributed to its composition."[96] Simultaneously, then, artistic innovation is both an intentional, teachable science guided by trained, mental "chymistry" toward the production of lasting value; *and* it is a felicitous accident occurring as the artist collaborates with and profits from unexpected chymical events as at ancient Corinth.[97]

When thus asking whether Reynolds painted his pictures, we need to recall how capacious the president's own works became for imagining felicitous, visual interventions from nonhuman collaborators. The architect should, so the president counseled in his "Discourse XIII" of 1786, "take advantage *sometimes* of that to which I am sure the Painter ought always to have his eyes open, I mean the use of accidents; to follow when they lead, and to improve them, rather than always to trust to a regular plan."[98] As told by Northcote, being open to the happy hand of chance was a working precept in the president's studio. Reynolds instructed his apprentice to always have two similar canvases on the go in the studio, so that "if chance produced a lucky hit, then instead of working upon the same piece, and perhaps by that means destroy the beauty which chance had given," it could simply be transferred onto the other picture.[99] Nor was chance the only nonhuman force to which a painter should avail himself. Northcote recounts a tale of an old woman who "remembered, that, at the time when she sat to Vandyke, for her portrait, and saw his pictures in his gallery, they appeared to have a white and raw look, in comparison with the mellow

Χρονος γαρ'ου τεκτων σοφος, *See Spectator*
Απαντα δεργα τομενος αδενεστερα Vol: II, Page 83.

VARNISH.

——— As Statues moulder into Worth. *P. W.*

To Nature and your Self appeal,
Nor learn of others, what to feel. Anon:

1761 *Rec.d* of half a Guinea
being the whole Payment for a Print of Sigismonda mourning over the Heart of
Guiscardo her murder'd Husband, w.h I promise to deliver, when finish'd:
NB. the price will be 15 after the Subscription is over.

and rich hue we now see in them, and which time alone must have given to them, adding much to their excellence." [100] The apprentice avowed a similar disappointment on his own first view of Reynolds's pictures fresh off the easel. He was repulsed by what he called "the sight of the raw, crude, fresh appearance of his new pictures, which . . . seemed to me by no means equal to those I had before seen and so much admired." [101] Northcote was hardly alone in embracing this aesthetic of patina, this preference for the darkening of artifacts caused by temporal oxidation. That taste was brilliantly satirized by William Hogarth who anthropomorphizes chymical process as Father Time blowing an inky, discoloring cloud of smoke onto a recently finished painting (fig. 11). [102] Instructively, it was just this collaboration between Reynolds and Time that enamelist Birch sought to perpetuate in his pictures. Birch reports that one of his finest achievements came through applying "a thin layer of yellow Enamel under the last coat of white, . . . [which] affects the beauty of Age seen in many of the old paintings in oil by the former masters." [103]

Asking the question "Did Joshua Reynolds paint his pictures?" thus opens onto a broader reexamination of the parameters of human intervention in Anglo-American pictorial process at the close of the eighteenth century. Even without enlisting familiar problems at materialist and idealist extremes—the sophisticated distribution of labor among assistants in a busy portrait painter's workshop or, say, claims for the necessity of nature, acting through the artist in the form of genius, for the creation of fine art—we are disabused by Reynolds and his contemporaries of any easy account of just what the painter did, when those actions were completed, and how their material residues would comport themselves to "pictures." [104] While staging the painter's "nice chymistry" as a rational, intentional business, "Discourse VI" simultaneously imagined a nonhuman agency of seren-dipitous chymical transformation at the heart of artistic invention. Like Aaron in his infamous account of the golden calf's yield ("I cast gold into the fire, and there came out this calf" [Exodus 32:24 (KJV)]), the president had explained image making as metallic transmutation by fire over which the artist's control was, if not indifferent, at least never total. [105] Reciprocally, as Northcote and others show, such chanced and chancy effects were not only desirably visible in Reynolds's works but veritably taught in his studio. Effectively, then, Reynolds had set up terms whereby neither he nor anyone else could be said to have painted his pictures exclusively. That is, whether or not "picture" adequately denotes their results, the painter's actions were necessarily

11
William Hogarth,
Time Smoking a Picture,
ca. 1761. Etching,
engraving, and
mezzotint, 10 ⅜ × 7 ¼ in.
(26.2 × 18.4 cm).
The British Museum,
London, Cc,1.167.

collaborations known and valued for changing chymically in time. From adepts in the secrets of what James Barry scornfully called "magilphs and mysteries" such as West and Allston to technical experimentalists as audacious as William Page ("America's Reynolds") and Ryder, the cornerstones of painting in the emergent American tradition cannot be seen apart from that volatile, Reynoldsian dynamic.[106]

Attending to that legacy also forces us back into the present. At the heart of an influential essay, literary critic Walter Benn Michaels analyzes a scene from Edith Wharton's *The House of Mirth* (1905) where protagonist Lily Bart reenacts a posture borrowed from none other than Joshua Reynolds. A charged, trembling play between intention and chance, action and accident, Lily Bart's tableau vivant performance as Reynolds's *Mrs. Lloyd* (1775–1776) exemplifies what Michaels calls "a certain moment in the appeal of indeterminacy," which he traces through chance operations, writing, and thinking about photography at the turn of the twentieth century.[107] Michaels's note of this passage from Wharton is suggestive given the growing role Reynolds has begun to play in histories of photography in the long nineteenth century.[108] But the question of pictorial ontology forced by Reynolds's unstable painted objects also offers a pathway toward rethinking propositions central to Michaels's account of painting and photography that figure crucially in broader theoretical debate. Namely, in a recent essay, Michaels has positioned painting as both a spent historical force and a fundamental other to photography. Invoking the vicissitudes of those shaped canvases interpreted by Fried in the 1960s (see fig. 4), he writes: "There is an important sense . . . in which the question about the [modernist] painting—is it a painting or an object?—has become the question about the photograph."[109] Is it a picture or an index? Is a photograph a representation made intentionally by an artist, or is it a replication caused in some way by the world? Photography's vitality to contemporary art and even its ability to sustain the possibility of art as such derive, Michaels claims, from its precarious extension of determinations that painting by its nature settles simply and unequivocally. Where objects are "causally indispensable" to photography's ways of picturing, painting is not so constrained. By Michaels's reading: "No one doubts the relevance of the portrait painter's intentionality to the portrait—everything on that canvas has been put there by him."[110]

Reynolds, Northcote, and their contemporaries disabuse us, however, of the confidence with which we can avow this view of painting in historical terms. Whatever may have been the local intentions

of the long eighteenth century's leading portrait painter in the Anglo-American tradition, the Reynoldsian Pictor could see himself as—was understood to be, and was valued for—enlisting the agency of nonhuman forces not entirely under his control so as to yield desirable effects, which would only become visible in time. If, as the testimony of Booth, Bone, Birch, and Hone makes clear, those temporally evolving chymical objects called "paintings" needed to both age and yet somehow also persist into the future as "pictures," then the Pictor's intentionality might well be seen as no less complicated than Michaels would have it be in photography. Indeed, in light of the unusual chymical experiments introduced into Anglo-American practice in Reynolds's paintings and their reciprocal relations to the innovative strategies of chymical replication by which they were disseminated, historians of Anglo-American art and theorists of photography alike would do well to extend the complex network of action and accident implicating the photograph to painting as well. Rather than purporting an ontological rupture between them, we might instead plot painting and photography, along with pollaplasias-mos, lithography, enameling, aquatint, and other techniques as so many moves within a broader Enlightenment tradition of working and thinking with temporally evolving chymical objects—a tradition in which what we now call photography is but one sequence of iterations, not a teleological culmination.

Two such chymical images and one final address to my titular question can make the advantages of this approach clearer. In the 1920s, English scholar C. H. Collins Baker was commissioned to catalogue the British art collection of Henry E. Huntington in southern California.[111] There, he became embroiled in an acrimonious dispute, then lawsuit, over the authenticity of a depiction of Lavinia sold by Countess Spencer to Huntington as a Reynolds by the Duveen Brothers.[112] Collins Baker did not believe a word of it. On the back of a photograph (fig. 12) now in the Huntington's conservation files, he wrote: "The Huntington version is a copy by a painter to whom the essence of Reynolds was unperceived. In the autograph version at Althorp, the hair has a silvery bloom. The arabesque or festoon of the lace edge of the cape is a lovely example of Reynolds's fluid calligraphic rhythm: rippling up and over the shoulder without a break in the flow." [113] Collins Baker might well have remembered the lessons that the tradition of West, Allston, and others had brought back to the United States from Reynolds's ambit. For, Collins Baker's connoisseurial judgments were overturned when period letters proved that Reynolds

had produced multiple versions of the picture for the Spencer family. In a nod to the slipperiness of Reynolds's liquid intelligence, a colleague subsequently forwarded to Collins Baker a chymical image then some thirty years old: a lithographed newspaper headline from the *New York Times* aligning Reynolds with pictorial piracy (see fig. 2).[114] Did Joshua Reynolds paint his pictures? In this light, yes; and he did so many times over.

Matthew C. Hunter

1 For this series, see Anthony Blunt, *The Paintings of Nicolas Poussin: A Critical Catalogue* (London: Phaidon, 1966), 73–76. For the king's visit, see William T. Whitley, *Artists and Their Friends in England, 1700–1799* (Boston: Medici Society, 1928), 2:75–78. On exhibitions at Somerset House more broadly, see David H. Solkin, ed., *Art on the Line: The Royal Academy Exhibitions at Somerset House, 1780–1836* (New Haven, CT: Yale University Press, 2002).

2 For more on Byres and his art dealing, see Paolo Coen, "Andrea Casali and James Byres: The Mutual Perception of the Roman and British Art Markets in the Eighteenth Century," *Journal for Eighteenth-Century Studies* 34, 3 (2011): 291–313; and John Ingamells, *A Dictionary of British and Irish Travellers in Italy, 1701–1800* (New Haven, CT: Yale University Press, 1997), 169–72. For the Fitzwilliam Museum's fund-raising efforts, see "Fitzwilliam Succeeds in Saving Poussin Masterpiece for the Nation," Nov. 2, 2012, accessed Dec. 3, 2013, http://www.cam.ac.uk/news/fitzwilliam-succeeds-in-saving-poussin-masterpiece-for-the-nation.

3 See Brian Fothergill, *Sir William Hamilton: Envoy Extraordinary* (London: Faber and Faber, 1969), 192–93.

4 Joshua Reynolds to Charles, 4th Duke of Rutland, Oct. 4, 1786, in *The Letters of Sir Joshua Reynolds*, ed. J. Ingamells and J. Edgcumbe (New Haven, CT: Yale University Press, 2000), 173.

5 Joshua Reynolds to Charles, 4th Duke of Rutland, July 5, 1785, in *Letters of Sir Joshua Reynolds*, 142. See Theodore Vrettos, *The Elgin Affair: The Abduction of Antiquity's Greatest Treasures and the Passions It Aroused* (New York: Arcade, 1997).

6 This image is likely not a pure lithograph but printed on top of copper etching; I thank Geoffrey Belknap for advising me on this point.

7 "Sir Joshua Reynolds Helped to Pirate Old Masters," *New York Times Sunday Magazine*, Feb. 1, 1914, 1. For more on one possible prompt to this editorial, the *Special Loan Exhibition of Old Masters of the British School*, which opened at the Duveen Brothers gallery in New York in January 1914 and prominently featured work by Reynolds, see Elizabeth A. Pergam, "Provenance as Pedigree: The Marketing of British Portraits in Gilded Age America," in *Provenance: An Alternative History of Art*, ed.

G. Feigenbam and I. Reist (Los Angeles: Getty Research Institute, 2012), 104–22. On the Old Master market and its players more broadly, see Flaminia Gennari Santori, *The Melancholy of Masterpieces: Old Master Paintings in America, 1900–1914* (Milan: 5 Continents, 2003); and John Brewer, *The American Leonardo: A Tale of Obsession, Art and Money* (Oxford: Oxford University Press, 2009).

8 Recent technical studies also indicate that Reynolds was not immune to repainting Old Master pictures in his collection, including works by Rembrandt; see Henri Neuendorf, "X-Ray Analysis Reveals Joshua Reynolds Repainted Rembrandt Masterpiece," *Artnet*, Mar. 5, 2015, accessed May 27, 2015, https://news.artnet.com/in-brief/x-ray-analysis-reveals-joshua-reynolds-repainted-rembrandt-masterpiece-273509.

9 Edmond Malone, "Some Account of the Life and Writings of Sir Joshua Reynolds," in *The Literary Works of Sir Joshua Reynolds*, 5th ed., ed. Edmond Malone (London: T. Cadell & W. Davies, 1819), 1:xli–ii.

10 See ibid., 1:xlii–xlv.

11 Joshua Reynolds, "Discourse VI," in *Discourses on Art*, ed. R. W. Wark (New Haven, CT: Yale University Press, 1997), 107.

12 For more on this picture, see John Newman, "Reynolds and Hone: 'The Conjuror' Unmasked," in *Reynolds*, ed. N. Penny (London: Royal Academy, 1986), 344–54; and Konstantinos Stefanis, "Nathaniel Hone's 1775 Exhibition: The First Single-Artist Retrospective," *Visual Culture in Britain* 14, 2 (2013): 131–53.

13 See Horace Walpole, *Anecdotes of Painting in England . . .* (Strawberry-Hill: Thomas Kirgate, 1771), 4:vii.

14 Joseph Farington, "Memoirs of the Life of Sir Joshua Reynolds with Observations on His Talents and Character," in Malone, *Literary Works of Sir Joshua Reynolds*, 1:ccxii.

15 I will subsequently abbreviate this title as *Morning Chronicle*.

16 "For the Morning Chronicle. To Sir Joshua Reynolds," *Morning Chronicle and London Advertiser*, May 11, 1773, n.p.

17 An interesting analogy might be drawn between this uncomfortable bleeding of image and pigments and contemporaneous confusions between painters' media and the makeup worn by their sitters; see Aimee Marcereau Degalan, "Dangerous Beauty: Painted Canvases and Painted Faces in Eighteenth-Century Britain" (PhD diss., Case Western Reserve University, 2007), esp. 124–26.

18 "To Sir Joshua Reynolds," n.p.

19 On the extent of the war's importance to art in Britain, see Douglas Fordham, *British Art and the Seven Years' War: Allegiance and Autonomy* (Philadelphia: University of Pennsylvania Press, 2010).

20 Although they are beyond the scope of this essay, precepts drawn from Mediterranean antiquity and the early Christian cult of images might be seen to subtend this conversation. Particularly relevant here would be Plato's distinction, as noted later in the essay, between an archetypal, immaterial idea (*eidos*) and its redundant replication by art (*mimesis techne*), as well as the differentiation forged in the era of Byzantine iconoclasm between the legitimate honor given to an archetype through reverence to a material image (*proskynesis*) and what would be translated by Carolingian observers of that Greek debate as the mistaken worship of the material image itself (*adoratio*). For general overviews of these traditions, see Erwin Panofsky, *Idea: A Concept in Art Theory* (Columbia: University of South Carolina Press, 1968); Hans Belting, *Likeness and Presence: A History of the Image before the Era of Art*, trans. E. Jephcott (Chicago: University of Chicago Press, 1994), esp. 144–63, 503–5, 533–35; and David Freedberg, *The Power of Images: Studies in the History and Theory of Response* (Chicago: University of Chicago Press, 1989), esp. 392–405.

21 James Elkins, *The Domain of Images* (Ithaca, NY: Cornell University Press, 1999), 55. For critiques of the ways in which academic art history has privileged two-dimensional "pictures" exemplified par excellence by post-Renaissance easel painting, see Michael Yonan, "Toward a Fusion of Art History and Material Culture Studies," *West 86th* 18, 2 (2011): 232–48.

22 Michael Fried, "Shape as Form: Frank Stella's Irregular Polygons," in *Art and Objecthood: Essays and Reviews* (Chicago: University of Chicago Press, 1998), 95. For Stella's own apposite thoughts (albeit from two decades later) on the antagonism between "pictoriality"

and materiality, see Frank Stella, *Working Space: The Charles Eliot Norton Lectures, 1983–84* (Cambridge, MA: Harvard University Press, 1986), esp. 71–98.

23 On the breadth and complexity of Goodman's engagement with modern art, see Curtis L. Carter, "*Hockey Seen*: Nelson Goodman," in *Hockey Seen: A Nightmare in Three Periods and Sudden Death: A Tribute to Nelson Goodman* (Milwaukee, WI: Haggerty Museum of Art, Marquette University, Sept. 28, 2006–Jan. 14, 2007), n.p.

24 Nelson Goodman, *Languages of Art: An Approach to a Theory of Symbols* (1968; repr., New York: Hackett, 1976), 229.

25 Jennifer L. Roberts, "Copley's Cargo: *Boy with a Squirrel* and the Dilemma of Transit," *American Art* 21, 2 (2007): 22.

26 Ibid., 22–23.

27 A fuller inquiry into the relations between the projects of Fried and Roberts is beyond the scope of this essay. But note should be made here between Fried's proposal (articulated in 1987) that his account of Thomas Eakins found its most important precedent in the "American portraits of John Singleton Copley, many of which also contain striking images of reflections," and the centrality of reflective surfaces to Roberts's recent interpretation of Copley's portraits. Compare Michael Fried, *Realism, Writing, Disfiguration: On Thomas Eakins and Stephen Crane* (Chicago: University of Chicago Press, 1987), 177n75; and Jennifer L. Roberts, *Transporting Visions: The Movement of Images in Early America* (Berkeley: University of California Press, 2014), esp. 34–49 (see also pp. 7, 169–70n19).

28 See Michael Fried, *Absorption and Theatricality: Painting and Beholder in the Age of Diderot* (Los Angeles: University of California Press, 1980).

29 For this quote, see Robert Smithson, "Letter to the Editor," in *Robert Smithson: The Collected Writings*, ed. J. Flam (Los Angeles: University of California Press, 1996), 67. See Jennifer L. Roberts, *Mirror-Travels: Robert Smithson and History* (New Haven, CT: Yale University Press, 2004), esp. 33–34; and Robert Linsley, "Mirror Travel in the Yucatan: Robert Smithson, Michael Fried, and the New Critical Drama," *RES: Anthropology and Aesthetics* (2000): 7–30. For more

Matthew C. Hunter

on the stakes shared between Fried and Smithson, see Walter Benn Michaels, *The Shape of the Signifier: 1967 to the End of History* (Princeton, NJ: Princeton University Press, 2004), esp. 82–128.

30 I owe this astute comparison to David H. Solkin, in conversation with Shelley Bennett; see Shelley Bennett's notes from conversation with Solkin from April 1, 1996, in the Huntington Art Gallery object file HEH 23.13.

31 Louis Simond, *Journal of a Tour and Residence in Great Britain during the Years 1810 and 1811*, 2nd ed. (Edinburgh: J. Ballantyne, 1817), 1:49.

32 William Mason, "Anecdotes of Sir Joshua Reynolds, Chiefly Relating to His Manner of Coloring. By W. Mason, the Poet," in *Sir Joshua Reynolds' Notes and Observations on Pictures*, ed. W. Cotton (London: J. R. Smith, 1859), 54.

33 [William Combe], *A Poetical Epistle to Sir Joshua Reynolds, Knt.* (London: Fielding and Walker, 1777), 5.

34 Mansfield Kirby Talley, "'All Good Pictures Crack': Sir Joshua Reynolds's Practice and Studio," in Penny, *Reynolds*, 55.

35 Neil Harris, *The Artist in American Society: The Formative Years, 1790–1860* (New York: George Braziller, 1966), 11. For a recent approach to Anglo-American art that informs my view, see David Peters Corbett and Sarah Monks, *Anglo-American: Artistic Exchange between Britain and the USA* (Chichester, West Sussex, UK: John Wiley & Sons, 2012).

36 On this American tradition, see Lance Mayer and Gay Myers, *American Painters on Technique: The Colonial Period to 1860* (Los Angeles: J. Paul Getty Museum, 2011); Lance Mayer and Gay Myers, *American Painters on Technique: 1860–1945* (Los Angeles: J. Paul Getty Museum, 2013); Joyce Hill Stoner, "Art Historical and Technical Evaluation of Works by Three Nineteenth Century Artists: Allston, Whistler, and Ryder," in *Appearance, Opinion, Change: Evaluating the Look of Paintings* (London: United Kingdom Institute for Conservation, 1990), 36–41; and David Bjelajac, *Washington Allston, Secret Societies and the Alchemy of Anglo-American Painting* (Cambridge: Cambridge University Press, 1997).

37 James Northcote, *The Life of Sir Joshua Reynolds*, 2 vols. (London: Henry Colburn, 1810), 1:237.

38 Samuel Johnson, *A Dictionary of the English Language* (London: Printed by W. Strahan, for J. and P. Knapton et al., 1755–1776), vol. 2, s.v. "picture."

39 Northcote, *The Life of Sir Joshua Reynolds*, 1:237. In point of fact, Reynolds did subsequently paint a portrait of a brewer (in this case, Samuel Whitbread) on a large copper plate; see David Mannings and Martin Postle, *Sir Joshua Reynolds: A Complete Catalogue of His Paintings* (New Haven, CT: Yale University Press, 2000), 1:470. I thank Alexandra Gent for very kindly calling this point to my attention.

40 Edgar Peters Bowron, "A Brief History of European Oil Paintings on Copper, 1560–1775," in *Copper as Canvas: Two Centuries of Masterpiece Paintings on Copper, 1575–1775*, ed. M. K. Komanecky (New York: Oxford University Press, 1999), 10–11.

41 Rica Jones, "Wright of Derby's Techniques of Painting," in *Wright of Derby*, by Judy Egerton (New York: Metropolitan Museum of Art, 1990), 263–71. On these techniques more broadly, see Isabel Horovitz, "The Materials and Techniques of European Paintings on Copper Supports," in Komanecky, *Copper as Canvas*, 63–92.

42 *A Catalogue of the Pictures, Sculptures, Models, Designs in Architecture, Drawings, Prints, &c. Exhibited by the Society of Artists of Great Britain . . .* (London: Printed by Harriot Bunce, printer to the Society, 1773), 3. More broadly, see Elizabeth E. Barker and Alex Kidson, *Joseph Wright of Derby in Liverpool* (New Haven, CT: Yale University Press, 2007), 186.

43 Northcote, *The Life of Sir Joshua Reynolds*, 1:239.

44 See *The Stanford Encyclopedia of Philosophy*, Summer 2012 Edition, ed. Edward N. Zalta, s.v. "Identity Over Time," by Andre Gallois, accessed Dec. 2, 2013, http://plato.stanford.edu/archives/sum2012/entries/identity-time/. See also Alexander Nagel and Christopher S. Wood, *Anachronic Renaissance* (New York: Zone Books, 2010), 8–9.

45 Martin Archer Shee, *The Commemoration of Reynolds, in Two Parts, with Notes, and Other Poems* (London: J. Murray, 1814), 12–13. For a digital visualization of that 1813 exhibition, see Janine Barchas et al.,

Did Joshua Reynolds Paint His Pictures?

What Jane Saw, accessed July 31, 2015, http://www.whatjanesaw.org/rooms.php?location=NRNE.

46 Ibid., 13–14.

47 Michael Baxandall, *Painting and Experience in Fifteenth-Century Italy: A Primer in the Social History of Pictorial Style* (Oxford: Clarendon Press, 1972), esp. 14–23.

48 John T. Smith, *Nollekens and His Times: A Life of That Celebrated Sculptor and Memoirs of Several Contemporary Artists, from the Time of Roubilliac, Hogarth and Reynolds to That of Fuseli, Flaxman and Blake* (London: Colburn, 1829), 2:292.

49 Compare Plato, *Platonis Opera*, ed. J. Burnet (Oxford: Oxford University Press, 1903), 596B–597E; and Plato, *The Republic*, trans. R. E. Allen (New Haven, CT: Yale University Press, 2006), bk. 10, 326–29. For an informative critical reading of this famous passage, see Stephen Halliwell, *The Aesthetics of Mimesis: Ancient Texts and Modern Problems* (Princeton, NJ: Princeton University Press, 2002), esp. 37–71.

50 For the Greek, see Plato, *Platonis Opera*, 597E.

51 On this point, see John Barrell, *The Political Theory of Painting from Reynolds to Hazlitt: "The Body of the Public"* (New Haven, CT: Yale University Press, 1986), 80. More recently, Celina Fox has characterized Reynolds as positing "an opposition between the mind and the hand, between principle and mere practice"; Celina Fox, *The Arts of Industry in the Age of Enlightenment* (New Haven, CT: Yale University Press, 2009), 216. For pedagogy in the early Royal Academy, see Holger Hoock, *The King's Artists: The Royal Academy of Arts and the Politics of British Culture, 1760–1840* (Oxford: Clarendon, 2005).

52 Northcote, *The Life of Sir Joshua Reynolds*, 1:83.

53 Waldron P. Belknap, *American Colonial Painting: Materials for a History*, ed. C. C. Sellers (Cambridge, MA: Belknap Press of Harvard University Press, 1959), 275.

54 For this claim, see Ellen D'Oench, *Copper into Gold: Prints by John Raphael Smith (1752–1812)* (New Haven, CT: Yale University Press, 1999), 25.

55 See Philipp André, *Specimens of Polyautography: Consisting of Impressions Taken from Original Drawings Made Purposely for This Work* (London: Published by P. André and J. Heath, 1803). For a fascinating account of the export of stone used to produce lithographs from Europe to the early United States, see Philip J. Weimerskirch, "Lithographic Stone in America," *Printing History* 11, 1 (1989): 2–15.

56 Walter Benjamin, "The Work of Art in the Age of Its Technological Reproducibility: Second Version," in *The Work of Art in the Age of Its Technological Reproducibility, and Other Writings on Media*, ed. Michael W. Jennings, Brigid Doherty, and Thomas Y. Levin, trans. E. Jephcott and others (Cambridge, MA: Harvard University Press, 2008), 20.

57 For concise overview of the Chemical Revolution, see William H. Brock, *The Fontana History of Chemistry* (London: Fontana, 1992), esp. 84–127. More broadly, see Jan Golinski, *Science as Public Culture: Chemistry and Enlightenment in Britain, 1760–1820* (New York: Cambridge University Press, 1992); and Archibald Clow and Nan L. Clow, *The Chemical Revolution: A Contribution to Social Technology* (London: Batchworth, 1952).

58 Thomas Fisher, "The Process of Polyautographic Printing," *Gentleman's Magazine* 78, 1 (1808): 194.

59 Michael Twyman, *Lithography, 1800–1850: The Techniques of Drawing on Stone in England and France and Their Application in Works of Topography* (London: Oxford University Press, 1970), 4.

60 For West's experimental facture, see Mayer and Myers, *American Painters on Technique: The Colonial Period to 1860*, 11–24; and Mark N. Aronson and Angus Trumble, *Benjamin West and the Venetian Secret* (New Haven, CT: Yale Center for British Art, 2008). More broadly, see Bjelajac, *Washington Allston*, esp. 32–65.

61 From this point in the essay onward, I employ the period spelling "chymical." While doing so follows the general contours of period orthography (including that of Reynolds, as discussed later in the essay), it also employs a strategy devised by recent historians of science that seeks to undermine the opposition of chemistry to its supposedly benighted other, alchemy. If, as William R. Newman and Lawrence Principe have influentially argued, it was only in the Enlightenment that these previously synonymous terms came to designate a hierarchical opposition, they remained

significantly fluid—even importantly confused—in Reynolds's ambit; see William R. Newman and Lawrence M. Principe, "Alchemy v. Chemistry: The Etymological Origins of a Historiographic Mistake," *Early Science and Medicine* 3, 1 (1998): 32–65.

62 Charles Robert Leslie and Tom Taylor, *Life and Times of Sir Joshua Reynolds* (London: John Murray, 1865), 1:112.

63 Compare Joseph Booth, *A Treatise Explanatory of the Nature and Properties of Pollaplasiasmos; or, The Original Invention of Multiplying Pictures in Oil Colours . . .* (London: J. Rozea, 1784); and Joseph Booth, *An Address to the Public on the Polygraphic Art* (London: J. Walter, 1788[?]), 4.

64 See The Polygraphic Society, *A Catalogue of Pictures Copied or Multiplied (for Sale) by A Chymical and Mechanical Process; Exhibited with the Capital Originals from which they have been taken, by The Polygraphic Society, at their Rooms, in Pall-Mall, Being their Eight Exhibition: Opened the 4th of April, 1792* (London: A. Grant, 1792), 11.

65 Booth, *An Address*, 9.

66 Ibid. For a classic account of eighteenth-century industrial artists' more familiar attempts to reconcile their projects with regnant neoclassical tastes and values, see Adrian Forty, *Objects of Desire: Design and Society since 1750* (New York: Pantheon Books, 1986), esp. 11–41.

67 David Saunders and Antony Griffiths, "Two Mechanical Oil Paintings after de Loutherbourg: History and Technique," in *Studying Old Master Paintings: Technology and Practice*, ed. M. Spring (London: Archetype, 2011), 191. See also Barbara Fogarty, "Matthew Boulton and Francis Eginton's Mechanical Paintings: Production and Consumption 1777 to 1781" (master's thesis, University of Birmingham, 2010).

68 Booth, *An Address*, 5.

69 The frequency with which any given Reynolds painting was reproduced in enamel is an important question, but one beyond the scope of this essay. As but one example: William Murray, first Earl of Mansfield, commissioned replicas by William Russell Birch after oil portraits by Reynolds and Copley between 1786 and 1793. See Julius Bryant, *Kenwood:*

Paintings in the Iveagh Bequest (New Haven, CT: Yale University Press, 2003), 260.

70 For more on Bone, see *Oxford Dictionary of National Biography*, s.v. "Bone, Henry (1755–1834)," by R. J. B. Walker, accessed May 16, 2013, http://www.oxforddnb.com/view/article/2836.

71 For Bone's technique, see Sarah Coffin and Bodo Hofstetter, *Portrait Miniatures in Enamel* (London: Philip Wilson Publishers, 2000), 9–11.

72 Smith, *Nollekens and His Times*, 2:292–93.

73 On Birch and his career, see Emily T. Cooperman and Lea Carson Sherk, *William Birch: Picturing the American Scene* (Philadelphia: University of Pennsylvania Press, 2011), esp. 66–98; and Therese O'Malley, "Cultivated Lives, Cultivated Spaces: The Scientific Garden in Philadelphia, 1740–1840," in *Knowing Nature: Art and Science in Philadelphia, 1740–1840*, ed. A. R. W. Meyers and L. L. Ford (New Haven, CT: Yale University Press, 2011), 36–59.

74 William Birch, *The Life and Anecdotes of William Russell Birch, Enamel Painter*, as reproduced in Cooperman and Sherk, *William Birch*, 169–70. I thank Emily T. Cooperman for helpful information on the dating of Birch's autobiography.

75 Ibid., 169.

76 Ibid., 171.

77 See Bruce Tattersall, *Stubbs & Wedgwood: Unique Alliance between Artist and Potter* (London: Tate Gallery, 1974).

78 Mason, "Anecdotes," 54.

79 For accounts of Reynolds's chymical reproducers insinuating themselves in his favor, compare Birch's account of his relations to this "father of the English School of Painting" and his catalogue of enamels after Reynolds (Birch, in Cooperman and Sherk, *William Birch*, 171–78, 242–48) and Booth's claim that a portrait offered in pollaplasiasmic reproduction "was painted by Sir Joshua Reynolds expressly for the Polygraphic Society" (The Polygraphic Society, *A Catalogue of Pictures*, 9). More broadly, see D'Oench, *Copper into Gold*, 13, 25–27.

Did Joshua Reynolds Paint His Pictures?

80 Mario Biagioli, *Galileo Courtier: The Practice of Science in the Culture of Absolutism* (Chicago: University of Chicago Press, 1993), 80.

81 Birch, in Cooperman and Sherk, *William Birch*, 171.

82 See Smith, *Nollekens and His Times*, 1:133. For an overview of Hone's career, see Adrian Le Harivel, *Nathaniel Hone the Elder* (Dublin: Town House, in association with the National Gallery of Ireland, 1992).

83 See Vladimir Nabokov, *Pale Fire* (1962; New York: Vintage International, 1989). On the historical connections between enamel painting and alchemy, see Michael Cole, *Cellini and the Principles of Sculpture* (Cambridge: Cambridge University Press, 2002), 15–42.

84 Robert Dossie, *The Handmaid to the Arts* (London: Printed for J. Nourse, 1764), 264. See also F. W. Gibbs, "Robert Dossie (1717–1777) and the Society of Arts," *Annals of Science* 7, 2 (1951): 149–72.

85 Cooperman and Sherk, *William Birch*, 66.

86 Birch, in Cooperman and Sherk, *William Birch*, 169.

87 Jonathan Levy, *Freaks of Fortune: The Emerging World of Capitalism and Risk in America* (Cambridge, MA: Harvard University Press, 2012), 3.

88 For his account of his relations with "my late friend and patron the Earl of Mansfield," see Birch, in Cooperman and Sherk, *William Birch*, 173–87. On Mansfield's importance to the legal foundations of risk, see Levy, *Freaks of Fortune*, 35, 40, 48.

89 For Mansfield's claim that "the great object in every branch of law, but especially in mercantile law, is certainty," see *Oxford Dictionary of National Biography*, s.v. "Murray, William, first earl of Mansfield (1705–1793)," by James Oldham, accessed Dec. 28, 2013, http://www.oxforddnb.com/view/article/19655.

90 See Levy, *Freaks of Fortune*, 34.

91 Northcote, *The Life of Sir Joshua Reynolds*, 2:21.

92 Joshua Reynolds, "Discourse VI," 94. For recent scholarship on early modern attempts to reckon with the production of artistic novelty through emulation,

see Richard T. Neer, "Poussin, Titian, and Tradition: *The Birth of Bacchus* and the Genealogy of Images," *Word & Image* 18, 3 (2002): 267–81; and Maria H. Loh, "New and Improved: Repetition as Originality in Italian Baroque Practice and Theory," *Art Bulletin* 86, 3 (Sept. 2004): 477–504.

93 Reynolds, "Discourse VI," 106.

94 Ibid., 107. For an interesting examination of the alchemical traditions informing theories of mind on which Reynolds could be drawing, see Antonio Clericuzio, "The Internal Laboratory: The Chemical Reinterpretation of Medical Spirits in England (1650–1680)," in *Alchemy and Chemistry in the 16th and 17th Centuries*, ed. P. Rattansi and A. Clericuzio (Boston: Kluwer, 2002), 51–83.

95 Donald Preziosi, *Rethinking Art History: Meditations on a Coy Science* (New Haven, CT: Yale University Press, 1989), 93.

96 For ancient sources and alchemical connections of this mythical story, see David M. Jacobson, "Corinthian Bronze and the Gold of the Alchemists," *Gold Bulletin* 33, 2 (2000): 60–66.

97 This reciprocal dialogue with artistic and chymical tradition seems to subtend Reynolds's claim in preparatory notes for "Discourse VI" that "when I recommend . . . enriching & manuring the mind with other mens thoughts I suppose the Artist to know his Art so as to know what to choose and what to reject"; cited in Frederick Whiley Hilles, *The Literary Career of Sir Joshua Reynolds* (Cambridge: Cambridge University Press, 1936), 224.

98 Joshua Reynolds, "Discourse XIII," in *Discourses on Art*, 243.

99 Northcote, *The Life of Sir Joshua Reynolds*, 2:7.

100 Ibid., 2:40.

101 Ibid., 2:40.

102 On patina, see articles by Randolph Starn, Eileen Cleere, and Darcy Grimaldo Grigsby in *Representations* 78, 1 (Spring 2002): 86–144.

103 Birch, in Cooperman and Sherk, *William Birch*, 170.

Matthew C. Hunter

104 For a recent overview of Reynolds's workshop practices, see S. Smiles, ed., *Sir Joshua Reynolds: The Acquisition of Genius* (Bristol: Sansom & Company, 2009). For the most influential period meditation on the role of genius in the fine arts, see Immanuel Kant, *Critique of Judgment* [1790], trans. W. Pluhar (Indianapolis, IN: Hackett, 1987), esp. § 46–7.

105 An instructive meditation on this episode is Joel Snyder, "What Happens by Itself in Photography?," in *Pursuits of Reason: Essays in Honor of Stanley Cavell*, ed. T. Cohen et al. (Lubbock: Texas Tech University Press, 1993), 361–73.

106 See John Gage, "Magilphs and Mysteries," *Apollo* 80 (July 1964): 38–41. For this labeling of Page, see Mayer and Myers, *American Painters on Technique: 1860–1945*, 1.

107 Walter Benn Michaels, "Action and Accident: Photography and Writing," in *The Gold Standard and the Logic of Naturalism: American Literature at the Turn of the Century* (Los Angeles: University of California Press, 1987), 239. More recently, see Robin Kelsey, "Of Fish, Birds, Cats, Mice, Spiders, Flies, Pigs, and Chimpanzees: How Chance Casts the Historic Action Photograph into Doubt," *History and Theory* 48 (Dec. 2009): 59–76.

108 See, for example, Joel Snyder, "Res Ipsa Loquitur," in *Things That Talk: Object Lessons from Art and Science*, ed. L. Daston (New York: Zone Books, 2004), 195–221; Steve Edwards, *The Making of English Photography: Allegories* (University Park, PA: Penn State University Press, 2006), esp. 136–46; and Josh Ellenbogen, *Reasoned and Unreasoned Images: The Photography of Bertillon, Galton, and Marey* (University Park, PA: Penn State University Press, 2012).

109 Walter Benn Michaels, "Photographs and Fossils," in *Photography Theory*, ed. J. Elkins (New York: Routledge, 2006), 442.

110 Ibid., 432, 444.

111 See C. H. Collins Baker, *Catalogue of British Paintings in the Henry E. Huntington Library and Art Gallery* (San Marino, CA: Huntington Library, 1936).

112 For this episode, see S. N. Behrman, *Duveen* (New York: Random House, 1952), 208–11. More recently, see Shelley M. Bennett, *The Art of Wealth:* *The Huntingtons in the Gilded Age* (San Marino, CA: Huntington Library, 2013), 271–81.

113 See Huntington Conservation File for 26.107 (After Joshua Reynolds, *Lavinia (Bingham), Countess Spenser*).

114 See [Mr. van West?] to C. H. Collins-Baker, Oct. 13, 1943, in Huntington Conservation File for 11.16 (Follower of Reynolds, *Unknown Man called Richard Brinsley Sheridan*).

MAGICAL PICTURES

Michael Gaudio

Magical Pictures; *or, Observations on Lightning and Thunder, Occasion'd by a Portrait of Dr. Franklin*

On a stormy afternoon in 1745, Gilbert Tennent (1703–1764), a leading preacher of the Great Awakening, was at home preparing the evening exercise for his Philadelphia congregation when a flash of lightning struck his chimney and then headed straight for the upstairs study, where it knocked Tennent to the floor, tore his shoes—melting a buckle on one of them—and scorched his feet.[1] For Tennent, the lightning strike was a sign from an angry God. Such episodes had long sparked fear in the hearts of the devout, spawning numerous pamphlets and sermons in the seventeenth and eighteenth centuries, on both sides of the Atlantic, that carried ominous titles like *The Sinner's Thundering Warning-Piece* (London, 1703), *Farther, and more terrible Warnings from God* (London, 1708), and *God's Terrible Doings are to be Observed* (Boston, 1746). After recovering from his own harrowing encounter with the lightning, Tennent saw fit to preach yet another sermon on the topic, not least of all to dispel rumors—circulated by his Moravian enemies—that the lightning strike was an expression of God's particular dissatisfaction with his ministry.[2] Tennent titled the published sermon *All Things Come Alike to All: A Sermon, On Eccles. IX . . . Occasioned by a Person's Being Struck by the Lightning and Thunder,* and in it he stressed that God's thunderous voice of warning could be visited upon anyone, good or wicked. It was the duty of Tennent, as one who had experienced God's anger and lived, to carry this warning to his congregation: "It is but reasonable my Brethren, that we should

2
Mason Chamberlin,
Benjamin Franklin (detail,
see fig. 1).

84

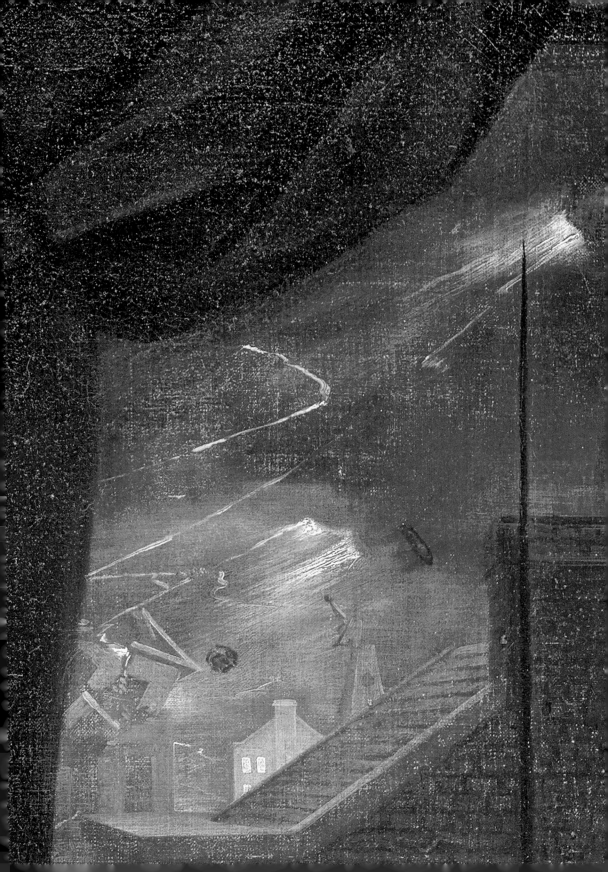

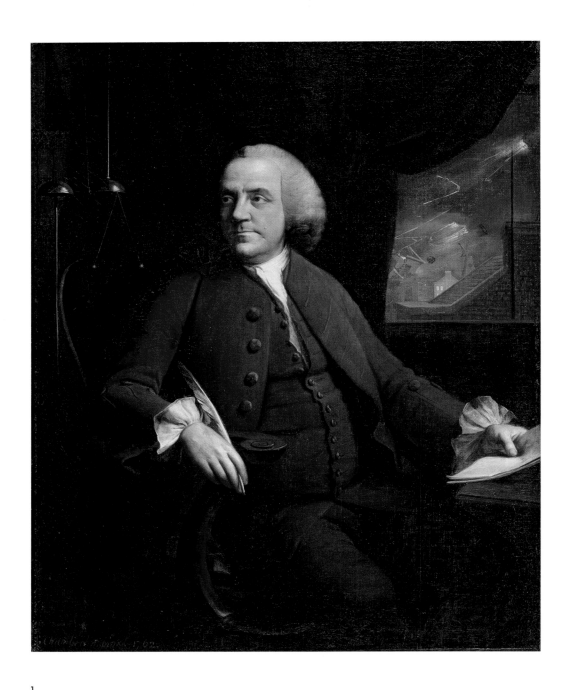

1
Mason Chamberlin,
Benjamin Franklin, 1762.
Oil on canvas, 50 ⅜ ×
40 ¾ in. (128 × 103.5 cm).
Philadelphia Museum
of Art, 1956-88-1.

Michael Gaudio

offer Homage to that great God, who is All-sufficient in himself, and whose Majestick Voice in the Thunder, produces such sudden and amazing Effects and Alterations in the Kingdoms of Nature and Providence. . . . Who can stand before this Holy Lord God, when once his Anger begins to burn?"[3]

If only Tennent had been protected by a lightning rod, like the one installed on a chimney outside the window of his friend Benjamin Franklin (1706–1790), as portrayed in 1762 by the London artist Mason Chamberlin (1722–1787) (figs. 1 and 2). A nearly life-sized Franklin sits in the upstairs study of his Philadelphia residence while outside his window we witness a storm like the one Tennent had experienced seventeen years earlier. One can almost hear the cracks of thunder as the roof of a nearby house and the steeple of a church, struck by a zigzagging bolt of lightning, explode in a violent burst of electrical energy. Two pieces of the destroyed structures—both of a brick-colored hue and perhaps intended to represent fragments of a chimney— are launched into the air by the blast. Yet Franklin, appearing calm and collected, does not seem to fear having his buckles melted, for his own invention protects him from God's burning anger. Franklin first introduced the idea of electrical conductors to the public in 1751 in his *Experiments and Observations on Electricity*. A few years later, in the second edition, he described the experiment in which we find him engaged in Chamberlin's portrait, where he turns his attention away from the storm and toward two small brass bells: "I erected an Iron Rod to draw Lightning down into my House, in order to make some Experiments on it, with two Bells to give notice when the rod should be electrified."[4] Paper in hand and quill at the ready, and with the volumes of his impressive library within reach just behind his chair, Benjamin Franklin, fellow of the Royal Society, employs the tools of experimental science to domesticate the lightning. He sits before us as the "Prometheus of modern times," a title Immanuel Kant conferred on him in 1756.[5] Having stolen fire from the heavens, Franklin reduces the thunderous voice of God to a gentle ring in the scholar's study, disenchanting the heavens for the sake of Enlightenment.

This was neither the first nor the last time Franklin was represented as a master of the lightning during his lifetime. In a mezzotint published the previous year, Franklin holds a volume entitled "Electrical Experiments" and stands before a desk on which sit quills, paper, and an electrostatic generator (fig. 3). The print is based on a portrait by Benjamin Wilson (1721–1788), who was not only a sought-after painter in London but, like his friend Franklin, an "electrician" and

3
James McArdell after
Benjamin Wilson,
Benjamin Franklin, 1761.
Mezzotint, 13 ⅞ × 10 in.
(35.3 × 25.2 cm).
The New York Public
Library, Astor, Lenox
and Tilden Foundations.
Miriam and Ira D.
Wallach Division of
Art, Prints and
Photographs, Print
Collection, 1239999.

fellow of the Royal Society. Wilson portrays Franklin standing before
a massive bolt of lightning that lays waste to a distant urban skyline.
Franklin's own vertical form reflects but also dwarfs the natural phenom-
enon; his left hand brushes against his volume as he points toward
the bolt in the distance, suggesting that the great experimentalist has
tamed the lightning by gathering its energies between the covers of
a book. The Wilson portrait, like Chamberlin's, foregrounds Franklin's
stature within London's scientific community at midcentury, a moment
of intense experimental fervor around electricity. By the 1770s, well
after Franklin's commitments as a public servant had taken him away
from active experimentation, artists continued to associate him with

the electrical fire as it developed into a powerful political rhetoric. Turgot's celebrated Latin epigram "Eripuit coelo fulmen sceptrumque tyrannis" (He snatched lightning from heaven, and the scepter from tyrants) received its visual interpretation in an etching of 1779, designed by Jean-Honoré Fragonard (1732–1806) and dedicated "To the Genius of Franklin" (fig. 4). An Olympian Franklin, more Zeus than Prometheus, dominates the composition. As the allegorical figure of America rests at his leg, Franklin directs the shield of France against the lightning with one hand and with the other commands a warrior to drive out Tyranny and Avarice.[6]

These are heroic portrayals, but of all the portraits made of him, Franklin seems to have been fondest of Chamberlin's. It was painted

4
Marguerite Gérard after Jean-Honoré Fragonard, *Au Génie de Franklin* (To the genius of Franklin), 1779. Etching, 20 ¼ × 15 ⅛ in. (51.6 × 38.4 cm). Davison Art Center, Wesleyan University, Middletown, Connecticut. Friends of the Davison Art Center funds, 1996, 1996.24.1.

at the end of his five-year stay in London from 1757 to 1762, a period during which Franklin played an official role as diplomat while reserving ample time to pursue his scientific interests. Commissioned by a Virginian who was then resident in the city, Colonel Philip Ludwell III, the painting went on display to the public at the Society of Artists in 1763; it now resides at the Philadelphia Museum of Art. We know little of the artist himself. An original member of the Royal Academy of Arts, Chamberlin was a devout Presbyterian who, unlike the fashionable artists of the West End, resided in the more commercial parish of Spitalfields where he specialized in painting likenesses of London tradesmen. He was a respected painter, although his unassuming portraits did occasionally receive criticism for a monotony of tone and expression. As a critic for the *Morning Post* wrote in 1784, after seeing the artist's portraits of his own family at the Society of Artists exhibition: "Mr. Chamberlin, his wife and son, are all frightfully alike, God bless 'em." [7] But Chamberlin's portrait of Franklin, while it may show a preference for muted tones and generally lacks Reynoldsian flair, undeniably captures a compelling likeness of the famous American. Franklin was pleased enough with the painting that he had a replica made for his son and ordered over one hundred mezzotint copies by the engraver Edward Fisher (1722–ca. 1782) (fig. 5). [8] The print became a kind of circum-atlantic calling card as Franklin circulated it through the colonial Atlantic Republic of Letters. He asked his cousin, for example, to distribute a dozen of the prints around Boston. "It being the only way in which I am now likely ever to visit my friends there," writes Franklin, "I hope a long Visit in this Shape will not be disagreable to them." [9] Indeed, here we encounter a Franklin not to be found in any other of the numerous portraits made of him: a gentleman-scientist who, despite the storm, has become absorbed in a moment of experimentation within the very domestic setting that served as his primary laboratory in his electrical pursuits. The portrait's modesty in presentation seems suited to the quiet gravity of its protagonist and setting.

Surely the portrait's appeal for Franklin lay in this calm intellectual heroism. But is the voice of God, which was so clearly heard by Tennent when he was struck by lightning in his study, so fully silenced within Franklin's? We should not be too quick to dismiss Tennent's awe before the lightning and thunder, for undoubtedly Franklin, too, would have thrilled to the violent destructiveness of the scene outside his window, a violence that exceeds the merely human proportions of the scholar's cozy study. His own scientific interests, after all, were

5
Edward Fisher after Mason Chamberlin, *Benjamin Franklin*, 1763. Mezzotint, 15 × 10 7/8 in. (38 × 27.7 cm). Library of Congress, Washington, DC. Prints and Photographs Division, LC-DIG-ppms-ca-10083.

Michael Gaudio

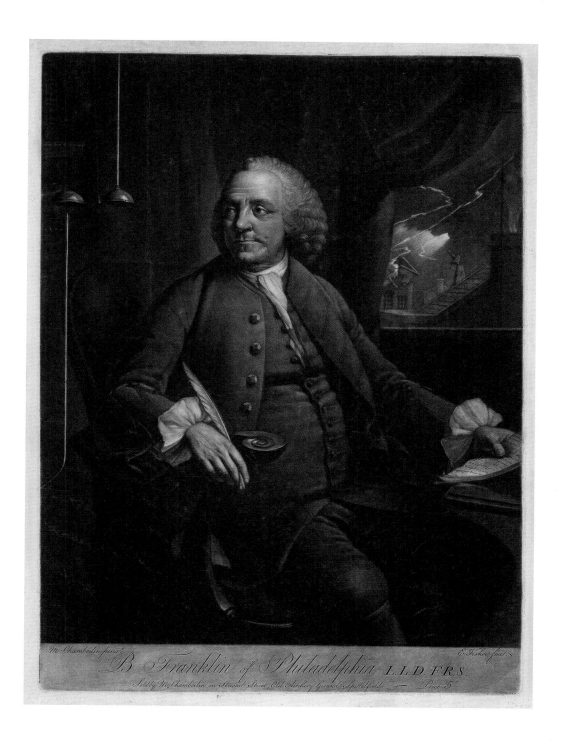

by no means limited to a quiet rationality. As James Delbourgo has shown, eighteenth-century electricity was both a science and a marvel, and the "tension between experimental claims to rational knowledge and the persistence of wonder at the surprising powers of the electric fire" is evident throughout Franklin's own writings.[10] Franklin and others cultivated a popular fascination with the wonders of electricity in which the public came to know this mysterious force by feeling its effects in their bodies. Franklin's colleague Ebenezer Kinnersley (1711–1778), for example, traveled widely in the 1750s lecturing on the electrical fire and demonstrating its powers in performances that included such attractions as "Fire darting from a Ladies Lips" and "a Battery of eleven Guns discharged by Fire issuing out of a Person's Finger."[11] Such demonstrations have become increasingly visible amid recent efforts, like Delbourgo's, to re-enchant the transatlantic Enlightenment by addressing its irrational, excessive, wondrous, and emotional qualities, qualities that entertained the audiences of electrical demonstrations, but which also led the God-fearing Gilbert Tennent to marvel at his melted buckle.

To what, then, should we attribute the lightning outside Franklin's study? Was it a natural phenomenon that could be known and contained by human art, or was it the mysterious workings of the divine? Chamberlin's picture offers no answer to this question; rather, its particular interest *as a picture* lies in the way it stages the question itself. Franklin's window, separating the storm outside from the calm within the study, forms a threshold between rationality and mystery, between the electrician's pen and God's thunderous voice. It is a threshold that invites reflection on the relationship between the lightning that descends from the sky and the "electrical fluid" manipulated by electricians in their experiments and performances, a hotly debated issue in the eighteenth century. But more than this, it invites reflection on the nature of representation itself, which for Franklin, as we will see, was a means of navigating the not always self-evident boundaries between enlightenment and enchantment. One might even say that Chamberlin's portrait poses an *electrical* model of representation in which meaning is understood to travel along alternating currents, one that moves from the chaotic and stormy world beyond the window to the calm that reigns inside the scholar's study, and another that takes us in the opposite direction. Finding the words to articulate this model won't be a matter of choosing which circuit to follow but of attempting to think them simultaneously.

L.
OMNIUM METU.

50.

6
"Omnium Metu," from
Julius Wilhelm Zincgref,
*Emblematum ethico-
politicorum centuria*,
[1619] 1666. Engraving,
3 3/8 × 3 3/8 in. (8.5 ×
8.5 cm). O. Meredith
Wilson Library Rare
Books Collection,
University of Minnesota,
Minneapolis.

The window, with its curtain drawn back, and looking almost as
if it were a picture hanging on Franklin's wall, is a good place to begin.
Through it we behold a meteorological spectacle of the kind that
had long been interpreted as a sign of divine wrath and punishment.
According to Mircea Eliade, across cultures there is an almost
universal belief in divine beings who inhabit the skies, who make
a brief visit to earth to establish moral laws, and who watch to see
that those laws are obeyed, "and lightning strikes all who infringe
them."[12] If at times certain free thinkers had protested against the
prevailing beliefs about lightning and thunder, like Lucretius who
insists in *De rerum natura* (first century BCE) that they are simply
elements set into motion by an indifferent nature, such views did
little to alter popular opinion. As Lucretius himself asks:

> *. . . whose mind does not cringe*
> * with superstitious fright,*
> *And whose flesh does not creep with awe,*
> * when the burnt earth shakes*
> *Struck by hair-raising bolts of lightning,*
> * and the vast sky quakes*
> *With rumbling thunder?*[13]

In Christian visual representations, lightning often assumes the form of an arrow, which is indicative of the divine intention behind it as well as a reference to the book of Psalms: "The clouds poured out water: the skies sent out a sound: thine arrows also went abroad."[14] One of the most popular emblem books in seventeenth-century Europe, Julius Wilhelm Zincgref's *Emblematum ethico-politicorum centuria* (1619), includes a device entitled "Omnium Metu" ("a terror to all") in which a city receives God's punishment in the form of a massive bolt that forks into four arrow-like prongs (fig. 6).[15] Lightning was the agent of divine Providence, a belief firmly held by Puritans who regularly witnessed the striking of houses and churches by lightning in New England.[16] Cotton Mather may have been a member of the Royal Society, but he too interpreted thunderstorms in these enchanted terms: "The *Thunder* has in it *the Voice of God*. . . . There is nothing able to stand before those *Lightnings*, which are stiled the *Arrows of God*."[17] Franklin's introduction of protective conductors during the 1750s, like the one that protects the nearby house in Chamberlin's painting, did show that one could at least redirect those arrows; but Franklin's innovation hardly brought an end to well-established beliefs about lightning and thunder. As the young John Adams complained: "I have heard some Persons of the highest Rank among us, say, that they really thought the Erection of Iron Points, was an impious attempt to robb the almighty of his Thunder, to wrest the Bolt of Vengeance out of his Hand."[18]

If Franklin could not change the minds of all God-fearing Christians, he certainly had an impact within the Republic of Letters. As a result of his influential *Experiments and Observations on Electricity* (the first edition appearing in 1751 and numerous expanded editions thereafter), and thanks to the publication of Joseph Priestley's (1733–1804) Franklinist account of electricity, *The History and Present State of Electricity* (1767), by the late 1760s the official historiography of electricity had effectively silenced debates among natural philosophers between experimental and religious accounts of the electrical fire.

7
After William Law, Plate VI: *The Wrath of God descends on Lucifer*, from Jakob Böhme, *The Works of Jacob Behmen, the Teutonic Theosopher*, 1764. Engraving, 9 ⅝ × 7 ⅝ in. (24.4 × 19.5 cm). O. Meredith Wilson Library Rare Books Collection, University of Minnesota, Minneapolis.

Priestley offered a rationalist and materialist explanation, one that stressed the progressive value of natural philosophy within civil society. There was a place for piety within this philosophy, but it was a piety that derived not from awe at the incomprehensible workings of the creator, but from recognition of the solemn responsibilities that came with the natural philosopher's ability to materialize that creator's powers.[19] Priestley's account had no room for entertaining possible tensions or contradictions between electricity—that is, the sparks demonstrated with the electrician's instruments—and the divine "celestial fire" manifested in the lightning.

Yet such tensions had recently—during the 1740s and 1750s— been at the center of public controversy in London about the nature of the electrical fire, and it is important to situate Chamberlin's portrait

of 1762 against this stormy background. The key figures in the controversy were the electrical demonstrator and instrument maker Benjamin Martin (1705–1782) and the surgeon and electrical amateur John Freke (1688–1756). Both men published books on electricity in 1746, and their ensuing debate, which Simon Schaffer has examined in depth, turned on the question of whether the electricity that appeared in demonstrations was a product of the electrician's instruments—this was Martin's materialist position, one in which natural philosophy trumped theological explanation—or the manifestation of a much greater, divine fire.[20] Freke argued the latter position, one in which he was guided by the writings of the seventeenth-century German theologian and mystic Jakob Böhme, or "Behmen" as he was known in England, whose philosophy of fire and spirit had become important for pietist critiques of Whig culture. Freke and others within his political and religious circle embraced a private, inner light to salvation and opposed it to the vulgarity of a shallow world of commerce in which showmen like Martin sought only to profit from God's creation.

An edition of Böhme's life and writings published in 1764 includes figures of his "deep principles" designed by William Law (1686–1761), one of the chief disseminators of Behmenist ideas in England. In one of the engravings, arrow-tipped bolts of lightning representing the wrath of God precipitate down (or outward in this diagrammatic rendering) from the divine celestial fire (fig. 7). In Freke's view, Martin's theatrical demonstrations were a debasement and a corruption of this celestial fire, a materialist reduction of Böhme's divine, vital principle to the product of a mere human instrument. If we were to find an image of Freke's fears realized, it might look something like the frontispiece to a French volume on the uses of electricity to heal paralysis, published in 1772, in which the healing light of an ineffable God manifests itself as a generator in the sky exuding rays of electrostatic energy (fig. 8).

In Benjamin Martin's view, Freke was a religious *enthusiast*, a superstitious dreamer for whom electricity was a mystery accessible only through nonrational experience. During the Protestant Reformation, mainstream Reformed theologians had critiqued the enthusiasm of their more radical brethren who made claims to prophecy and divine inspiration unmediated by scripture, and who often engaged in ecstatic or convulsive behaviors. Enthusiasm has a complex history, and it could come in many stripes, from Freke's pietist enthusiasm, which was cultivated within conservative Tory circles and stressed private individual illumination, to the more public enthusiasm of the

8
Frontispiece to Abbé Sans, *Guérison de la paralysie par l'électricité* (Healing paralysis with electricity), 1772. Engraving, 5 ⅛ × 3 ⅛ in. (13 × 8 cm). Library and Artifact Collections of the Bakken Museum, Minneapolis.

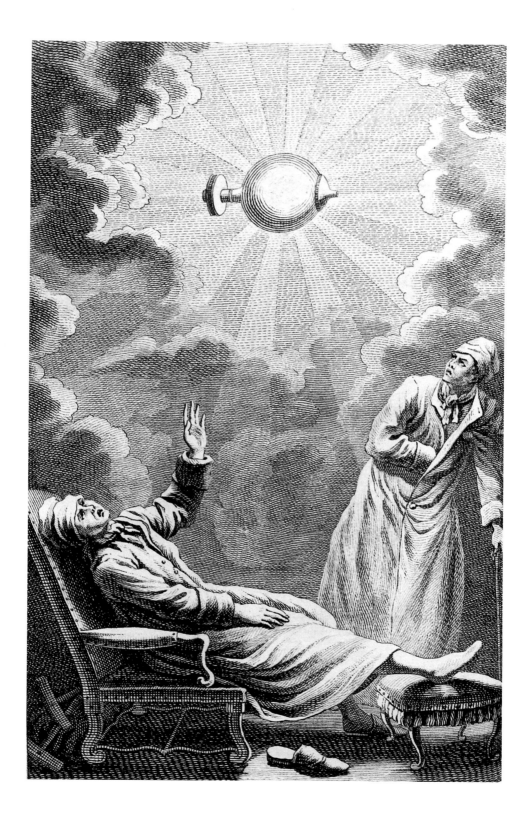

Magical Pictures

religious revival.[21] What remained consistent among all enthusiasts, however, was their quickness to see God's direct interventions in the world and to bear witness to them. It is the enthusiast who would attribute the lightning strikes outside Franklin's window to the wrath of God, whereas the rational electrician would see a God who has established laws in the world and allowed them to take their course, leaving them discoverable and useful to mankind.

Across the Atlantic, resistance to the enthusiasm of the Great Awakening directly shaped how one of the key figures in electrical experimentation, Ebenezer Kinnersley, conceived his practice. Kinnersley was a Baptist preacher who rejected the enthusiasm of preachers like Gilbert Tennent and George Whitefield, and he railed against them for whipping up audiences into "Enthusiastical Raptures and Exstasies" in which they pretend "they have large Communications from God; to have seen ravishing Visions; to have been encompass'd, as it were, with Flames of lightning, and there to have beheld our Blessed Saviour nail'd to the Cross, and bleeding before their Eyes in particular for them."[22] Against such ravings, Kinnersley sought to wed piety to reason in the form of polite and educational electrical entertainments. If electricity was a wonder, it was a rational wonder, operating according to laws set forth by the God of Nature. But even so, the electrical demonstration hardly appealed to reason alone. Kinnersley's audiences were not invited simply to think about electricity like so many Franklins in their studies; they were asked to feel its effects. When a man came up from the crowd to kiss the young woman who was connected to an electrostatic generator, they both experienced the electrical fire as an unmediated bodily revelation. Experiment and enthusiasm, in other words, could at times be difficult to distinguish, as one might expect to be the case in a society where matters of science and religion crossed paths at every turn.[23] Kinnersley, after all, brought a preacher's devotion to his electrical pursuits; and even Franklin, a friend of Whitefield and Tennent and printer of their sermons, had been involved in the dissemination of the awakening.[24]

While the line separating scientific enlightenment from the enthusiasm of the revival could at times become ambiguous, everything still depended on maintaining it. Chamberlin's portrait may in this regard be understood as a kind of protective conductor, redirecting the enthusiastic response inspired by its lightning storm toward rational ends. Franklin, significantly, turns away from the storm. Instead of directing us toward the distant scene—as sitters often do

in portraits with emblematic features, like the portrait by Benjamin Wilson—Franklin's relationship to it is indirect, prosthetic. It is through his instruments, his art, that he draws down the lightning. Franklin himself is a solid, somewhat rotund presence. He sits upright in his chair, his posture echoing the stable verticality of the lightning rod out the window and contrasting with the toppling buildings in the distance. He is a singular, alert intelligence whose keen senses are attuned to his devices: the bells, which ring in defiant, rationalist answer to the common practice—one that Franklin critiqued—of ringing church bells to ward off God's anger in the lightning; and the two cork balls, suspended from one of the bells by silk threads, that repel each other as they become charged.[25] Franklin looks and he listens. His perceptions will, in turn, be harnessed by a powerful intellect that will transfer them through his pen to his paper. Lightning will become words on the page, a letter to his friend Peter Collinson: it was this series of letters that became the *Experiments and Observations on Electricity*.[26] A tight circuit thus runs from the lightning to the bells to the man to recorded observation. The portrait insists that through Franklin's instrumental rationality, nature is transformed into knowledge. If the explosions outside the window signify dispersion and chaos, electricity uncontained, then the prominent armrest of Franklin's chair, terminating in a decorative scroll, signifies the opposite: spiraling in on itself, the hand-carved scrollwork stands for the focused work of the writing hand that rests on it. In the scholar's study, nature is contained by human art.

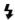

It would be a mistake, however, to overstate the painting's efficiency as a conductor, for Franklin's bells were not always so successful at redirecting the lightning. The bells were the terminating points of a wire that ran from the lightning rod, through the roof, and then divided at the well of the staircase outside the study. One night Franklin was awakened by "loud cracks on the staircase," and upon opening the door, he noticed that "the fire passed, sometimes in very large quick cracks from bell to bell, and sometimes in a continued dense, white stream, seemingly as large as my finger, whereby the whole staircase was enlightened as with sunshine, so that one might see to pick up a pin."[27] At other times the bells sounded loudly enough to be heard all over the house, prompting Franklin's wife, Deborah, to write to him in London and complain about the disturbing ringing.[28]

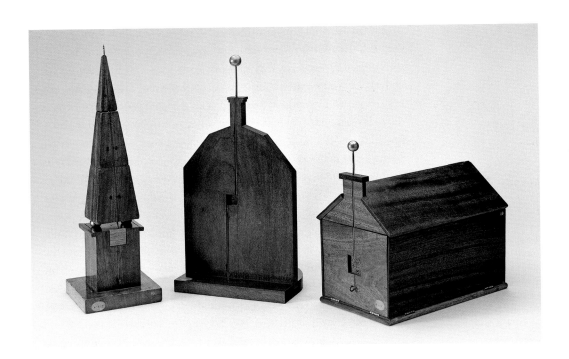

9
Thunder houses,
ca. 1765–1789.

Left to right, 16 ⅜ ×
4 ¾ × 4 ¾ in. (41.6 × 12 ×
12 cm), 15 ½ × 7 ½ ×
5 ⅞ in. (39.3 × 19 × 15 cm),
10 ½ × 6 ¼ × 10 ⅜ in.
(26.7 × 15.8 × 26.4 cm).
Collection of Historical
Scientific Instruments,
Harvard University,
Cambridge, Massachu-
setts, 0018, 0017, 0019.

Franklin's bells may have toned down the thunderstorm, but something of the storm remained in them, a reminder that eighteenth-century electrical experimentation sought to know the electrical fire not just as words on paper but as a felt force. What if, then, as interpreters of Chamberlin's portrait, we adopted a less unidirectional perspective, one that would likely be closer to Franklin's own? What if, instead of moving from the chaos outside into a subdued interior and coming to rest there, we turned back toward the storm? To do so would be to see the world outside the window as an amplified version of what happens within, the lightning as an exemplification of the kinds of marvels that both Franklin and Kinnersley sought to reproduce in their experiments even as they harnessed nature's power.

Indeed, the scene outside the window might just *be* another experiment. The buildings that are being destroyed by the lightning bolts recall a popular electrical demonstration of the period, staged by Kinnersley and many others, known as the "thunder house." [29] Figure 9 includes three eighteenth-century examples from the Harvard collection of scientific instruments: a tall jointed steeple (left), the profile of a house (center), and a church with a small steeple (right). If an electrician applied a spark to the conducting tip of the jointed steeple or house profile while interrupting the internal circuit that

runs from the tip to the ground, the model would collapse. In the case of the steeple, the top sections would fly off in a manner similar to the collapsing steeple in Chamberlin's painting. The thunder house with the small steeple was used in a somewhat more dramatic demonstration, illustrated on the title page to an eighteenth-century German instructional text on electricity (fig. 10). The conducting rod of this type of thunder house included a chain that could be attached to the rod in order to direct electricity away from the model, but if the chain was removed (as it is in the illustration), and if a spark was applied from a Leiden jar or electrostatic machine, the electricity would pass directly into the house and there ignite a packet of gunpowder, causing the walls of the house to blow apart like the house outside Franklin's window. As the German engraving makes clear in its inclusion of the parallel background case of an unprotected church that has burst into flame because of a lightning strike, the thunder house demonstrates the protective value of the lightning rod.

As this experimental model suggests, electricians were—like painters—consummate imitators of nature. They re-created lightning

10
Title page illustration to Dominikus Beck, *Kurzer Entwurf der Lehre von der Elektricität* (Short outline of the theory of electricity), 1787. Engraving, 2 ¼ × 2 ⅞ in. (5.6 × 7.3 cm). Library and Artifact Collections of the Bakken Museum, Minneapolis.

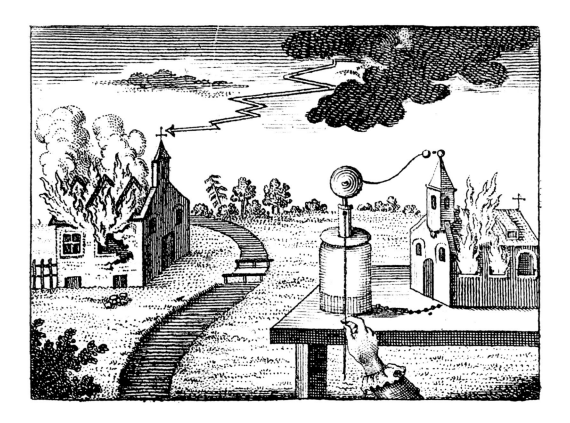

in controlled conditions in order to experience it on a smaller scale. Priestley wrote that the electricians of his day imitate "in miniature all the known effects of that tremendous power." [30] Franklin, for instance, describes an experiment in which he imitated a cloud by making a pasteboard tube ten feet long and a foot in diameter, charged and suspended by silk threads, and then drew electricity from it.[31] Priestley was certain that in conducting such experiments, electricians were "disarming the thunder of its power of doing mischief, and, without any apprehension of danger to themselves, drawing lightning from the clouds into a private room, and amusing themselves at their leisure, by performing with it all the experiments that are exhibited by electrical machines." [32] But in spite of this insistence that human art is capable of mastering the lightning, the line between the storm and its imitation was not always so clearly marked, for electricians often did apprehend danger to themselves during their experiments. Franklin notes that he drew a charge from his model cloud that was strong enough to make his knuckle ache.[33] Electricians regularly reported receiving powerful shocks in the line of duty, and in the most famous case of a thunder-storm intruding on the protected realm of experiment, the German electrician Georg Wilhelm Richmann was killed in 1753 when a bolt of lightning struck an ungrounded conductor in his laboratory.[34] The difficulty of determining whether the scene outside Franklin's window is nature or its imitation is therefore significant, because it puts into question a crucial distinction on which Priestley's disenchanting narrative depends.

Positioned between his experiment and the thunderstorm, turning toward his bells but prepared, it appears, to turn his attention back toward the window at any moment, Chamberlin's Franklin is more ambivalent than a Priestlian interpretation of the painting would allow. If he is Prometheus having stolen fire from the gods, he is also Hercules at the crossroads confronted with a choice between an experi-mentalism that resides comfortably within the study and one that reaches toward the inexplicable wonders of the thunderstorm. The challenge of deciding how we should read Chamberlin's portrait comes down to a question of how meaning flows through the world and the role of human art in discovering that meaning. Does it flow into the study, where thunder and lightning are explained by the laws revealed through the experiments of natural philosophers? Or does it flow out the window, toward a God whose mystery is always in excess of the human art that attempts to reveal it? If Chamberlin has captured Franklin at a decisive experimental moment, the papers in Franklin's

left hand nevertheless remain blank.[35] Firm conclusions are not yet to be drawn. We can only contemplate the choice the portrait offers.

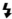

The question of whether the origins of the electrical fire are divine or natural is by no means restricted to Enlightenment natural philosophy. It is a pictorial question as well, a question of what a picture can adequately represent and what might lie beyond the capacities of human art. For the same reason human societies long attributed lightning to the gods, lightning has been a marker of the limits of representation. In his *Natural History* (first century CE), Pliny praised Apelles for painting "things that cannot be represented in pictures—thunder, lightning and thunderbolts."[36] In the sixteenth century, Pliny's comment provided Erasmus with language for praising the modern Apelles, Albrecht Dürer, whose art tests the limits of pictorial naturalism by depicting the undepictable: "fire; rays of light; thunderstorms; lightning; thunderbolts."[37] Kant later found a place for lightning and thunder within his aesthetics of the sublime, since the fear excited by "thunder clouds towering up into the heavens, bringing with them flashes of lightning and crashes of thunder," confronts us with our inability to take in the immensity of a nature that lies beyond the representational capacities of our senses.[38]

It is surely of interest, moreover, that one of the most heavily glossed art-historical texts of the early twentieth century, an essay concerned with the origins and limits of symbolic representation, turns on this problem of representing the lightning: Aby Warburg's (1866–1929) lecture delivered at Ludwig Binswanger's sanatorium at Kreuzlingen in 1923, a study of the snake as a lightning symbol in the Pueblo cultures of the southwestern United States. Warburg based his lecture on his observations during a trip he had taken to the American Southwest over thirty years earlier. The Hopi Snake Dance—a seasonal ritual which Warburg, in fact, never witnessed—is the lecture's centerpiece. Although Warburg, in his eagerness to find parallels to the pagan primitivism he detected within Renaissance art, appears to have misunderstood important aspects of the dance, the lecture nevertheless provides a compelling illustration of his mythic thinking about the origins of the symbol.[39] For Warburg, the Snake Dance demonstrated the achievement of a level of symbolic control over nature's processes. Through its mimetic magic, the Hopi dancers entered "into cultic exchange with the most dangerous beast, the live serpent," first through

an intimate struggle with nature as they held the snakes in their hands and mouths, and then by releasing the snakes back into nature, only now transformed. No longer a terror from the underworld holding man in fear, the serpent now became a symbol capable of returning as the lightning to produce rain. This symbol, Warburg found, still survived in the drawings of Hopi schoolchildren, some of whom, despite the impact of modern American schooling, continued to depict lightning as an arrow-tongued serpent.[40]

Warburg was seeking in the Hopi dances an antidote to a technological modernity initiated by Franklin. Franklin is mentioned only briefly in the closing paragraphs of the lecture, but he carries much symbolic weight for Warburg, who saw Franklin as the modern Prometheus who destroys the reflective distance so hard-won by primitive man. Believing he has conquered nature, technological man steals the lightning directly from nature without need of the symbol; instead, "the lightning serpent is diverted straight to the ground by a lightning conductor. Scientific explanation has disposed of mythological causation."[41] Warburg's Franklin is a version of the

11
Aby Warburg, *Uncle Sam*, 1895–1896. Photograph. The Warburg Institute Archive, London.

great disenchanter that Max Weber had portrayed twenty years earlier as the embodiment of the spirit of capitalism, the "bland deist" for whom the highest good is to make money, and whose utilitarianism has no room for reflection because it is preoccupied with the endless work of reducing everything in the world to its monetary end.[42] At the close of his slide lecture, Warburg offered his audience an image for this figure, a photograph he took in San Francisco of a man whom he calls "Uncle Sam in a stovepipe hat," the "gold-seeker" who has ousted primitive man and who hurries down the street while above his head runs the wire with which "he has wrested lightning from nature" (fig. 11).[43]

There is some irony in the fact that Warburg's lecture can help us see beyond his own caricatured image of Franklin. Warburg's notion of "a culture of symbolic connection," which he positioned between "a culture of touch" on the one hand, where man has not yet achieved freedom from the oppressive terrors of nature, and on the other hand "a culture of thought," which has so alienated itself from those terrors that it believes itself to be past them, is an apt description of the in-between world Chamberlin has conjured in his portrait of Franklin.[44] Seated between a chaotic nature and his electrical device, Franklin is no Uncle Sam. On the contrary, he occupies the liminal condition of Warburg's dancers: if Franklin is a disenchanter, he is nevertheless one who wrests the lightning from nature through an experimental mimicry that has not yet fully severed its magical links with the world beyond his window. There is still room for wonder in Franklin's study, and a final example of the electrician's art may help us see how a sober Presbyterian painter in eighteenth-century London put that wonder to work.

In his *Experiments and Observations*, Franklin describes an experiment, originally devised by Kinnersley, called "the magical picture." The electrician begins with "a metzotinto with a frame and glass, suppose of the King (God preserve him)." A mezzotint by John Smith (1652–1743), after Sir Godfrey Kneller's (1646–1723) portrait of King George II, is the kind of picture Franklin must have had in mind (fig. 12). Franklin then provides detailed instructions for cutting out the interior of the picture and then pasting the border and interior sections to opposite sides of the piece of glass, which has been gilt with foil (a conductor) on portions of both the front and back. Then a crown is made from foil and inserted into a slit in the print at the top of the king's head,

12
John Smith after Sir
Godfrey Kneller, *King
George II*, ca. 1727–1743.
Mezzotint, 13 ⅝ ×
9 ⅞ in. (34.5 × 25 cm).
Stanford University
Libraries, California.
Special Collections and
University Archives,
Leon Kolb collection
of portraits, 0516.

so the crown touches the unseen foil behind the picture. The end
result, which had the appearance of a typical framed mezzotint
when held in the electrician's hand, was now ready to be tested on a
member of the audience. "If now," writes Franklin, "the picture be
moderately electrified, and another person take hold of the frame with
one hand, so that his fingers touch its inside gilding, and with the other
hand endeavor to take off the crown, he will receive a terrible blow,
and fail in the attempt. . . . The operator, who holds the picture by
the upper end, where the inside of the frame is not gilt, to prevent its
falling, feels nothing of the shock, and may touch the face of the
picture without danger."[45]

The magical picture belongs to the myriad educational entertainments of the Enlightenment, from automata to magic lantern shows to trompe l'oeil painting, that taught lessons about discernment and deception. Earnest experimentalists and charlatans alike (it was not always easy to tell the difference), understanding that knowledge was a matter of experience, created illusions and dared their audiences to trust the evidence of their senses. Often the stakes in such entertainments were political, and indeed Wendy Bellion has shown that these pleasurable deceptions were vital to the creation of "citizen spectators" in the early American republic.[46] The magical picture, too, comes with a political lesson, in this case a lesson about loyal subjects of the king within the colonial Atlantic. While the performer, who does not touch the foil, pretends his immunity to electrical shock "is a test of his loyalty," the individual who removes the king's crown is punished for his seditious act. Franklin further writes that if the performance is carried out with a ring of persons to take the shock, it may be called "The Conspirators."[47]

The audience is entertained by the electrician's trick and enjoys its political lesson; but the real lesson, of course, is about the dangers of credulity. The magical picture plays on the (superstitious) belief in the animated picture, the fetish that has the capacity to answer back and punish the individual who offends it. It is the irrational primitive with his fetish who fails to see through its magic, and thus he endows a mere object with powers that any enlightened observer would realize it cannot possibly sustain.[48] The disenchanting electrician who performs the "magical picture" experiment would seem to be a version of Warburg's Uncle Sam. He teaches us that what looks like magic is really just electricity, a phenomenon that answers to man and not to the gods. While the audience member who removes the king's crown appears to be punished with a shock for his political act of desacralization, we know the true act of desacralization belongs to the electrician, who shows that the image never was magical in the first place.

But there's more to the performance of the magical picture than this dry, rationalist lesson. We know the picture is not magical, yet we still feel its invisible force in our bones when we receive its shock. The disavowal of the fetish is incomplete because its effects continue to be felt in the body even after the lesson is learned, and it is here, in the gap between knowledge and experience, that Franklin's experiment opens a space for reflection. Perhaps it even opens onto a theory of picturing, which would proceed as follows: in order to disenchant the picture we have to enchant it; *disenchantment comes through an*

opening onto an electrical potential that lies beyond the frame of representation. Or outside the window, as the case may be. All of this seems fully polite and rational, but still we catch a glimpse of what might lie beyond our understanding. And Franklin does go on to note that "if the picture were highly charged, the consequence might perhaps be as fatal as that of high-treason."[49]

When Franklin sent prints of Chamberlin's portrait to his friends in Boston, he hoped that "a long Visit in this Shape" would not be disagreeable to them. He seems to have sensed that Chamberlin's portrait carried something of his presence within it. Why else would he have ordered so many mezzotints? Franklin fetishized Chamberlin's portrait, just a bit. It is easy—too easy—to look at Chamberlin's portrait and dismiss its shock, its magic. Art history, a practice normally carried out within the comfort and quiet of the study, tends toward the containment of this shock, capturing the potential of pictures within disciplinary frameworks that allow us to turn our heads from the problem posed by the scene outside the window. But just beyond those frameworks, just behind Franklin's head, the lightning still prompts reflection—as it did for Apelles's admirers—about "things that cannot be represented in pictures." We can think of Chamberlin's portrait as a kind of "magical picture." It is its capacity to shock— a capacity contained and framed, yes, but still full of electrical potential and capable of opening, temporarily at least, to an experience beyond the frame—that creates the very conditions of possibility for this painterly demonstration of Benjamin Franklin's Promethean art.

This article has benefited much from the questions and comments of audiences at the Center for Advanced Study in the Visual Arts and at Harvard's Department of History of Art and Architecture. Special thanks to Matthew Hunter, Jennifer Marshall, and Jennifer Roberts for their insights.

1 Charles Brockden describes the event in a letter to Thomas Noble of July 21, 1745. See Milton J. Coalter Jr., *Gilbert Tennent, Son of Thunder: A Case Study of Continental Pietism's Impact on the First Great Awakening in the Middle Colonies* (New York: Greenwood Press, 1986), 125–26.

2 Ibid., 126.

3 Gilbert Tennent, *All Things Come Alike to All: A Sermon, On Eccles. IX. 1, 2 and 3 Verses. Occasioned by a Person's Being Struck by the Lightning and Thunder* (Philadelphia: printed by William Bradford, 1745), 40.

4 Benjamin Franklin, *New Experiments and Observations on Electricity* (London: D. Henry and R. Cave, 1754), 112.

5 The phrase appears in Kant's essay from 1756: "Continued observations on the earthquakes that have been experienced for some time," trans. Olaf Reinhardt, in *The Cambridge Edition of the Works of Immanuel Kant: Natural Science*, ed. Eric Watkins (Cambridge: Cambridge University Press, 2012), 373. It should be noted that Kant's praise for Franklin is decidedly ambivalent (even though the literature on Franklin never notes this fact, despite the frequency with which the phrase is quoted). The full passage is monitory: in Kant's view, Promethean endeavors such as Franklin's ultimately lead man "to the humbling reminder, which is where he ought properly to start, that he is never anything more than a human being" (ibid.).

6 See Mary D. Sheriff, "'Au Génie de Franklin': An Allegory by J.-H. Fragonard," *Proceedings of the American Philosophical Society* 127, 3 (June 16, 1983): 180–93. There is a third portrait made during Franklin's lifetime that directly associates him with the lightning. Painted by Charles Willson Peale (1741–1827) in 1789 and in the collection of the Philadelphia History Museum, the portrait shows an older Franklin who is seated, holding a lightning rod, with a bolt of lightning out the window. On the portraiture of Franklin, see also Brandon Frame Fortune and Deborah J. Warner, *Franklin & His Friends: Portraying the Man of Science in Eighteenth-Century America* (Washington, DC: Smithsonian National Portrait Gallery, 1999); Deborah Jean Warner, "Portrait Prints of Men of Science in Eighteenth-Century America," *Imprint* 25, 1 (Spring 2000): 26–33; Wayne Craven, "The American and British Portraits of Benjamin Franklin," in *Reappraising Benjamin Franklin: A Bicentennial Perspective*, ed. J. A. Leo Lemay (Newark: University of Delaware Press, 1993), 247–71; Richard Dorment, *British Painting in the Philadelphia Museum of Art: From the Seventeenth through the Nineteenth Century* (Philadelphia: Philadelphia Museum of Art, 1986), 38–44; and Charles Coleman Sellers, *Benjamin Franklin in Portraiture* (New Haven, CT: Yale University Press, 1962).

7 William T. Whitley, *Artists and Their Friends in England, 1700–1799* (London: The Medici Society, 1928), 375. The key sources on Chamberlin's life are ibid., 83–84; and Edward Edwards, *Anecdotes of Painters Who Have Resided or Been Born in England* (London: Leigh and Sotheby, et al., 1808), 121–22.

8 According to Debora Jean Warner, William Franklin ordered another hundred copies a few years later. On the circulation of the print, see Warner, "Portrait Prints of Men of Science," 27–28; and Fortune and Warner, *Franklin & His Friends*, 77.

9 Benjamin Franklin to Jonathan Williams, Feb. 24, 1764, in *The Papers of Benjamin Franklin*, vol. 11, ed. Leonard W. Labaree (New Haven, CT: Yale University Press, 1967), 89.

10 James Delbourgo, *A Most Amazing Scene of Wonders: Electricity and Enlightenment in Early America* (Cambridge, MA: Harvard University Press, 2006), 16.

11 "Notice is hereby given to the Curious," *New York Gazette*, June 1, 1752.

12 Mircea Eliade, *Patterns in Comparative Religion* (New York: Sheed & Ward, 1958), 38.

13 Lucretius, *The Nature of Things*, trans. A. E. Stallings (London: Penguin Books, 2007), 187.

14 Psalm 77:17, in *The Bible: Authorized King James Version*, ed. Robert Carroll and Stephen Pricket (Oxford: Oxford University Press, 1997), 681. See also Psalms 18:14 and 144:6 and Zechariah 9:14. For a medieval example of this iconography, see the

thirteenth-century Bible Moralisée in the Bodleian Library, MS. Bodl. 270b, fol. 132r; in one of the illustrated roundels on this page, God sends down lightning in the form of arrowheads onto the Saracens.

15 See the recent critical edition: Julius Wilhelm Zincgref, *Emblematum ethico-politica*, 2 vols., ed. Dieter Mertens and Theodor Verweyen (Tübingen: M. Niemeyer, 1993).

16 See Robert Blair St. George, *Conversing by Signs: Poetics of Implication in Colonial New England Culture* (Chapel Hill: University of North Carolina Press, 1998), 181–83; and David D. Hall, *Worlds of Wonder, Days of Judgment: Popular Religious Belief in Early New England* (New York: Alfred A. Knopf, 1989).

17 Cotton Mather, *The Christian Philosopher*, ed. Winton U. Solberg (Urbana: University of Illinois Press, 1994), 72. See also James Campbell, *Recovering Benjamin Franklin: An Exploration of a Life of Science and Service* (Peru, IL: Carus, 1999), 64.

18 John Adams, quoted in I. Bernard Cohen, *Benjamin Franklin's Science* (Cambridge, MA: Harvard University Press, 1990), 153. On debates about conductors, see ibid., 118–58; and Delbourgo, *A Most Amazing Scene of Wonders*, 50–86.

19 On the significance of Priestley's publication for the historiography of electricity, see Simon Schaffer, "The Consuming Flame: Electrical Showmen and Tory Mystics in the World of Goods," in *Consumption and the World of Goods*, ed. John Brewer and Roy Porter (London: Routledge, 1993), 512–15.

20 See ibid.

21 On Freke's enthusiasm, see ibid., 502–4. On the history of enthusiasm generally in early modern Europe, see Michael Heyd, *"Be Sober and Reasonable": The Critique of Enthusiasm in the Seventeenth and Early Eighteenth Centuries* (New York: E. J. Brill, 1995).

22 Ebenezer Kinnersley, *Pennsylvania Gazette*, July 24, 1740, as quoted in Thomas S. Kidd, *The Great Awakening: The Roots of Evangelical Christianity in Colonial America* (New Haven, CT: Yale University Press, 2007), 66.

23 On the *Venus Electrificata*, or electric kiss, see Delbourgo, *A Most Amazing Scene of Wonders*,

115–19. It is important to note that experimentalists could themselves be charged with enthusiasm: see Heyd, *"Be Sober and Reasonable,"* 144–64.

24 Franklin was the publisher of Whitefield's sermons and journals; he also published Tennent's most famous sermon, *The Danger of an Unconverted Ministry* (1740). On the friendship and collaboration between Franklin and Whitefield, see Frank Lambert, "Subscribing for Profits and Piety: The Friendship of Benjamin Franklin and George Whitefield," *William and Mary Quarterly* 50, 3 (July 1993): 529–54.

25 On the ringing of church bells, see Cohen, *Benjamin Franklin's Science*, 119–25. The bells in Franklin's study were caused to ring by a small brass ball suspended between them, which vibrated when electrified (ibid., 89). The ball is just visible in the Chamberlin portrait and slightly more so in the mezzotint.

26 The experiment with the bells and cork balls is mentioned in the letter of April 18, 1754, in Franklin, *New Experiments and Observations* (1754), 128–29.

27 Franklin, quoted in Cohen, *Benjamin Franklin's Science*, 90. See also Delbourgo, *A Most Amazing Scene of Wonders*, 60.

28 J. A. Leo Lemay, *Life of Benjamin Franklin*, vol. 3, *Soldier, Scientist, and Politician, 1748–1757* (Philadelphia: University of Pennsylvania Press, 2009), 129; and Joyce E. Chaplin, *The First Scientific American: Benjamin Franklin and the Pursuit of Genius* (New York: Basic Books, 2006), 138.

29 Fortune and Warner, *Franklin & His Friends*, 74.

30 Joseph Priestley, *History and Present State of Electricity*, 1775, as quoted in Simon Schaffer, "Natural Philosophy and Public Spectacle in the Eighteenth Century," *History of Science* 21 (1983): 8.

31 Benjamin Franklin, *Experiments and Observations on Electricity* (London: E. Cave, 1751), 59–62.

32 Priestley, quoted in Schaffer, "Natural Philosophy and Public Spectacle," 8.

33 Franklin, *Experiments and Observations* (1751), 60.

34 See Delbourgo, *A Most Amazing Scene of Wonders*, 14–15, 60.

35 This is true of the original painting, although Fisher's mezzotint does show Franklin's writing on the sheet.

36 Pliny, *Natural History*, vol. 9, trans. H. Rackham (Cambridge, MA: Harvard University Press, 1952), 333.

37 Erwin Panofsky, "Erasmus and the Visual Arts," *Journal of the Warburg and Courtauld Institutes* 32 (1969): 225.

38 Immanuel Kant, *Critique of the Power of Judgment*, ed. Paul Guyer, trans. Paul Guyer and Eric Matthews (Cambridge: Cambridge University Press, 2000), 144.

39 On Warburg's misinterpretation of the Hopi dances, see David Freedberg, "Warburg's Mask: A Study in Idolatry," in *Anthropologies of Art*, ed. Mariet Westerman (Williamstown, MA: Clark Institute, 2005), 3–25. On Warburg's mythic thought, see Joseph Mali, *Mythistory: The Making of a Modern Historiography* (Chicago: University of Chicago Press), 133–86.

40 Aby M. Warburg, *Images from the Region of the Pueblo Indians of North America*, trans. Michael P. Steinberg (Ithaca, NY: Cornell University Press, 1995), 51.

41 Ibid., 50. Warburg mentions Franklin in the company of the Wright brothers, "the modern Icarus" (54).

42 Max Weber, *The Protestant Ethic and the Spirit of Capitalism*, trans. Stephen Kalberg (Los Angeles: Roxbury, 2002), 14–18.

43 Warburg, *Images from the Region of the Pueblo Indians*, 53.

44 Ibid., 17.

45 Franklin, *Experiments and Observations* (1751), 27.

46 Wendy Bellion, *Citizen Spectator: Art, Illusion, and Visual Perception in Early National America* (Chapel Hill: University of North Carolina Press, 2011). Also see Delbourgo, *A Most Amazing Scene of Wonders*, 129–64; and Barbara Marie Stafford, *Artful Science: Enlightenment Entertainment and the Eclipse of Visual Education* (Cambridge: MIT Press, 1996).

47 Franklin, *Experiments and Observations* (1751), 28.

48 On the Enlightenment fetish, see William Pietz, "The Problem of the Fetish, IIIa: Bosman's Guinea and the Enlightenment Theory of Fetishism," *RES: Anthropology and Aesthetics* 16 (Autumn 1988): 105–24; and W. J. T. Mitchell, *What Do Pictures Want? The Lives and Loves of Images* (Chicago: University of Chicago Press, 2005), 145–68, 188–96.

49 Franklin, *Experiments and Observations* (1751), 28.

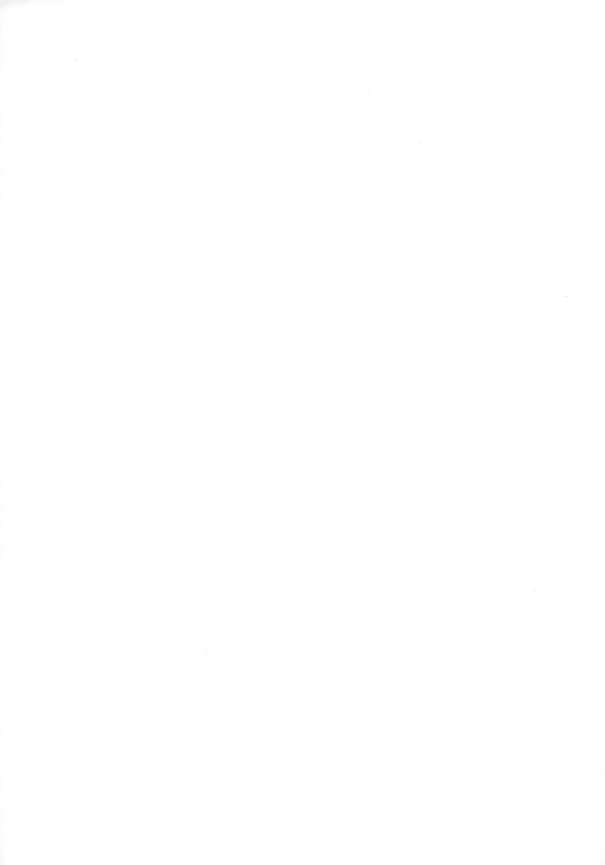

CONJURING
INFO

Elizabeth W. Hutchinson

Conjuring in Fog: *Eadweard Muybridge at Point Reyes*

In 1871, Eadweard Muybridge (1830–1904) traveled on the steamship *Shubrick* from San Francisco to the headlands of Point Reyes, some thirty-four miles north. With a small party, he landed on the beach at Drake's Bay, so called because this inlet is supposed to be the stopping place of the British navigator during his Pacific voyage of 1579, and made his way to the top of the cliff to create a portrait of the lighthouse which had recently been erected there (fig. 1).

This picture has been praised as a masterpiece of romantic reverie. Several qualities of the image are essential to this interpretation, including the positioning of the figures so that they do not interact with one another but gaze down at the crashing surf, and the fact that the horizon dissolves into an inchoate, misty abyss whose depth and distance are impossible to fathom. It is Muybridge's ability to inspire this kind of metaphysical association that has caused his work to be identified within the immense archive of nineteenth-century landscape photographs as works of art. While he is perhaps best known for his motion studies, Muybridge is also a celebrated recorder of the western landscape. His 1868 and 1872 images of Yosemite, produced using large glass negatives called "mammoth plates" carried into the park on mules and sensitized and exposed in the field, have been praised as unsurpassed masterpieces (fig. 2).[1]

Muybridge is generally known as a photographer who is able to make the unseen seen, especially in the motion studies he began

1
Eadweard Muybridge, *First Order Light-House at Punta de los Reyes*, 1871. Albumen print from plate glass negative, 7 × 9 in. (17.78 × 22.86 cm). United States Coast Guard Historian's Office, Washington, DC.

114

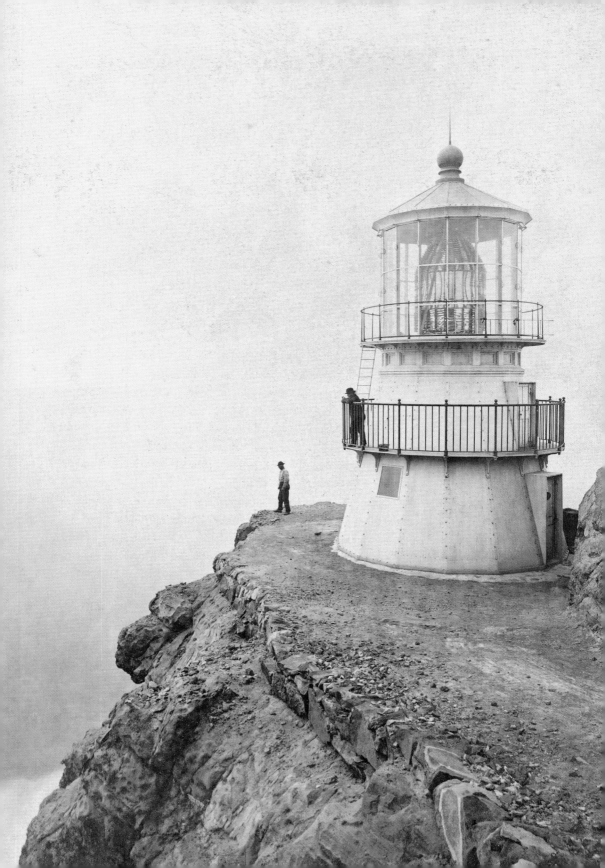

producing in the early 1870s and continued making at the University of Pennsylvania in the 1880s.[2] Indeed, he may be as famous for inventing the technological means of capturing individual moments of human and animal locomotion—batteries of cameras whose shutters were triggered by trip lines—as for the images themselves. But in the lighthouse pictures, what is notable is the unavailability of detail, particularly in the skies and seas that make up the backgrounds of the compositions.

Point Reyes is the westernmost spot on the West Coast of the continental United States, visible on a clear day from fifty miles offshore, and thus a significant landmark for those traveling by sea, as many still did at the time of Muybridge's exposures. This prominence is hardly obvious from his views of the building, however. For while it is clear from the composition that the light stands on, indeed takes up most of, a point jutting out over the sea, the background offers only a hint of sea and sky, with no horizon line to separate them. Indeed, the frothy water down below has the same tone and texture as the billowy clouds, reminding the viewer that both are composed of the same material elements.

While lacking a pleasing depiction of recessional space, the view is not without visual interest. Stymied in an attempt to penetrate the scene further, the viewer is prompted to look down, study the details of the rocky cliff in the foreground, and notice how the massive rocks below give way to a more sculpted and controlled plane of a road edged by cut boulders at the top. The rock in the right foreground with its white ring facing directly out catches our attention, especially as the rock just behind it seems to be another piece cut from the same boulder. One might see this as an articulation of the mastery of man over nature, a minor version of the achievement better represented by the lighthouse itself that is the focus of the composition.

Tiered like the cliff, the lighthouse looks solid and stable. We can see the rivets holding the exterior together, and the door facing the cliff is further protected from the elements by a protruding metal doorframe. The railing on the balcony comes up to the armpits of the man standing there, again offering a reassuring sense of security, and the light itself is secure within a double enclosure—exterior rail and interior casing of windows, covered with a slanting roof whose top is the only touch of whimsy in the scene. The light, as we can see, is massive, much taller than a human figure. The composition shows the bulb unobstructed in all directions, reminding us of the power of the light, a first-order Fresnel lens, whose compact form achieves

2
Eadweard Muybridge, *Falls of the Yosemite*, 1872. Albumen print from plate glass negative, 21 ¼ × 16 ¾ in. (54.0 × 42.5 cm). Yale University Art Gallery, New Haven, Connecticut. Gift of Harrison H. Augur, B.A. 1964, 1980.27.3.

Elizabeth W. Hutchinson

Conjuring in Fog

projection power by incorporating rings of prisms on each domed surface to capture and reflect more light from the internal source than the bulkier lenses which preceded it.[3]

In his 1873 catalog of photographic views, Muybridge lists thirteen whole-plate (seven-by-nine-inch) views of Pacific coast lighthouses and seventy-two stereoscopic views of the same subject. In both groups, the Point Reyes light is prominently featured; it comes first in the catalog listing, and while there is only one large print of each venue, no fewer than fourteen of the stereos depict this site. This is more than any other lighthouse included in the group. When examined as a whole, these images share many qualities with the photograph with which I began. In particular, most show the lighthouse or the point from close range in compositions that lack a background or horizon line, in many cases dedicating a significant portion of the composition to a milky, impenetrable sky, as, for example, in the view from the lighthouse looking south (fig. 3). Under the right conditions, this point of view might have revealed a glimpse of the Farallon Islands or a whale breaching in the gulf, but this photograph is impenetrable; the eye catches on the rough cliff face in the immediate foreground whose consistent texture gives no clear sense of the scale or distance of each crag. Presenting a drop-off immediately inside the bottom frame, the picture offers viewers no purchase on the view, undermining the sense of mastery offered by other western landscape photographs of the period such as the images made by Timothy O'Sullivan (1840–1882) for the United States Geological Survey.[4]

3
Eadweard Muybridge, *Point Reyes, from Light-House Looking South*, 1871. Stereographic albumen print from plate glass negative, 3 × 3 in. (7.62 × 7.62 cm) (each exposure). Bancroft Library, University of California, Berkeley, BANC PIC 1971.055: 834-STER.

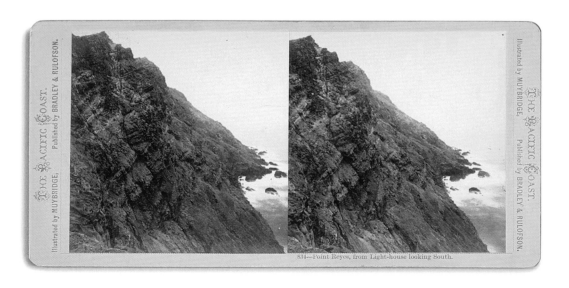

834—Point Reyes, from Light-house looking South.

Elizabeth W. Hutchinson

4

Caspar David Friedrich, *Der Wanderer über dem Nebelmeer* (Wanderer above the sea of fog), 1818. Oil on canvas, 37 × 29 in. (94.8 × 74.8 cm). Hamburger Kunsthalle, Hamburg. On permanent loan from the Foundation for the Promotion of the Hamburg Art Collections.

Does this lack of the vanishing point essential to picturesque landscape representation signal aesthetic failure? Muybridge scholars have folded the potentially aberrant lighthouse photographs back into the artist's oeuvre by linking them to the same kind of aesthetic experience of nature that has been found in Caspar David Friedrich's (1774–1840) haunting depictions of lone observers contemplating the sublime vastness of the North Sea, such as the 1818 *Wanderer above the Sea of Fog* (fig. 4). For example, Philip Brookman writes of *Point Reyes, from Light-House Looking South* (1871), "[Muybridge] brings forth at once both the moment fixed in the photograph and the eternal nature of time. . . .The structure's symbolic relationship to the natural world—the light is a warning signal to sailors about a physical danger they do not see—is transcended by the vastness of the ocean. The sailor's journey is one, like that of Odysseus, with no ground on which to stand, no horizon, and no safe harbor in site."[5] In this interpretation, the figures positioned in the composition take on the role of the Romantic *Rückenfigur* marveling at nature. This Romanticism is similarly evoked by Muybridge biographer Rebecca Solnit, who describes "his pleasure in observing natural phenomena for their own sake . . . [as] evidence of his persistent passion for the mutable, the fleeting, and the unstable" enabling the abstract conception of time as an unending series of moments.[6]

The problem with this interpretation is that Muybridge's figures are not "above the fog" like Friedrich's heroic wanderer but are stuck within it, a fact that is reinforced when looking at his other depictions of Point Reyes. Whether he looks north, south, down at the water, or out to sea, there is no getting "above the fog," and this Odysseus-like predicament was, for Muybridge's patrons, the United States Coast Survey, far from allegorical. Point Reyes is the second foggiest place in North America, and the difficulty of seeing in this region is testified to by the numerous carcasses of ships that came to lie on the seafloor surrounding it, twenty-one in the three decades preceding the illumination of the Point Reyes light.[7] The *San Francisco Chronicle* described the waters of the region as "a land of wrecks," and one letter to the Lighthouse Board listed the total costs incurred there in the 1860s alone (the damage or loss of seven vessels) as $756,827.[8] As one book offering navigational advice noted: "Sailing vessels from the northern coast are sometimes two and even three weeks without observations on account of the density of the fogs."[9]

From this perspective, it might be said that the fog in Muybridge's pictures is less about metaphor than it is about materiality—offering

a record of the geographical and climatic conditions of the Pacific coast and the instruments used by Muybridge and his employers to engage this environment in a way that met their own needs. Significantly, we might also think of the fragments of silver fixed to the surface of an albumen-coated piece of paper that present the *image* of fog to us as material. And we might further recall that making a photograph in foggy conditions unsettled the photographer's confidence in the operation of his tools. As a result, I would argue that these photographs do not demonstrate mastery over that environment but, rather, document a struggle and negotiation between human and nonhuman forces in the environment. In yielding information about this engagement, they offer an opportunity to gain a deeper understanding of the material practice of photography even as they unsettle complacent narratives about the ease with which nature can be pictorially claimed and controlled by human beings. As my investigation of the Pacific coast environment and period writings about its significance will demonstrate, Muybridge's photographs document what political theorist Jane Bennett would later call "the negative power or recalcitrance of things." The best interpretation of this body of work requires moving beyond an exclusive focus on the image maker and his or her human patrons, critics, and collaborators to an understanding of how each interacts with the natural world and vice versa.[10]

By considering the landscape to be a potentially interfering factor in the making of images of the American West, I want to complicate an older argument, which has asserted that a visual representation of space as already known and owned was sufficient to control geographic territory, advanced in the work of scholars such as Albert Boime, Alan Trachtenberg, Nancy Anderson, and W. J. T. Mitchell.[11] These scholars have made a vital contribution by identifying the key role played by aesthetic landscape representation in the conceptual work of westward expansion, but their reliance on a notion of conquest through image making belies the fraught and often failing negotiations with nature that were frequently involved in the work of expansion. Focusing on an example that challenges the confidence in Manifest Destiny expressed by the painters and photographers they discuss, my work serves to undermine our sense of the inevitability of American settler colonialism.[12]

As I will argue, Muybridge's work at Point Reyes is very revealing about the specific challenges involved in depicting the Pacific coast for American sailors in the second half of the nineteenth century. In meeting these challenges, Muybridge engaged the visual culture of navigation that had emerged from earlier attempts to envision the

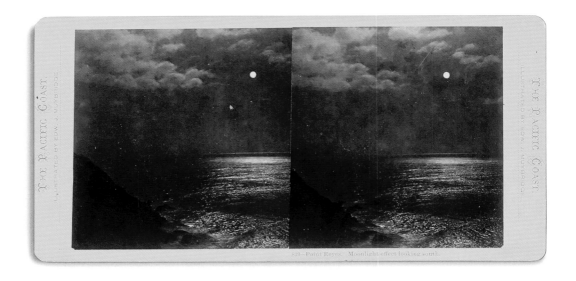

unfamiliar, but the resulting work may best be understood as a sign of negotiation, not mastery. I will show that Muybridge's visual strategies not only reveal his own culture's insecurity about how meaningfully to frame the Pacific, but they also open up opportunities for a careful viewer to see that this coastal landscape was not nearly as alien to members of other cultural groups.

From the moment of its origins, photography has been celebrated as an artifact made simultaneously by man and nature. While we have moved on from William Henry Fox Talbot's notion that photographs are drawn by the "pencil of nature," we still cling to photography's indexicality—Peirce's term denoting the physical relationship between that which is photographed and the resulting image—as its defining quality. This line of thought has produced extraordinary photo criticism, particularly in Roland Barthes's work on how photographic meaning is produced both through what is self-consciously put into a picture by the photographer and by the "punctums" that may occur because of details in the scene outside of the image maker's control or even consciousness.[13]

As long as there has been photography there have also been interferences in the direct communication between object and image that this kind of analysis implies. In our digital age when retouching the celebrity image is frankly expected, we are most sensitive to those

interferences which are intentionally placed there, such as the widespread phenomenon of spirit photography in the nineteenth century or other early forms of photocollage. Muybridge was certainly alert to the potential of retouching; he frequently created composite prints that borrowed information from two different negatives, as in his presentation of a moonlight effect at Point Reyes in an image that was undoubtedly taken on the same foggy day as the other Point Reyes photographs already discussed (fig. 5). By 1871, Muybridge was an experienced and persistent camera operator. He even developed new tools keyed to the challenges he faced. For example, in 1869, he patented what he called a sky shade, a device that could be attached to the frame of a camera to limit the exposure of a portion of the negative by casting the top part of the lens in shadow, solving a persistent problem facing landscape photographers: the fact that the blue light of the sky was exposed more quickly than the rest of the negative, resulting in pictures that showed no atmospheric details.

At the same time, it would be wrong to suggest Muybridge or anyone else exercised complete control over the photographic process at this time. Elsewhere, I have discussed another kind of intervention which occurred because damage to the negative created marks in a finished photographic print that were unconnected to the scene in which the photograph was made.[14] The fingerprint in the late print of this Carleton Watkins (1829–1916) photograph (fig. 6) is not the result of self-conscious manipulation but, rather, a reminder of the usually unmarked material processes that occur between the moment of exposure and the finished print encountered by the viewer of a so-called straight photograph.

These processes occurred both in the camera and in the darkroom. When one considers the steps Muybridge undertook to create his Point Reyes images, it is easy to see that there were many opportunities for such things to happen. Muybridge traveled to Point Reyes on a ship moving through uncertain seas and landed at a beach from which his equipment would have been lifted by rope to the top of the peninsula. At any point in this process, his wooden box camera could have been jostled in such a way to create a slight crack at a joint that would allow light to leak in, a glass plate for a negative could have cracked, chemicals could have spilled. Once he had set up a shot, he prepared and exposed a negative and then packed everything up for the precarious trip back to his darkroom.

Avoiding damage to equipment was only one obstacle in Muybridge's way in making these pictures. The photographer also

113. Section of the "Grizzly Giant," 33 feet diameter, Mariposa Grove, Cal. | Photo, San Francisco.

grappled with atmospheric conditions that influenced the effectiveness of the chemical operations involved in making his exposures. Marcus Aurelius Root (1808–1888), a noted photographer and writer based in Philadelphia, wrote about the necessity for photographers to understand the impact weather had on their practices in the field and darkroom: "Changes of weather affect the action of the sunbeam upon the chemical coating which receives the impression, and accelerate or retard the development of such impressions," and he tells of a colleague whose work was impeded during damp weather so much that he was, to quote Root, "(technically speaking) 'lost in the fog.'" [15] Root notes that the presence of some "fleecy clouds and vaporous haze" is beneficial because of its ability to dilute the bright-blue light of a clear sky. The underlying lesson is that the photographer needs to understand atmospheric conditions, such as humidity and what Root calls "electricity," and work with them in order to produce the desired result. Root's words remind us that Muybridge would have had to adjust the chemistry used to coat his negatives and assess the modifications needed in his shooting practice to give the fog which surrounds Point Reyes the pictorial form he desired.

My discussion so far has focused on confronting fog as an atmospheric condition. But in the history of photography, the term also refers to a cloudy passage in the visual field that does *not* index the weather. Photographic fog is defined as a coating that appears on a negative obscuring the recorded image. As M. Carey Lea (1823–1897), whose writings Muybridge followed in the professional journal the *Philadelphia Photographer*, notes, "Fogging is a trouble that affects different operators very variously; some are very frequently, others almost never affected by it. The learner may expect to be frequently troubled; the experienced operator will have learned how to avoid it, except, perhaps, when he works under unusual conditions, or with chemicals different from those which he habitually employs." [16]

Fogging took many forms, ranging from a negative that was completely blank, or one in which an image disappeared over the course of developing, to negatives that when developed had only a narrow tonal range. In addition, fogging could occur in isolated parts of an image. Lea diagnosed three potential sources of photographic fog: issues with the camera, in particular a camera that leaked light onto the unexposed negative; issues with the chemistry of the emulsion or the developing baths, ranging from old or inactive materials to mistakes in preparing solutions; and problems with "the atmosphere of the dark room," which could stem from the presence of fumes or dampness. [17]

6
Carleton Watkins,
Section of the Grizzly Giant with Galen Clark, Mariposa Grove, Yosemite, 1865–1866, printed ca. 1876. Albumen print from plate glass negative, 20 9/16 × 16 in. (52.23 × 40.64 cm). Metropolitan Museum of Art, New York. The Elisha Whittelsey Collection, The Elisha Whittelsey Fund, 1972, 1972.643.3.

Chemical fogging can be quite obvious. But in some of Muybridge's Point Reyes images, it is difficult to determine what kind of fog we are seeing (fig. 7). While the veil across the expansive background of a distant view of the lighthouse seems to be a record of vapor *seen*, the relative lack of tonal range and clear focus in the rocks in the foreground seem to signal what Lea would call an "operational failure." This becomes clearer when showing the image next to the close-up of the lighthouse, in which both the details of the foreground and the richness of color are more dramatic (see fig. 1). Interestingly, both prints are darker in the lower-left corner than in other portions of the image, which may record a distinctive aspect of Muybridge's handling of the plates or reflect the inability of his lens to expose his negatives evenly. What we see in this corner of the view is something not visible to Muybridge at the site—fog or another kind of "failure" that indexes not Point Reyes but the materials from and through which such an image is produced. This kind of fog might be an artifact of the other kind—a disruption of the image caused by the humidity in the air at Point Reyes—or bring into our consciousness another environment altogether, perhaps the inside of Muybridge's camera or the darkened room on Montgomery Street in San Francisco where the glass plate from which the pictures were made sat in a bath.

The ability to respond to material challenges was presented by Root and Lea as part of the photographer's job, a construction that sees picture making as the act of a human in control of his tools and surroundings. But given the frequent occurrence of failure, it could be more effective to think about a photograph as the product of what has been called "distributed agency."[18] Robin Kelsey has argued that photographs can be seen as "vitally address[ing] . . . the material conditions of [their] production."[19] Building on (and departing from) Rosalind Krauss's earlier writings on nineteenth-century photography, Kelsey reminds us that the cameramen of Muybridge's generation approached their work with a keen sense of the specific task at hand as well their own pictorial ambitions. For Timothy O'Sullivan, for example, the conditions of his work were structured by the record-making and propagandistic needs of the Wheeler Survey in the American Southwest. Kelsey takes into account not only the research done by the surveyors but also the material mode of conveying that research in illustrated reports as structuring conditions for O'Sullivan's work. Such things are also important to take into consideration in coming to terms with Muybridge's photographs for the US government.

Elizabeth W. Hutchinson

7
Eadweard Muybridge,
*First Order Light-House
at Punta de los Reyes*,
1871. Albumen print
from plate glass negative,
7 × 9 in. (17.78 × 22.86 cm).
United States Coast
Guard Historian's Office,
Washington, DC.

However, I would argue that the environment in which the images were made can also be seen as a contributor to the photographs.

But first, what was the task, broadly speaking, that Muybridge was executing in making these pictures? The records of Muybridge's commission to make these photographs are incomplete. The Light-house Board files in Washington, DC, include a letter from Muybridge to Colonel R. S. Williamson negotiating fees for the task of making

pictures of new lighthouses when they are completed.[20] According to Muybridge scholar Gordon Hendricks, some of the earlier lighthouses had been documented by a different firm that no longer wanted the job.[21] Muybridge asked for a daily fee of twenty dollars for time and expenses and in return offered to send two prints of each light and additional views when requested, with multiple prints furnished for an additional cost. The board saved money by asking Muybridge to accompany the tender ship *Shubrick* on its annual trip to supply and maintain the Pacific coast lighthouses. Muybridge undertook the commission in January of 1871, when nineteen of the projected twenty-one lights had been completed and lit. The images from Point Reyes were submitted to Washington in early May of that year.[22]

As this timing indicates, these photographs were not made as a means of facilitating the siting or construction of the lighthouses but as evidence of their completion. As such, it would be wrong to think of them as "scientific" pictures. Indeed, as Robin Kelsey and Jennifer Tucker have pointed out, the tendency of later scholars to interpret pictures made under the auspices of nineteenth-century scientific endeavors as contributing to that scientific research is generally inaccurate. For example, the photographers on the United States Geological Survey projects were generating promotional materials and documents of work accomplished, not providing evidence to support a geological claim.[23] Muybridge's pictures served a similar promotional purpose at least once. In March 1874, the Lighthouse Board supplied images (and presumably information) for an article promoting American lighthouses published in *Harpers New Monthly Magazine*. Author Charles Nordhoff praises the board for making the American lighthouse service "at the head of all for its excellence of different devices for relieving navigation risks."[24] Nordhoff goes on to explain the particular challenges offered by the Pacific coast environment and to champion the board's ability to respond to these challenges by making different choices about building design in different locales. Illustrations of thirteen different lighthouses and buoys demonstrate this variety and an engraved copy of Muybridge's Point Reyes photo appears among them. The fact that the United States Coast Guard historical collection has exhibition prints of many of Muybridge's photos, mounted on heavy stock with printed titles that identify the view but not the photographer (see fig. 7), suggests that these images circulated, perhaps for other illustrations or for inclusion in an exhibition of the board's work.[25] The modern Coast Guard absorbed the lighthouse service in 1939.

Elizabeth W. Hutchinson

Muybridge claimed that "the careful execution and surpassing excellence of his work has occasioned his being employed during several years by the U.S. government in the production of the numerous views upon this Coast, required by the Treasury and War Departments."[26] However, it is likely that Muybridge's relationship to the government was convenient and informal, based not only on the quality of his work, but also on his availability and location close to the work. The logistics of the assignment were coordinated by George Davidson, who was director of United States Coast Survey activities in the Pacific. The Coast Survey worked closely with the Lighthouse Board, sharing many key staff members. For example, when Congress created the Lighthouse Board in 1852 as a division of the Department of the Treasury responsible for constructing and maintaining lighthouses and other navigational aids, the group included Alexander Dallas Bache, who was the superintendent of the US Coast Survey.

This agency was created in 1807 to enhance American navigation and naval defense by producing a consistent and systematic study of coastal waters using the latest scientific methods. Science in the service of commerce was considered an appropriate federal investment in the Early Republic, when there were misgivings about the appropriate extent of governmental patronage. Because of this, the Coast Survey (and, to a lesser extent, its military complement and sometime rival, the Army Topographical Engineers) attracted some of the best scientific minds of the time. Especially under Bache, great-grandson of Benjamin Franklin and founder of the American Academy of Sciences, the Coast Survey became the organization taking on the most complex and ambitious work on the continent, with many figures going on from the agency to found science departments at major universities. Davidson had been a student of Bache's when the latter taught at Philadelphia's rigorous Central High School, and he followed his mentor into the Coast Survey. He was sent to California to produce reliable navigational charts shortly after the Gold Rush made them essential, and except for a break during the Civil War, he conducted the rest of his career from San Francisco, publishing several editions of *The Pacific Coast: Coast Pilot of California, Oregon, and Washington Territory* (hereafter *Pacific Coast Pilot*),[27] producing numerous charts, and conducting the first American exploration of Alaska in 1867. Like Bache, he had broad scientific interests, at one time holding the presidency of the California Academy of Sciences.

It is unclear how Davidson came to hire Muybridge for the lighthouse commission. Perhaps they shared information about Alaska

before Muybridge's trip there in 1868. The encounter may have occurred at the Mercantile Library, an organization established in 1852 to foster conversations about literature and science. Muybridge served as a director of the library and donated copies of his photographs of California scenery. The California Academy of Sciences, where Davidson served as president in 1871, may also have been the site of an encounter between the two men. Or the commission may have been the result of a referral from a member of San Francisco's elite, many of whom were commissioning Muybridge to document their properties in the late 1860s and early 1870s.

The Coast Survey and Lighthouse Board came to Muybridge within the context of a multipronged effort to tame the Pacific coast environment by making accurate visual representations of it in the form of maps and charts and using lighthouses, fog signals, and channel markers to direct mariners past its often undetectable hazards. The particular dangers of the Pacific coast are the result of its environment. It is often the case that when humanists and social scientists discuss the Pacific, or the Atlantic, for that matter, it is the objects that transcend the ocean that take focus, whether they be exotic trade goods, human chattel, Enlightenment notions, or works of art. The ocean is an arena in which societies interact, sometimes peacefully and profitably and just as frequently with conflict. We discuss the China trade, the Pacific theater of war, and Pacific empire as expressions of human desires and ambitions. But as we move further into an Anthropocene—a term used to describe the historical period in which human activities began to significantly affect the operations of the natural environment[28]—it is vital to also consider how we might look at human interactions with natural systems in earlier periods and reconstruct the roles played by aspects of the environment in these social histories. Such investigations would not only reveal how the Pacific ecosystem helped shape the social conflicts and negotiations that took place within it, but might also offer models from the past that could help envision future human-nonhuman interactions.

The topography and weather of the Pacific coast of the Americas are intimately related, as the fog is an artifact of the geological formation known as the Pacific Coast Ranges, a line of mountain ranges that extend down from Alaska through South America along the edge of the American continents. These peaks, the result of plate tectonics, trap moisture blown in off the ocean by the prevailing westerly winds ("Westerlies") along much of the coastline. Pacific waters may be thought of as making up a vast ecosystem held together by prevailing

winds and currents that circulate plant and animal species throughout the ocean. These winds and currents also served to propel trade vessels across the waters, bringing them west along the equator and driving them back toward the Americas along the northern and southern reaches of the Atlantic. Like the whales that inspired so much human exploration of the Pacific, other creatures are also disseminated throughout those waters, including mollusks, algae, and the birds that feed on them. Pacific peoples mastered these natural forces enough to themselves follow the prevailing currents for hundreds of miles, and when whaling and the China trade brought European ships into the region, they, too, followed the circular paths inscribed by natural forces, generally without making landfall along the most mountainous areas of the Coast Ranges. The Manila Galleons, the Spanish trading ships that helped fuel the economy of the Spanish Empire by bringing the China trade to Mexico, depended on a knowledge of and cooperation with these natural forces.

John Law has argued that it is impossible to understand the Western oceanic expansion of the early modern period unless "the technological, the economic, the political, the social and the natural are all seen as interrelated."[29] His explanation of the Portuguese dominance of the early spice trade draws on the fact that the Portuguese mobilized and combined elements of all these categories. Law interprets the specific tools through which exploration was carried out as providing an example of Latour's conception of distributed agency that collectively, in Law's words, "extract[s] compliance from the environment."[30] Law explains the essential qualities of tools that offered material support of long-distance control: they must be portable and durably designed to survive and adapt to the instability of sea travel. Fitting under this umbrella are five things: seaworthy vessels; astronomical knowledge communicated through tables and charts that mark the movement of the sun and stars throughout time and space and indicate how to take measurements; geographical knowledge similarly documented in charts, maps, and journals; instruments for taking these measurements such as astrolabes and quadrants; and skilled human navigators with both the physical and mental acuity to manage. For Law, the agents involved in long-distance maritime control can be summarized as "documents, devices, and drilled people." Charts and other graphic navigational aids that visualized the natural hazards of the ocean were a key component of human competition in the region, and these things were closely guarded; each commercial or national interest developed and kept close control over its own resources.

As soon as it was a nation, the United States eagerly entered this sphere to sponsor its own oceanic surveys. The first Yankee whaling ships came to the Pacific in 1791, and in 1828, the United States Congress voted to send an expedition to the Pacific with the purpose of developing commerce and fishing there by making reliable documents of its own. This act resulted in the United States Exploring Expedition of 1838–1842.[31] In addition to maps and charts, good navigation relied on physical objects to guide ships through coastal waters. One of the early acts of the United States was to support its own military and civilian navigation by founding the United States Lighthouse Establishment, an institution within the Department of the Treasury, in 1789. The first federally built lighthouse was erected at Cape Henry at the entrance to the Chesapeake Bay in 1792. Fifteen years later, feeling a demand for better and more extensive charting of American waters, the United States also established the Coast Survey. The agency worked with the Lighthouse Board (the heir of the Lighthouse Establishment) to choose locations for Pacific coast lights. Throughout the early nineteenth century, the need for lighthouses, beacons, and buoys was a regular refrain in political speeches, including Andrew Jackson's State of the Union in 1834.[32]

By and large, the early economic development in the Pacific didn't require coastal charts or supports for coastal navigation. While there was some Spanish and Russian settlement along the Pacific coast, ocean travel did not include the need to develop major ports along these shores or to develop navigational aids to help manage traffic arriving from multiple directions. This changed with the US annexation of California and the onslaught of vessels seeking port during the Gold Rush. The coastal fog, combined with the treacherous shoals, islands, and submerged rocks that are the marine extension of the Coastal Range, increased the frequency of wrecks and necessitated the federal establishment of navigational aids. In 1849, the Coast Survey extended its work to charting the 1,300 miles of US coastline (8,900 miles counting bays and inlets). The work began with taking measurements of the depth of channels into and out of major ports (fig. 8) and proceeded with the proposal of locations for a series of lighthouses which would facilitate the traffic into California harbors. Within two decades, the survey put this knowledge into the hands of all citizens. George Davidson's *Pacific Coast Pilot*, first published in 1869 and revised and expanded twenty years later, was an almanac-like book combining a narrative description of a region and its hazards; demographic, ethnographic, and historical information; and advice

Elizabeth W. Hutchinson

8
United States Coast
Survey, "Preliminary
Chart of the Entrance
to San Francisco Bay,"
1856. Printed illustration,
20 ½ × 38 in. (52.07 ×
96.52 cm).

for navigators, including descriptions of landmarks and suggestions for proceeding in a wide array of conditions of weather, season, and time of day.

Navigational aids were particularly important because the development of ocean-worthy propeller-driven iron steamships meant that travel could be conducted without relying on winds and currents. But the coastal environment held dangers even for these ships.

The fact that West Coast lighthouses were planned in the early 1850s and were only finished being built when Muybridge made his pictures in the 1870s gives a hint at some of the challenges involved in extracting environmental compliance from the region. There were social factors—during the Gold Rush, workers often abandoned the Coast Survey for the lure of riches in the goldfields, and Civil War service called up many of the experienced engineers, including Davidson, and the Coast Survey continually faced legislative opposition to the appropriations needed to support its operation.[33] But the ecosystem provided its own challenges. Law does not consider nature

an actor in the system of distributed power he describes. Yet it is helpful to think about how natural forces resisted the human control of the Pacific coast.

The Coast Survey's work was more about groping for knowledge than asserting control. This is well illustrated by the fact that much of its research was achieved by a practice called "sounding." The very name of this procedure, which involved lowering a weighted line to determine the depth of a channel and the nature of the seafloor, reminds us of navigation's reliance on all the senses working together: sounding appeals as much to the sense of feeling as it does to hearing, and moving forward relies on cross-referencing sensory experiences, since different atmospheric conditions affect not only sight but also the movement of sound waves. But the thick atmosphere of the Pacific coast confounded the senses. Fog not only denies sailors the ability to detect obstacles using sight; it also impairs hearing, as it changes the direction and strength of sound waves. In 1858, for example, the Lighthouse Board determined that the weather at South Farallon Island rendered the lighthouse frequently useless and had a fog signal installed, only to find the latter was also unreliable due to the atmosphere's interference. [34]

Because of these conditions, the coastline was routinely described as unmanageable and the Coast Survey was viewed with skepticism. Before the Farallon light was finished, an article stated that it "could be of no use in entering the harbor in foggy weather, and probably but little any other time."[35] Further up the coast was the challenge of opening safe passage into the mouth of the Columbia, where the roiling encounter of ocean and river offered unpredictable hazards. "Mere description can give little idea of the terrors of the bar of the Columbia," wrote Charles Wilkes, commander of the United States Exploring Expedition. After losing a boat there, he called it "one of the most fearful sights that can possibly meet the eye of the sailor."[36] When the project of erecting lighthouses began, the Lighthouse Board itself faced this problem, losing *The Oriole*, a ship full of supplies en route to build the light at Cape Disappointment on the Washington coast at the mouth of the Columbia River in 1853.[37]

This circumstance helps explain why each Pacific coast light had the different architectural features described by Nordhoff. On the Atlantic coast, most lighthouses are tall, slender beacons that extend into the sky with an attached keeper's residence. Many eastern lights were built from the same architectural plans. But on the Pacific coast, the location of a beacon dictated the height and shape of the tower

as well as the proximity of the keeper's home. As a result, a light might appear as a tower or be nestled into a cliff face. This development only occurred over time, however, as a result of trial and error. In the beginning, the Lighthouse Board set out to efficiently and inexpensively install six lighthouses all based on plans drawn up by the Baltimore architectural firm Gibbons and Kelly.[38] But this model proved unequal to the conditions in at least one location and had to be redesigned.[39]

Fog was a particular challenge for the Pacific lighthouse project that took years and experimentation to tackle. When a light was erected at Point Loma in 1855 according to the architectural plan generally used for Atlantic coast lights, it proved to be so tall that it was usually obscured by fog. A similar issue occurred at Point Bonita, on the northern side of the entrance to San Francisco Bay, and the Lighthouse Board moved the building two decades after it had been erected. Point Bonita's fog signal also met with problems, as its construction was hampered by a series of landslides.[40] The Lighthouse Board also encountered problems because the erection of navigational aids was occurring at the same time as American settlement of the environment instead of decades or centuries later, as had been the case in the East. At Point Loma, construction was delayed because of the need to build an eight-mile road to transport the materials to the site from the city of San Diego across the bay. Only later did planners realize that the point was too narrow for a cistern,[41] so there was a need to cart water to the light. Similar poor planning resulted in the need to rebuild lights, because when expensive Fresnel lenses arrived from France for installation, it was discovered that the buildings were too small to accommodate them.

Point Reyes was the site of similar challenges. The stumpy lighthouse represents an attempt to keep the beacon below the fog line. So is the fact that the light itself was built on a ledge three hundred feet below the top of the cliff—a feat that required hauling materials first up to the top from the beach in Drake's Bay and then lowering them down over the point. While the light was located on a natural rock shelf, it was determined that the fog signal needed to be as close to the water line as possible to be audible in thick weather, meaning that workers had to blast another shelf further down the cliff. As in San Diego, making space for a cistern to store the water needed to operate the steam-driven fog whistle necessitated further work. While solutions to these challenges were found, it is difficult to characterize the Pacific coast environment as "compliant" with the desires of the Coast Survey.

9
James McNeill Whistler,
*Sketches on the Coast
Survey Plate*, 1854.
Etching, plate: 5 ¾ ×
10 in. (14.6 × 25.4 cm);
sheet: 6 × 10 1/4 in.
(15.24 × 26.03 cm).
National Gallery of Art,
Washington, DC.
Rosenwald Collection,
1943.3.8396.

Rather, geological, meteorological, and oceanographic factors inter-fered with the agency's progress, exerting force over both the activity of the surveyors and the visual and architectural results of their work, and they continue to affect the navigational activity involving them.

This factor sheds light on Muybridge's lighthouse pictures. Photographs that document the completion of the lighthouses as well as the challenging terrain in which they were erected could provide valuable endorsements of the work of the Coast Survey and Lighthouse Board with which to rebuke skeptical legislators. As Robin Kelsey has argued, one of the "veiled" messages of archives of Geological Survey photographs in the nineteenth century is their implicit work as promo-tional material for the agency itself. "The reason for this," he writes, "is not merely that some degree of self-presentation among social entities is unavoidable but also that archives, especially publicly funded ones, rely on political support for their maintenance and growth."[42] Present-ing themselves as neutral records, survey photographs circulated to legislators, public officials, and the general public as evidence of the success of the surveying project and the need for its continued support.

Muybridge's photographs of lighthouses fit these criteria, and the value of giving visible form to this challenging environment could explain some of the ways in which Muybridge's composition eludes the norms of the picturesque.

In addition to their promotional use, Muybridge's photographs may have been distributed by the Coast Survey to navigators to supplement the visual information on charts and maps made by the agency before the lighthouses had been built. Before the advent of radar, navigators relied on making visual contact with landmarks as much as following the information given on charts. The Coast Survey's work often began with the production of drawings called "coast profiles" that traced the outlines of the cliffs, harbors, and islands that served as heading points for setting a course. West Point alumnus James McNeill Whistler (1834–1903) produced such drawings during his employment at the Coastal Survey in 1854–1855 that demonstrate the desired characteristics of such work (fig. 9). Such pictures were not only for information gathering but were also shared with mariners. For example, one Coastal Survey publication shows the outline of the northern California coast with coast profiles incorporated to correspond roughly with their geographic location (fig. 10). To facilitate visual apprehension of location, the *Pacific Coast Pilot* offers bearings between different landmarks and visual descriptions of each site such as Point Reyes from a variety of approaches—north, south, or west—so that a navigator would not find himself in the same position as Richard Henry Dana, author of the wildly popular memoir *Two Years before the Mast*, who described making a landing in San Francisco Bay wholly by accident after having charted a course for Monterey, a town 120 miles to the south, because of a lack of familiarity with the region.[43] The completion of the lighthouses gave navigators additional visual information to use in steering; even when a light was not lit, the profile of a building on the coast—in the case of the Pacific lighthouses, a *distinctive* building—could provide information that would be useful in confirming a ship's location. Although Muybridge was unable to make photographs from the deck of a ship because of the long exposure times needed by his camera making it impossible to get a sharp image from a floating surface, his photographs are careful to describe the direction in which a view is taken, a precaution that would have made the photographs a valuable supplement to a navigator's resources. Significantly, coast profiles usually eschew unnecessary detail. George Davidson's drawings for the 1869 *Pacific Coast Pilot* avoid shadows

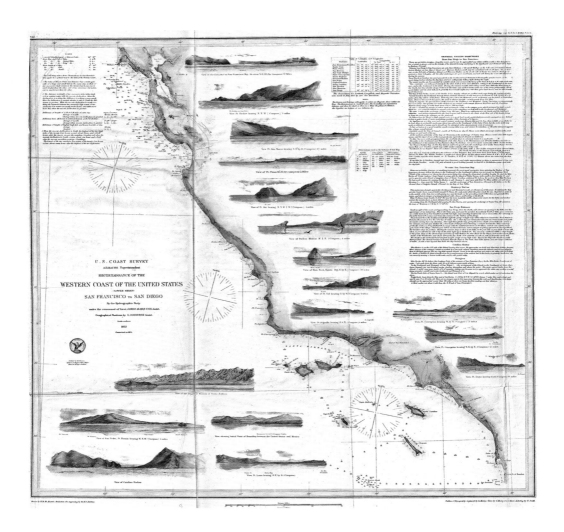

10
United States Coast Survey, "Reconnaissance of the Western Coast of the United States," 1854. Illustration, 22 × 23 in. (55.88 × 58.42 cm).

or other signs that could point to a specific time of day or year, and his emphasis on the outline of a coastal form downplays any sense of recession or distance from the shore to the peaks on the horizon. The qualities of Muybridge's photographs that lack aesthetic beauty might be seen to have more value when used in this way.

The value of the Point Reyes images for sailors is meaningful not only to explain what they show but also what they don't. By turning his camera *toward* the coastline, Muybridge turned away from the interior of Point Reyes, refusing the viewer information about how other

Elizabeth W. Hutchinson

human communities negotiated the natural conditions of the region and each other. Considering how other groups extracted environmental compliance from this area helps illuminate alternatives to the ways in which Muybridge and his patrons sought to exercise control and to represent the accomplishment of this goal. It also helps us see the unfolding of settler colonialism in the region — first with the Spanish displacement of indigenous peoples and again with Americanization — as an emplaced historical process that played out not only *because of* the region's rich natural resources but also in *negotiation* with nature.

While Anglo-Americans were only just becoming masters of a Pacific environment in the post–Civil War period, there were other populations around the Pacific who had long since developed ways of working with the currents, winds, rocks, and fogs. We might see this in the rich and varied use to which indigenous people of northern California put the tree that thrives in fog, the coast live oak. The original Miwok inhabitants of Marin County developed many cultural traditions around acorns, which served as a staple food. Miwok basketry is linked to the gathering, cooking, and presenting of acorns, and both baskets and nuts feature prominently in ceremonial life. For centuries, Coast Miwok people moved through the Point Reyes landscape from bluff to beach in seasonal cycles that did not require building roads or blasting shelves or developing foghorns or other means of countering the effects of foul weather.[44]

Muybridge did not make pictures of indigenous people in Marin County, though he did document the Sierra Miwok community in Yosemite. This is likely because the Coast Miwok people had been dispossessed, first through Mexican land grants to what the ranchers called "unclaimed" territory and then due to an 1861 federal law claiming US title to all California territory not protected by prior Spanish land grants. Many Miwok people had been forced to leave the area during the Americanization of California; others remained as squatters or wage laborers on ranches owned by Anglos, often intermarrying with the European immigrants who came to the area to work in the dairy industry, as curator Theresa Harlan has demonstrated in an essay on photographs of the family of Coast Miwok Bertha Felix Campigli.[45] But this does not mean that Miwoks accepted this alienation from a familiar ecosystem placidly. The years when Muybridge executed his work at Point Reyes were marked by the spread of the Bole Maru cult, a local adaptation of the Ghost Dance, a pan-Indian movement predicting a disastrous end of the world and, with it, settler colonial

culture. The landscape that extended behind the photographer as he made his exposure was dotted with sweathouses and sites of Miwok, Pomo, Wintun, and Maidu congregation.

In another piece of writing, I have explored the colonial strategy of choosing a point of view that eschews depicting the violent conflicts that accompanied the imposition of American power over a Pacific landscape.[46] As I explained in my reading of *The Wreck of the "Ancon" in Loring Bay, Alaska* from 1889, the painter Albert Bierstadt (1830–1902) chose a vantage point turned away from a salmon cannery, denying the industrialization of the coast and the bitter battles among native, Chinese, and Anglo workers that accompanied it, and instead presenting the viewer with a seemingly peaceful wilderness waiting for conquest to reach out a gentle hand (fig. 11). Only the wrecked ship points to the submerged dangers lurking in this environment.

Turning away from Marin County to look out onto the sea, Muybridge, too, eschews an image of human struggles against nature and one another. Maps of the time show the boundaries of the ranches crowded onto the Miwok homeland. The rectangular shape of these ranches shows a new relationship to the landscape, one not defined by ecology—Miwok bands divided territory by watershed—but by rigid lines that cut across natural features. The establishment of ranches in the region began in 1834, with a grant made to Irish-born Mexican citizen John Reed from the Mexican government. As one rancher observed, the climatic conditions, including heavy dews, encouraged a "great luxuriance to the wild oats and other grains and grasses," which supported all kinds of grazing animals, such as the local elk and black-tailed deer.[47] By the time of the American takeover, there were twenty ranches on the land, the majority in the hands of Americans who had purchased or wrested them from the original grantees through expensive court battles.[48] By 1870, white landowners were consolidating smaller ranches and using the majority of the space for dairy farming, and Marin became the leading county in California in the production of both butter and cheese for decades.[49] The foggy conditions of the peninsula enriched the grazing land, but the introduction of cattle transformed the varied ecosystem as the animals grazed away the brush that had sustained local grazing species and reduced the sustainability of the coast live oaks.[50] Pastures dried up for several months each year, so acres were cultivated for grains—oats, hay, or barley—to cover the difference, further threatening indigenous plant life.

In picturing Point Reyes, Muybridge didn't record an indigenous ease with the coastal environment or an Anglo destruction of it. But

Elizabeth W. Hutchinson

11
Albert Bierstadt, *The Wreck of the "Ancon" in Loring Bay, Alaska*, 1889. Oil on paper mounted on Masonite, 14 ⅛ × 19 ¾ in. (35.88 × 50.16 cm). Museum of Fine Arts, Boston. Gift of Martha C. Karolik for the M. and M. Karolik Collection of American Paintings, 1815-1865, 47.1250.

he does have one photograph that hints at richer Pacific social and natural history. Among the exposures from this commission is one titled *The "Heathen Chinese" Abalone Merchant at Drake's Bay* (1871) (fig. 12). Muybridge's language characterizes the figure as alien and evokes the anti-Chinese sentiment brewing in California at the time. But, in fact, this gatherer looks quite at home, using familiar tools to engage in a familiar act. While Muybridge's motivation may have been to present a picturesque view—something Anthony Lee identifies as one means of controlling Chinese Americans by viewing them through an aestheticizing Western lens—the photograph also reminds us that some aspects of Chinese life persisted on both sides of the ocean.[51] Abalone is a mollusk that is distributed throughout the world's oceans, but most species are found in the waters of the Pacific Rim where abalone has been harvested by humans for thousands of years. A staple of the Miwok diet, abalone was also a particularly important foodstuff in coastal China. Thus it is possible to see the man in Muybridge's photograph having enough familiarity with this environment to continue a cultural practice despite his relocation across the sea.

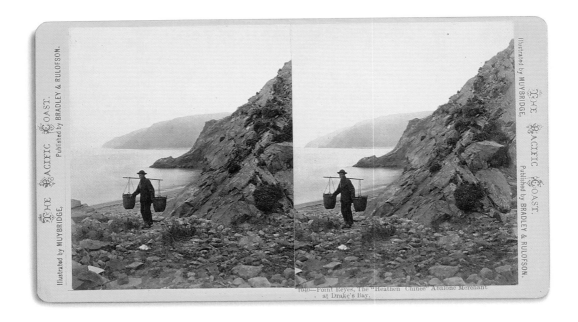

The image within the stereograph reads: "1040—Point Reyes, The "Heathen Chinee" Abalone Merchant at Drake's Bay."

12
Eadweard Muybridge,
*The "Heathen Chinese"
Abalone Merchant
at Drake's Bay*, 1871.
Stereographic albumen
print from plate glass
negative, 3 × 3 in. (7.62 ×
7.62 cm) (each exposure).
Bancroft Library,
University of California,
Berkeley, BANC PIC
1971.055: 1040-STER.

The majority of Chinese people in America came from the southeastern region of that country, especially Guangdong Province. This is a region that was active in international trade since the fifteenth century and housed Macao, the first European settlement in China. The Chinese were not only familiar with the Pacific ecosystem; they were also experienced in traversing its waters. While Anglo-Americans in California sought to impose order on the Pacific, the ships they used to get there were frequently staffed by mariners who hailed from coastal China. Pacific Islanders, too, were part of these crews, as the Polynesian Queequeg signed on to Melville's *Pequod*—a Pacific whaling ship—suggests. Such sailors made up the "drilled people" who supported American control of the Pacific, to use Law's term. Yet the fact that they shared across lines of national identity a knowledge of interacting with the ocean environment supports a more complex notion of international competition in long-distance maritime control than Law's study allows. It also undermines the conceptualization of control as something that can be imposed without this knowledge.

Other objects of visual culture support this reading of Pacific navigation. A true contextualization of Muybridge's photographs might involve not only an archive of charts, maps, and measurements that brought the Pacific into view for American audiences, but also the material objects that already existed in his time that testify to the already-accomplished collaboration with the Pacific environment

by the peoples who had inhabited it for centuries. As Mary Malloy demonstrates, Pacific trade networks routinely circulated objects made of coastal materials (grasses, shells, furs) and commercial goods (coins, pottery, printed cloth) among Alaska, the Hawaiian islands, the coast of California, and Southeast China at this time—for instance, one could find examples of Tlingit weaving near the site of Muybridge's photographs at the Russian settlement of Bodega.[52] While Muybridge seems to have cut this history of complex negotiations between humans *in* the natural environment and between humans *and* the natural environment out of his pictures, like fog, it creeps back into the frame when the viewer begins to look closely.

In many ways, the interpretive project I have undertaken here draws on one of art history's older methodologies. In his classic text *Art and Illusion*, Ernst Gombrich defined the art historian's job as interpreting a work in light of the two tasks faced by artists— "making," or imaginative/expressive invention, and "matching," or using a preexisting visual schema to render the work legible to its audience. As Gombrich puts it, "Every artist has to know and construct a schema before he can adjust it to the needs of portrayal."[53] As I have argued, the balance in Muybridge's Point Reyes photographs, which have often been interpreted as expressive inventions, lies in the latter field. Muybridge, a man who undertook ocean voyages many times before visiting Point Reyes and who traveled on this trip with the sailors most likely to make use of his images, undertook his act of picturing in relationship to the visual culture of navigation. Christopher Wood has argued that Gombrich's work paved the way for the study of visual culture that has allowed art historians to ground their readings of works of art in a broad array of visual sources, as I do here.[54] But my goals for this essay go beyond finding a simple explanation of why Muybridge chose to compose and expose these pictures this way.

In this reading, I have explored how thing theory might enrich our understanding of the act of picturing. Building on Robin Kelsey's call for understanding photography in relation to the "material conditions of its production," I seek to expand the field of materiality being considered.[55] Seeing Muybridge's photographs of Point Reyes as the product of distributed agency helps explain some of the distinctive visual features of this work that has so far eluded interpretation. But, more importantly, by offering an opportunity to think about the

difficulty with which a photographer, like other Americans of Muybridge's generation, struggled to extract compliance out of the Pacific coast environment, these photographs give us a record of human activity that does not presume human autonomy. Moreover, by suggesting some other ways in which people in the same region engaged the nonhuman forces of this environment, I hope I have illuminated that the triumphant narrative of American expansion that is frequently seen as confirmed by visual culture is not only not inevitable; it is not accurate. By focusing on the stumbling progress of lighthouse building and the difficulty with which sailors, surveyors, and photographers struggled to impose control over the material environment of the West Coast, I hope I have shown that, like the work of the Coast Survey, which reduced but did not eliminate the number of shipwrecks along the obdurate Pacific coast, Muybridge's pictures only partially bring this landscape under control.

Elizabeth W. Hutchinson

1 These works are heavily featured in Philip Brookman, ed., *Helios: Eadweard Muybridge in a Time of Change* (Washington, DC: Corcoran Gallery of Art, 2010), which circulated to several international art museums.

2 Eadweard Muybridge, *Animal Locomotion: An Electro-photographic Investigation of Consecutive Phases of Animal Movements, 1872–1885* (Philadelphia: Published under the auspices of University of Pennsylvania, 1887).

3 For more on the Fresnel lens, see Franklin Institute, *Report on the Dioptric System of August Fresnel for the Illumination of Lighthouses* (Philadelphia: Grattan and McLean, 1850).

4 For a classic illustration of this critical approach, see Alan Trachtenberg, "Naming the View," ch. 3 in *Reading American Photographs: Images as History, Mathew Brady to Walker Evans* (New York: Hill and Wang, 1989).

5 Philip Brookman, "Helios: Eadweard Muybridge in a Time of Change," in Brookman, *Helios*, 54.

6 Rebecca Solnit, *River of Shadows: Eadweard Muybridge and the Technological Wild West* (New York: Viking, 2003), 50.

7 "Shipwrecks at Point Reyes," accessed May 4, 2015, http://www.nps.gov/pore/learn/historyculture/people_maritime_shipwrecks.htm.

8 "Sirens That Do Not Tempt," *San Francisco Chronicle*, Sept. 25, 1887. See also an undated letter to William B. Shubrick from Board of Marine Underwriters, Letters Received, vol. 285, United States Light House Board, National Archives and Records Association, RG 26, cited in Anna Coxe Toogood, *A Civil History of Golden Gate National Recreation Area and Point Reyes National Seashore, California* (Denver: National Park Service, 1980), 244.

9 George Davidson, *The Pacific Coast: Coast Pilot of California, Oregon, and Washington Territory* (Washington, DC: Government Printing Office, 1889), 223.

10 Jane Bennett, *Vibrant Matter: A Political Ecology of Things* (Durham, NC: Duke University Press, 2010), 1. In Bennett's terms, the fog might be considered to be intervening in the picture making. Bennett uses Bruno Latour's "actor-network theory" to explain how nonhuman forces such as fog might exert influence, even though they have no will to act. Such a point of view allows for a perception of agency as distributed across an ontologically heterogeneous field rather than being localized only in one or a collective human source (Bennett, *Vibrant Matter*, 23).

11 In addition to Trachtenberg, "Naming the View," see Nancy K. Anderson, "'The Kiss of Enterprise': The Western Landscape as Symbol and Resource," in *The West as America: Reinterpreting Images of the Frontier, 1820–1920*, ed. William Truettner (Washington, DC: Smithsonian Institution, 1991), 237–84; Albert Boime, *The Magisterial Gaze: Manifest Destiny and the American Landscape Painting, c. 1830–1865* (Washington, DC: Smithsonian Institution, 1991); and W. J. T. Mitchell, *Landscape and Power* (Chicago: University of Chicago Press, 1994).

12 According to Patrick Wolfe, settler colonialism is the ongoing settlement of a colonial society that operates on the logic of the elimination of native society. Patrick Wolfe, "Settler Colonialism and the Elimination of the Native," *Journal of Genocide Research* 8, 4 (Dec. 2006): 387–409. It has been used to describe all colonial systems which destroy in order to replace, including knowledge systems about the natural world.

13 Roland Barthes, "Rhetoric of the Image," in *Image, Music, Text*, ed. and trans. Stephen Heath (New York: Hill and Wang, 1977), 32–51. See also Tom Gunning, "What's the Point of an Index? Or, Faking Photographs," *NORDICOM Review* 5, 1/2 (Sept. 2004): 39–49.

14 Elizabeth Hutchinson, "They Might Be Giants: Galen Clark, Carleton Watkins and the Big Tree," *October* 109 (Summer 2004): 47–63.

15 Marcus Aurelius Root, *The Camera and the Pencil; or, The Heliographic Art* (New York: Appleton, 1864), 132–33.

16 M. Carey Lea, *A Manual of Photography* (Philadelphia: Benerman and Wilson, 1868), 230.

17 Ibid., 230–35.

18 The term "distributed agency" has been used most prominently by Bruno Latour. See Latour, *Science*

in Action: How to Follow Scientists and Engineers through Society (Cambridge, MA: Harvard University Press, 1987). It is meaningful here to also note that Jennifer Tucker has discussed "failure" as a prominent characteristic of nineteenth-century photography, and she lists a lack of skill as one of many factors in this. Jennifer Tucker, Nature Exposed: Photography as Eyewitness in Victorian Science (Baltimore, MD: Johns Hopkins University Press, 2005), 3–4. However, Tucker's use of the term "skill" suggests a confidence in the potential for the human to master the nonhuman.

19 Robin Kelsey, "Materiality," Art Bulletin (Mar. 2013): 21.

20 Letter from Muybridge to Colonel R. S. Williamson, Jan. 13, 1871, Letters Received by the United States Light House Board, quoted in Solnit, River of Shadows, 263.

21 Gordon Hendricks, Eadweard Muybridge: Father of the Motion Picture (New York: Grossman Publishers, 1975), 29–30.

22 See John A. Martini, Inventory of Eadweard Muybridge's Photographs of Lands within the Future Golden Gate National Recreation Area, 1868–1873: Images from the Bancroft Library and Other Archival Collections (Fairfax, CA: J. Martini, 2000).

23 See Robin Kelsey, Archive Style: Photographs & Illustrations for U.S. Surveys, 1850–1890 (Berkeley: University of California Press, 2007); and Tucker, Nature Exposed.

24 Charles Nordhoff, "The Light-Houses of the United States," Harper's New Monthly Magazine, Mar. 1874, 465–77. The quotation is from page 469, and Muybridge's photograph is illustrated on page 472.

25 The Coast Guard has made photographs of California light stations, including many by Muybridge, available online at http://www.uscg.mil/history/weblighthouses/LHCA.asp (accessed June 29, 2015).

26 Eadweard Muybridge, Catalog of Photographic Views Illustrating the Yosemite, Mammoth Trees, Geyser Springs, and Other Remarkable and Interesting Scenery of the Far West (San Francisco: Bradley and Rulofson, 1873), 2.

27 George Davidson, The Pacific Coast: Coast Pilot of California, Oregon, and Washington Territory (Washington, DC: Government Printing Office, 1869).

28 For a discussion of the critical development of the term "Anthropocene," see Will Steffen, Jacques Grinevald, Paul Crutzen and John McNeill, "The Anthropocene: Conceptual and Historical Perspectives," Philosophical Transactions of the Royal Society A 369 (2011): 842–67.

29 John Law, "On the Methods of Long-Distance Control: Vessels, Navigation and the Portuguese Route to India," in Power, Action and Belief: A New Sociology of Knowledge?, ed. John Law, Sociological Review Monograph 32 (London: Routledge, 1986), 235.

30 Ibid., 240.

31 For the Exploring Expedition, see Nathaniel Philbrick, Sea of Glory: America's Voyage of Discovery: The U.S. Exploring Expedition, 1838–1842 (New York: Viking, 2003).

32 A summary of the United States Lighthouse Service can be found in Hugh Richard Slotten, Patronage, Practice, and the Culture of American Science: Alexander Dallas Bache and the U.S. Coast Survey (New York: Cambridge University Press, 1994). Andrew Jackson, "Second Annual Message to Congress, December 6, 1830," Gales and Seaton's Register of Debates in Congress, 21st Congress, 2nd Session, appendix, v. This speech is better known for laying out Jackson's support for Indian Removal.

33 See Slotten, Patronage.

34 Oscar Lewis, George Davidson, Pioneer West Coast Scientist (Berkeley: University of California Press, 1954).

35 "Light Houses," Daily Alta California, Jan. 1, 1851, 2.

36 John Wilkes, A Narrative of the United States Exploring Expedition (Philadelphia, 1849), 4:243.

37 Pamela Welty and Randy Leffingwell, Lighthouses of the Pacific Coast (Minneapolis, MN: Voyageur Press, 2000), 35.

38 Ibid., 31.

39 Ibid., 43.

40 Toogood, *Civil History*, 211–28, 243.

41 These mishaps and others are outlined in chapter 2 of Welty and Leffingwell, *Lighthouses*.

42 Kelsey, *Archive Style*, 5.

43 Richard Henry Dana, *Two Years before the Mast: A Personal Narrative* (New York: Harper Brothers, 1842), 280.

44 For an overview of Coast Miwok life in the pre-US period, see Toogood, *Civil History*, 3–6.

45 Theresa Harlan, "A View of Our Home, Tomales Bay, Calif.: Portrait of a Coast Miwok Family, 1930–1945," in *Our People, Our Lands, Our Images: International Indigenous Photographers*, ed. Hulleah Tsinhnajinnie and Veronica Pasalacqua (Berkeley, CA: Heyday Books for R. C. Gorman Museum, 2006).

46 Elizabeth Hutchinson, "'A Narrow Escape': Albert Bierstadt's *Wreck of the Ancon*," *American Art* (Spring 2013): 50–69.

47 Toogood, *Civil History*, 45.

48 Ibid., 63–64.

49 In 1862, Marin County produced 200,000 pounds of butter and 300,000 pounds of cheese. Ibid., 96.

50 Aida López-Sánchez et al., "Effects of Cattle Management on Oak Regeneration in Northern Californian Mediterranean Oak Woodlands," *P One* (Aug. 15, 2014), doi:10.1371/journal.pone.0105472. See also "Impacts of Grazing," US Fish and Wildlife Service, accessed June 29, 2015, http://www.fws.gov/invasives/staffTrainingModule/methods/grazing/impacts.html.

51 Anthony Lee, "Picturesque Chinatown," in *Picturing Chinatown: Art and Orientalism in San Francisco* (Berkeley: University of California Press, 2001), 59–100.

52 Mary Malloy, *Souvenirs of the Fur Trade: Northwest Coast Indian Art and Artifacts Collected by American Mariners, 1788–1844* (Cambridge, MA: Peabody Museum of Archaeology and Ethnology, 2000), 49.

53 Ernst Gombrich, *Art and Illusion: A Study in the Psychology of Pictorial Representation* (New York: Bollingen Foundation, 1961), 116.

54 Christopher S. Wood, "Art History Reviewed VI: E. H. Gombrich's 'Art and Illusion: A Study in the Psychology of Pictorial Representation,' 1960," *Burlington Magazine*, Dec. 2009, 837.

55 Kelsey, "Materiality," 22.

LEARNING FROM LEARNING

Ulla Haselstein

Learning from Cézanne:
Stein's Working with and through Picturing

One of the many anecdotes told in *The Autobiography of Alice B. Toklas* is the story of how Gertrude Stein (1874–1946) learned about Cézanne (1839–1906) from her brother Leo (1872–1947), who had seen some of Cézanne's paintings at Charles Loeser's villa in Florence in the summer of 1903; Loeser had been told about Cézanne's work by the latter's close friend Claude Pissarro. At the turn of the century, Cézanne was known only by a small circle of friends, critics, and fellow artists.[1] This was soon to change, however — due to a large exhibition of Cézanne's paintings at the Salon d'Automne of 1904, but also because of the Steins, who bought their first Cézanne in 1904 from Vollard.[2] On Saturday nights at 27, rue de Fleurus, the Steins' collection of contemporary art could be inspected by the crowd of visitors,[3] and Leo would extemporize on modern art, explaining Cézanne's aesthetics and comparing his work to that of other artists.[4] In those early days in Paris, Gertrude Stein left the terrain of art criticism to her brother. Later, in 1904, the Steins bought "a big Cézanne," namely, a portrait of the artist's wife. This painting was a major inspiration for Stein's writing. As she herself put it: "[I]n looking and looking at this picture Gertrude Stein wrote *Three Lives.*"[5]

In an interview she gave in the last year of her life, Stein recollected her beginnings as a writer and emphasized her indebtedness to Cézanne:

Paul Cézanne,
La Conduite d'eau
(detail, see fig. 1).

*Everything I have done has been influenced by Flaubert
and Cézanne, and this gave me a new feeling of composi-
tion. Up to that time composition had consisted of a
central idea, to which everything else was an accompani-
ment and separate but was not an end in itself, and
Cézanne conceived the idea that in composition one thing
was as important as another thing. Each part is as impor-
tant as the whole, and that impressed me enormously,
and it impressed me so much that I began to write* Three
Lives *under this influence and this idea of composition,
and I was more interested in composition at that moment,
this background of a word-system, which had come to me
from this reading that I had done.* [. . .]

*After all, to me one human being is as important as
another human being, and you might say that the
landscape has the same values, a blade of grass has the
same value as a tree. Because the realism of the people
who did realism before was a realism of trying to make
people real. I was not interested in making the people real
but in the essence or, as a painter would call it, value.
One cannot live without the other. This was an entirely
new idea and had been done a little by the Russians but
had not been conceived as a reality until I came along,
but I got it largely from Cézanne. Flaubert was there as
a theme. He, too, had a little of the feeling about this
thing, but they none of them conceived it as an entity, no
more than any painter had done other than Cézanne.*[6]

Stein gives Flaubert and the Russian writers their due as precur-
sors of modernist literature, but she singles out Cézanne's idea of
composition as the true artistic watershed and celebrates him for his
egalitarianism: "one thing was as important as another thing." Stein
may allude here to Théodore Duret's well-known remark that for
Cézanne "a few apples and a napkin on a table assume the same
grandeur as a human head or a view by the sea."[7] More specifically,
Stein refers to Cézanne's technique of modeling through colors of
equal value. Destroying the effect of different levels of illusionistic
space, a flatness is created that contributes to the play with the hierarchy
of figure and ground characteristic for Cézanne's paintings.[8] In the
late works, the brushstrokes form color patches built up into a network
of repetitions and resemblances that traverses the contours of the

represented objects. As a consequence, figure and ground merge, and the mimetic illusion of the picture becomes incoherent, while the brushmarks display rhythms which may or may not trace the contours of the motif.[9] The compositional and the representational order engage in a process of exchange,[10] for "[t]he general principle at work in [Cézanne's] art is analogy: one thing is made to look like, or somehow be like, another, despite the differences and dissimilarities that otherwise obtain."[11] The taches are interrelated, and yet remain distinct, often separated by white intervals. The "unfinishedness" of Cézanne's paintings is an integral element of the pictorial organization. At the same time, the zones of white canvas show (and signify[12]) the processual character and conceptual openness of Cézanne's pictures and provoke an activity of the viewer that Stein, in her comments quoted above, calls "reading."

Cézanne famously coined the term *réalisation* to characterize his artistic aim, which he once described as attempting "to see like a newborn child."[13] Stressing aspects of process and movement, *réalisation* has been widely and controversially discussed by critics, art historians, and fellow artists. Did Cézanne's impressionist aims inhibit "his observing an object as a differentiated part of a whole 'sensation' of nature," as Richard Shiff claimed?[14] Or were the distortions of the paintings conceptually motivated, amounting to a "drama of pictorial integration" that stages the "mosaic of decisions that determine [the painting] *becoming* a work of art," as William Rubin argued?[15] Did Cézanne attempt "to paint the primordial world" as an "emerging order" of "objects in the act of appearing," as phenomenologist Maurice Merleau-Ponty wrote?[16] Or did Cézanne's "relentless attentiveness to the data of the senses" bring about "a dissolution of unity, a destabilization of objects," which displaces the body of the viewer "into a stream of change, of time," as Jonathan Crary maintained?[17] Stein's appreciation of Cézanne's art never wavered, but what consequences she drew from it varied over time. In the first part of my essay, I will show how Stein used Cézanne's picturing as a foil for her literary experiments. In the second part, I will analyze Stein's portrait of Cézanne both as a homage to the artist and a modernist *paragone*.

There are two artistic strategies which Stein discovered in looking at Cézanne's paintings. Cézanne paid close attention to the cognitive processes involved in perception and decided to present the processes rather than represent the results. This mode of presentation is a self-referential mode of picturing: it makes the viewer experience the production of a picture as the transformation of sensation into visual

signs by a synthesizing act of the imagination. Cézanne's paintings suspend this act of imagination and thereby make it visible—as a lack that keeps the correlation between visual sense data and visual meanings open and variable. "Looking and looking" at Cézanne's pictures, Stein submitted to this experience of picturing again and again. She had studied philosophy and psychology with William James and had conducted psychological experiments at the Harvard Psychology Lab. For her, the cognitive act of the synthesizing imagination translated into the habitual act of integrating sense data into visual signs respectively, which in turn relied on visual schematizations also formed through habit. Cézanne's artistic imagination was no different from any other painter's or indeed anyone else's, but his eye-opening insight consisted in finding a way to visually (re)present picturing (which for Stein turns the canvas into something akin to a text in that it requires reading). At the same time, Cézanne's picturing could serve as a model for her writing only in a limited way since the reader deals with several sorts of sense data simultaneously: in order to create meaning, visual data (consisting of letters, but also of blanks and typographical signs) must be recognized as referring to words and sentences, as culturally coded schematizations of sound "images." But of course words and sentences are not sound "images." Not all words are referential: pronouns refer to recursive processes, conjunctions create logical connections, tropes interlink words with other words; and then there is grammar as a normative set of schematizations which turns the temporal sequentiality of sounds into larger recognizable patterns. Looking and looking at Cézanne's paintings as experiments with picturing, Stein set herself the aim of making the reader aware of the process of imagination as a habitual process of integrating sense data through pattern recognition. But she also came to see herself as outperforming Cézanne's picturing; since in writing, the suspension of the synthesizing act allows for a variety of different experiments—with sound, with time, and with grammatical and logical order.

In the interview quoted above, Stein described Cézanne's artistic innovation as an egalitarian composition, a conceptualization that reflected her own concerns in writing *Three Lives* (finished in 1906 and published in 1909). In the life stories of lower-class women that make up the volume, the protagonists are treated by the narrator as contemporary social types defined on the basis of class and gender, and in the

case of "Melanctha," also race. The quoted dialogues of the characters are studded with dialect phrases and repetitive speech patterns, and their behavior is shown to mainly consist of unconscious habits. There thus appears to be a profound disparity between each servant-woman's consciousness and the narrator's consciousness, as the latter articulates a panoramic knowledge of society while the servants are confined to a very constrained social world. But the narrator's characterization of the protagonists as social types is undermined by a compositional use of repetition: the repetitive speech patterns occur in both the servants' and their mistresses' discourse — and in the narrator's discourse as well. Initially, such repetitions appear as an ironical mimicking of a servant's way of speaking; after all, *Three Lives* was inspired by Flaubert's *Trois Contes* (1877) and his ironical use of free indirect discourse which fuses the narrator's and the characters' voices. But in *Three Lives*, this merging of voices also occurs in passages clearly marked as narrative commentary, and the irony turns against the narrator's authority and unmasks it as pretentious and self-aggrandizing. As the differences among the characters and between the characters and the narrator become blurred, the narrator's psychological insight appears to be built on a lack of self-reflexivity and an unconscious complicity with social privilege.[18] Compositionally, the repetitions in *Three Lives* function like the color patches in Cézanne's paintings, for they dissolve the hierarchy of narrative levels. As a consequence, the narration is turned into a decentered textual field organized by a network of similarities and nodal points of heightened intensity. There is the *representational* meaning of the repetitions bound up with the concepts of character, gender, race, and class, and there is a *self-referential* meaning of the repetitions as literalizations of mimetic imitation. In addition, repetitions figure *rhetorically* as acts of confirmation, as instructive demonstrations, or as ironical gestures. And there is a *performative* meaning of repetition as iteration that works against the linearity of the life story, and its conventional form as a process of development, by exposing the insistence of desires as intertwined with social conditions that give them their form through habit. The lack of imaginative synthesis thus throws several distinct strata of textual signification into relief that lend themselves to different discursive regimes of meaning.

A different view of Cézanne's art can be culled from an entry in one of Stein's notebooks from 1909: "I believe in reality as Cézanne or Caliban

believe in it. I believe in repetition. Yes. Always and always, must write the hymn of repetition."[19] The parallelism of the first and the second sentence highlights two artistic credos from which Stein deduces her conclusion. The pairing of Cézanne with Caliban indicates that in 1909 Stein read, as did Merleau-Ponty many years later, Cézanne's *réalisation* as an effort to disclose a primordial form of reality.[20] The allusion to *The Tempest* explains why: Prospero taught Caliban to speak and conceptually divide up the world. Caliban's acquisition of language is bound up with his subjection to a master, which is why he famously claims to have only learned to curse. But Caliban also appears to possess a gift for poetry, as is shown when he lovingly describes his island home as "full of noises / Sounds and sweet airs, that give delight and hurt not. / Sometimes a thousand twangling instruments / Will hum about mine ears."[21] To speak means to use signifiers employing a limited and differentially organized spectrum of sounds, and to subject oneself to the performative force of language, which shapes human perceptions by filtering them through a differentially organized conceptual grid. Having learned to speak, Caliban cannot return to his former state of nature, but he retains a sensitivity to the "noises, sounds, and sweet airs" of nature.

Walter Pater famously wrote that "all art constantly aspires to the condition of music."[22] Stein reconfigured this symbolist idea under the auspices of Cézanne and Caliban. This evocation of an undifferentiated multitude of aural perceptions can be related to two types of Stein's portraiture. The first is concerned with the psychological analysis of character and bound up with a technique she called "talking and listening." If Cézanne showed through picturing how a force field of visual and tactile sensations is filtered and streamlined into signs organizing the perception of objects, Stein showed that listening is more than a decoding of the meaning. Since speaking means to represent a subject for another subject, listening can be extended to the force field of speech as both coded and uncoded sound production in order to register a subject's preference of certain patterns of words, rhythms, tones of voice, and structures of emphasis. Stein's portraits of Matisse and Picasso (both 1912) are built on this insight.

In *Tender Buttons* (1914), a collection of texts which Stein characterized as "portraits of things," she employs different strategies: the meaning of words is no longer determined by syntax and context, because the words are arranged into contingent sequences; the phonetic and syllabic components of the words are made productive, generating "poetic" similarities; puns and anagrams make use of the visual

dimension of writing to create uncoded forms of creating coherence. The result is the "noise" of a chaotic agglomeration of words, alternating with moments of "harmonies of sweet airs," when rhymes, rhythms, or puns suggest possible paths to construct reference and coherence. When such texts are read aloud and the reader's body is turned into an instrument that "hums about her ears," the portrayed object "appears" flitteringly until it is once again dissolved in the noise. Again, Walter Pater may be quoted here, who came close to Cézanne's concept of picturing when he wrote, "'To see the object as in itself it really is' has been justly said to be the aim of all true criticism whatsoever: and in aesthetic criticism the first step towards seeing one's object as it really is, is to know one's own impression at it really is, to discriminate it, to realise it distinctly." [23] Held together by acoustic, rhythmic, and semantic recurrences, the texts in *Tender Buttons* neither represent nor categorize the things they "portray," but present verbal equivalents of the things in question by weaving interlocking chains of words around the object's name, visual *gestalt*, and affective content.[24]

Only in her lecture "Pictures," written for her reading tour across the United States in 1933–34, did Stein describe Cézanne's paintings (and his mode of picturing) in some detail. Starting with her responses to paintings in her early youth, Stein reviews her aesthetic self-education by going through a long list of painters and museum collections. These snippets of memory are presented as elements of a process of retrospective self-reflection: Stein tries to understand the aesthetic principles that inform her value judgments when "looking at oil paintings." She remembers that she "liked Rubens landscapes because they all moved together," and that she "liked Titians because they did not move at all." Paintings by Velasquez "bothered" her, "because they were too real and yet they were not real enough," while El Greco "excited" her, because "there the oil painting neither moved nor was it still nor was it real." [25] Stein obviously responded in a relaxed and rather indifferent manner to paintings whose representational strategies could be unequivocally defined. In contrast, there were paintings that provoked emotions in Stein ranging from slight irritation ("bothered") to ambivalent intensity ("excited"). She attributed these responses to the contradictory structures or structural imbalances of the paintings in question. It is the process of reception she is concerned with. Looking and looking is more than just looking: it indicates a growing intensity,

Gertrude Stein's Portrait of Cézanne

of being provoked to look again and again, a process of being challenged and getting involved in one's own receptivity to the power of the painting.

Stein formulates her judgments by applying the same small number of conventional criteria of art criticism to each painting. The resulting repetitions and syntactic parallelisms emphasize the methodical nature of her comparative analysis. They also provide the background to mark the deviations from the steady interconnecting flow of remembrance and reflection when she shows how the memories of her ambivalent responses to the paintings of Velasquez and El Greco influence the level of affectivity of her discourse in the present. The review culminates in Stein's encounter with Cézanne's works, which is staged as an enigmatic yet ultimately pleasurable experience (a presentation that fits Kant's definition of the sublime as an experience that unsettles the synthesizing power of the imagination).[26] Stein first presents the reader with a train of thought set in motion by Cézanne's "pictures" and then switches her terminology by addressing them as "oil paintings":

> And then slowly through all this and looking at many many pictures I came to Cézanne and there you were, at least there I was, not all at once but as soon as I got used to it. The landscape looked like a landscape that is to say what is yellow in the landscape looked yellow in the oil painting, and what was blue in the landscape looked blue in the oil painting, and if it did not there still was the oil painting, the oil painting by Cézanne. The same thing was true of the people there was no reason why it should be but it was, the same thing was true of the chairs, the same thing was true of the apples. The apples looked like apples the chairs looked like chairs and it all had nothing to do with anything because if they did not look like apples or chairs or landscape or people they were apples and chairs and landscape and people. They were so entirely these things that they were not an oil painting and yet that is just what the Cézannes were they were an oil painting. They were so entirely an oil painting that it was all there whether they were finished, the paintings, or whether they were not finished. Finished or unfinished it always was what it looked like the very essence of an oil painting because everything was always there, really there.[27]

Even after many decades, the memory of Stein's first encounter with Cézanne's paintings is so powerful that it disrupts the order of her discourse—or so she makes the reader feel, by using the colloquial interjection "there you were." But this disruption is immediately reintegrated: repeating her words, but changing the pronoun and the verb form to the first person, she turns the interjection into a self-reference and thus performatively highlights her resumption of reflexive self-control. Stein's account for the stunning quality of Cézanne's paintings is threefold. At first she stresses their similarity with other pictures: like the painters before him, Cézanne uses color mimetically, which is why his paintings resemble the objects they represent. However, with some of his paintings, the search for such resemblances fails, and in other paintings, the illusionistic effect is destroyed or at least much reduced by their unfinishedness. Trompe l'œil can thus definitely be ruled out—and yet the paintings outperform even the most exact painterly representations by making their objects intensely present to the viewer. Cézanne's apples may or may not look like apples, but they are apples.

On the one hand, Stein explains Cézanne's works in a similar manner as the paintings by Velasquez and El Greco, namely, by negations and paradoxes: conceptual thought can only register the paintings' refusal to conform to the established conventions of picturing. But Stein also comes up with positive descriptions: "the apples *are* apples," and "everything was always there, really *there*." With the help of verbal gestures such as tonal emphasis and the repetition of the deictic term "there," Stein stresses a unique ontological effect of Cézanne's paintings, links it to their indexical structure, and ends with a paradox: by pointing the viewer's attention to the referential meaning in the real world, and at the same time to the "oil paintings" as artistic productions, Cézanne exposes the painting as an overdetermined zone of picturing which stages and prolongs the cognitive processes of visual perception by withholding a stable image. Cézanne's picturing created an epiphany for Stein by making her understand that the presence of recognizable objects in the world is the result of acts of imagination that are continuously performed by every subject but rendered visible and readable as such for the first time by Cézanne's oil paintings.

In the lecture, Stein continued her analysis of Cézanne's work with an abridged version of her portrait of Cézanne (written in 1923).[28] It is reprinted below in its full length:

CÉZANNE

The Irish lady can say, that to-day is every day.
Caesar can say that every day is to-day and they say that
every day is as they say.

In this way we have a place to stay and he was not
met because he was settled to stay. When I said settled
I meant settled to stay. When I said settled to stay I meant
settled to stay Saturday. In this way a mouth is a mouth.
In this way if in as a mouth if in as a mouth where, if in
as a mouth where and there. Believe they have water too.
Believe they have that water too and blue when you see
blue, is all blue precious too, is all that that is precious too
is all that and they meant to absolve you. In this way
Cézanne nearly did nearly in this way Cézanne nearly did
nearly did and nearly did. And was I surprised. Was I
very surprised. Was I surprised. I was surprised and in that
patient, are you patient when you find bees. Bees in a
garden make a specialty of honey and so does honey.
Honey and prayer. Honey and there. There where the grass
can grow nearly four times yearly.

Obviously this portrait neither characterizes Cézanne as a person
nor describes his paintings. It shares some general features with
many other texts by Stein. The sentences are decontextualized, their
grammatic structure is simple and often fragmentary, and the punctua-
tion is irregular. Repetitions abound: they occur on the level of sounds,
syllables, words, combinations of words, and sentences, creating
recursive structures of self-quotation, mirror effects, series of emphatic
confirmations, rhymes, and rhythmic movements. There are also
some specific features of the text that can be readily observed at a
cursory glance. The deictic phrase "in this way" occurs five times; it is
used anaphorically and thus forms a prominent element of the text's
internal structure. The color "blue" is mentioned three times, but
this series remains restricted to a single sentence; "blue" also marks
the only manifest reference to Cézanne's art. The word "bees" occurs
twice, and "honey" four times. In the absence of conventional
meaning, some words suggest themselves to be grouped together into
semantic clusters: "water"—"blue"—"see" ["sea"], for example, or
"bees"—"honey"—"grass." The words "mouth," "say," "honey," and
"water" form a third cluster that intersects with the other two and
constitutes a common ground of orality, which again self-referentially

stresses the importance of sound, and hence the linguistic materiality of Stein's portraiture as compared to Cézanne's.

Then there are names and personal pronouns: "Caesar" and "Cézanne," "he" and "we" and "I" and "they" and "you." Together, they form a matrix of relations among subjects as the basic structure of the portrait. "He" and "I" presumably refer to Cézanne as the portrayed subject and to Stein as the portraitist, respectively. "We" is an ambiguous term. It refers to the community to which the speaker (presumably Stein) belongs, but may or may not include "the Irish lady," "Caesar," and "they," and probably excludes the subsequent "he." Linked with "Cézanne" by alliteration, "Caesar" means Stein herself (who would thus occasionally assume an external vantage point toward herself and talk about herself in the third person, as she did ten years later in *The Autobiography of Alice B. Toklas*). For Stein not only called herself "Caesar" in her posthumously published erotic texts, but because of her haircut and her regal demeanor, she reminded many of her friends of a Roman emperor. In an act of rebellion against the traditional regime of power, Caesar famously crossed the Rubicon River and inaugurated a new era of world history; he thus provided Stein with an image for herself as a heroic transgressor of artistic conventions (and of sexual conventions as well, since Caesar's alleged homosexual behavior was a subject of gossip in antiquity). Linked with Cézanne by alliteration, "Caesar" casts Stein in the role of the ruling figure of modernism whose artistic achievements are prepared by her precursor Cézanne.

Playing with the similarities and differences of the sounds of the names, the pairing of Cézanne and Caesar suggests that the portrait will present Stein's view on the similarities and differences between the work of the two artists, giving Cézanne precedence and Stein prominence in the history of modernism. The first paragraph has expository character. While the "Irish lady" (probably an allusion to Joyce's character Molly Bloom—*Ulysses* had appeared in 1922) can say that "to-day is every day," "Caesar"/Stein can say that "every day is to-day." While Joyce turned a presentation of a single day in Dublin into a timeless monument of modern writing, Stein's Caesarean maxim was that every day constitutes a "to-day," another chance to throw the dice and break the regime of tradition. The paragraph ends with the statement "[t]hey say that every day is as they say," which either confirms Joyce's and Stein's conviction of the truth of their vision and underlines their performative potency as artists or stresses their difference from the anonymous crowd content with knowledge of everyday life. Cézanne is not mentioned in the first paragraph, but his name is

present in several acoustic allusions—in the alliteration with "Caesar," and in echo of the first syllable in the reiterated verb form "say": there are echoes of *Cézanne* in what Joyce and Stein *say*.

Given this reading of the first paragraph, it may be expected that the second paragraph will address and elaborate the argument inscribed in the first paragraph, namely, that Cézanne's work influenced contemporary avant-garde writing. This would require Stein either to describe and discuss some of his work (which is evidently not the case) or to transpose (the structure of) Cézanne's work into her writing as a kind of quotation or allusion. The portrait would then refer to Cézanne's work but be a work of Stein's; while presenting Cézanne's mode of picturing, it would also articulate Stein's difference from it. The deictic phrase "in this way" occurs five times in the text and may be understood self-referentially, that is, as a strong hint addressed to the reader to regard the composition of the portrait as the key to the problem of defining contemporary writing both as a consequence of Cézanne's work and as a move beyond its limits. Many sentences are incomplete or constructed by a montage of decontextualized words, but the gaps can be filled by the reader—tentatively to be sure—by moving forward or backward in the text in the attempt to find connections or clues by closely observing semantic, syntactic, and, most importantly, acoustic similarities. Dorrit Cohn once stated that all interior monologues "conform to two principal tendencies: syntactical abbreviation and lexical opaqueness,"[29] and Stein's portrait displays both characteristics.

"In this way we have a place to stay and he was not met because he was settled to stay." A chain of rhymes links the sentence to the first paragraph ("day"—"say" ["Cé"]—"way"—"stay"), which suggests that the pronoun "we" refers to the group of contemporary avant-garde writers who conceive of every day in a new way. This reference would then signal a shift of perspective from an external to an internal angle, and Stein would now be speaking as a member of the group in question. The text oscillates between distance and proximity, between objectivity and self-reflection based on Stein's personal involvement in the matter. The group of "we" is situated in the present and thus juxtaposed to "him," who is referred to in the past tense. This contrasting reading is supported by the verb "to settle," which means to occupy a permanent dwelling place, while "to have a place to stay" signifies some temporary lodging. In sum: "we" are alive and still on the move, while Cézanne cannot be met because he belongs to the past. He had died in 1906, and at the time of the creation of the portrait, his claim

to fame had indeed been settled, and he had been assigned an out-standing but fixed place in the history of art.

These statements are reiterated in the following sentences. Engaging in an interior monologue which amounts to a dialogue with the reader, the speaker recursively reiterates her previous remark and quotes it to both confirm and revise it: "When I said settled I meant settled to stay. When I said settled to stay I meant settled to stay Saturday." The supplement in the third repetition of the phrase "settled to stay" comes as a surprise and retroactively transforms the semantic architecture of the sentence. "He was settled to stay Saturday" no longer signifies Cézanne's immobility, but rather the opposite by indicating a short rest. Stein's weekly soirées on the rue de Fleurus (where she and Alice B. Toklas and her artist friends had a place to stay) took place on Saturdays. Cézanne, a recluse, who had withdrawn from Paris to his hometown, Aix-en-Provence, and whom Stein never met, is thus posthumously integrated into the circle of artists around Stein. It is in their work that he lives on.

The next sentence seems cryptic at first: "In this way a mouth is a mouth. In this way if in as a mouth if in as a mouth where, if in as a mouth where and there." Again, repetitions and variations are used and establish a recursive structure by which a statement is confirmed and at the same time thoroughly revised. "Mouth" can be readily decoded as a metonym for language and speech. The two sentences performa-tively elaborate and metatextually theorize the point Stein had just made by adding the word "Saturday" to a sentence that is otherwise repeated identically (and had been previously defined as complete by punctuation). Verbal statements are never identical but change their meaning subtly or radically with each occurrence; all it takes is shifting the emphasis, replacing or adding or leaving out a word, framing a sentence by a conditional conjunction ("if"), or changing the context of a word ("where and there").[30] But "mouth" can also be used as a metaphor or a catachresis (e.g., "the mouth of a river"), and this latter term may cataphorically refer to the noun "water" in the next sentence: "Believe they have water too." It is unclear whom the imperative "believe" addresses. Is it the reader? Or is Stein talking to herself in an unsignaled interior monologue in which the first-person pronoun is elided? Perhaps "they" (contemporary writers such as Joyce and herself) "have water too" because they are, like Cézanne, engaged in a new mode of (re)presentation.

The enigmatic phrase "they have water too" is repeated as the beginning of the next sentence and engenders another performative

instance of self-reflection and revision. As the sentence continues, "water" is semantically connected with "blue" while "too" is reiterated several times and rhymes with "blue" and with "you," a (once again ambiguous) pronoun. "Believe they have that water too and blue when you see blue, is all blue precious too, is all that that is precious too is all that and they meant to absolve you." This is a sentence made up of many internal rhymes and intersecting rhythms. Its meaning hinges on the segmentation the reader chooses. But in any event, the color blue is at the center, a decision of Stein's that is highly motivated in a portrait of Cézanne since blue is the dominant color of many of his paintings, and many viewers have commented on this fact. While Cézanne himself linked his use of blue to his effort "to give the feeling of air," [31] most viewers have ascribed symbolic or atmospheric value to it.[32] But to Stein such interpretations (by an anonymous crowd of "they") rather appeared as attempts to "absolve" Cézanne (presumably from the sin of deviating from the norm of mimesis). "Believe they have that water too and blue when you see blue" is a complex construction indeed, though its beginning once again stages the point that was made by the previous sentence. The repetition is almost identical; but the deictic demonstrative pronoun "that" has replaced the definite article, the phrase "and blue" has been added, and the subclause "when you see blue" follows as an afterthought and spells out the conditions for the truth claim of the main clause. If the pronoun "they" again refers to "to-day's" writers, the sentence addresses their capability to (re)present the visible world as Cézanne could. They have "that water too" and they have "blue when you see blue"—but of course they cannot represent blue water visually as a painter can by using color; they have to use the *words* "blue" and "water." The remainder of the sentence, "is all blue precious too, is all that that is precious too is all that," ponders the question of the putative symbolic value of the color blue in Cézanne's paintings, with the repetitions/the mirroring/the chiastic permutations performatively indicating both the intensity and inconclusiveness of Stein's ruminations, and the nature of the problem she is struggling with: mimesis, imitation, representation as reduplication, the founding concept of Western aesthetic theory. This reading is supported by Stein's "Pictures" lecture quoted above, which Stein used as a frame for her portrait of Cézanne. There "blue" is discussed as the point of convergence between visual perception and conventional visual representation, and as the point of divergence between conventional representation and Cézanne's picturing: "what was blue in the landscape looked blue in the oil painting, and if it did not there still was the oil painting, the oil painting by Cézanne."

The overall strategy of Stein's portrait of Cézanne reminds one of Cézanne's taches with their double function of referentiality and self-referentiality. But it is also becoming evident that the text possesses more possibilities to realize such a structure than a painting does. In the next sentence of the portrait (once again introduced by the deictic term "in this way") Cézanne is finally mentioned. "In this way Cézanne nearly did nearly in this way Cézanne nearly did nearly did and nearly did." Because of the elliptic structure of the sentence, it is unclear what it was that Cézanne did, but because of its grammatical structure, it is clear that Stein emphasizes both Cézanne's passionate effort and his closeness to certain results he, however, did not achieve. As before, repetitions, mirrorings, and permutations abound and revolve around the crucial word that is lacking. With the series of repetitions, Stein may wish to highlight Cézanne's long struggle with motifs, such as the Mont Sainte-Victoire, and/or his consistency in committing himself to his aesthetic project of *réalisation*. At the same time, the series of repetitions also stages Stein's own signature device as a writer. But what was it that Cézanne "nearly did"? And is what he nearly did something that Stein in contrast did do? Presumably it is the step into modernism, which she claimed to have accomplished in *Three Lives* because of her encounter with Cézanne's paintings, when she grasped Cézanne's strategy of leaving parts of the canvas unfinished in order to highlight the painting's materiality and at the same time make the viewer aware of her imaginative investment in the painting by her effort of filling in the blanks.

In the next sentences, Stein stages the overwhelming experience of looking and looking at his work by repeating a phrase that straddles the border between a statement and an incredulous question by dislodging the personal pronoun "I" from its usual position in the sentence: "And was I surprised. Was I very surprised. Was I surprised." Only with the fourth attempt is she able to break away from the series and return to the regular grammatical form of the statement: "I was surprised." But she does not explain why she was surprised; she leaves that to be deduced from the mode of her coming to terms with that experience. The changing intensities and grammatical forms of this unsettling surprise correspond to the previous statement: "Cézanne nearly did." The symmetry suggests that the text works backward to indicate the process of recollection and notes the mode of handling the surprise before mentioning the surprise itself. But the sentence that brings the normalization of Stein's state of exception is longer than I just quoted it. It runs, "I was surprised and in that patient, are you patient when you

find bees." Stein calls her own statement—that she was surprised and patient—retroactively into doubt when she adds the rhetorical question. Cézanne's paintings obviously piqued her, provoked her to imitate him and outperform him to do what he only came close to doing.

The final sentences of the portrait are dedicated to a demonstration of Stein's achievement by engaging in a playful painting with words. This is the limit case of the concept of picturing, for Stein does not produce a picture at all. Instead she refers to paintings by Cézanne as objects of her desire and admiration, and the reason for desire and admiration is their staging of picturing. In these final sentences, many words are semantically interconnected, and there are repetitions and rhymes, but the meaning is at first entirely opaque: "Bees in a garden make a specialty of honey and so does honey. Honey and prayer. Honey and there. There where the grass can grow nearly four times yearly." But the group "bees"—"garden"—"honey"—"grass" suggests an idyllic landscape, perhaps in the South of France, where it is warm and where grass grows four times a year: the landscape that Cézanne painted numerous times. As Stein tells the story in *The Autobiography of Alice B. Toklas*, at their very first visit to Cézanne's gallerist, Vollard, in the fall of 1904, Gertrude and Leo Stein wanted to buy such a landscape, but Vollard was reluctant and only showed them some small studies. But the Steins insisted:

> They said what they wanted was one of those marvelously yellow sunny Aix landscapes of which Loeser had several examples. Once more Vollard went off and this time he came back with a wonderful small green landscape. It was lovely, it covered all the canvas, it did not cost much, and they bought it." [33]

The Steins wanted oil paintings; Vollard showed them studies. They wanted a yellow painting; he gave them a green one—which turned out to be a good thing after all, as it was satisfactory to the as yet untutored taste of the Steins (it pleased the eye and did not appear unfinished), and to their limited budget as well. The self-ironical narrative tone highlights the Steins' naïveté before Cézanne taught them to "look."

The Cézanne portrait's final sentences probably refer to this scene, that is, to the painting the Steins bought, to the kind of painting they would have liked to buy, and to the kind of study Vollard initially offered them. Figure 1 shows *La Conduite d'eau* (ca. 1879), which

1
Paul Cézanne,
La Conduite d'eau
(The spring house),
ca. 1879. Oil on
canvas, 23 ⅝ × 19 ¹¹⁄₁₆ in.
(60 × 50 cm).
The Barnes Foundation,
Philadelphia, BF129.

Ulla Haselstein

Gertrude Stein's Portrait of Cézanne

the Steins bought, and figure 2 shows a watercolor of Mont Sainte-Victoire from circa 1902–1906 as an example of a "yellow" study Vollard might have offered them. I include them here as illustrations that highlight the difference between Cézanne's picturing and the lessons Stein drew from it. For "grass" is semantically, metonymically, and perceptually connected to the word "green," while "bees" and "honey" are connected to the word "yellow" (the portrait may have referred to this scene right from the beginning, since the latent word "green" connects the final sentence to the first where the "Irish lady" figures prominently). The memory of the first purchase of a painting by Cézanne thus serves as an internal frame to the portrait. With the next two short fragmentary sentences—"Honey and prayer. Honey and there"—Stein alludes to Cézanne's collection of sense impressions of nature, which he condensed in the honey (colors) of his landscapes ("there") in order to express his religious reverence of nature. But since only a text, not a painting, may be said to be taken into the mouth and tasted (when read aloud), "honey" may also refer to Stein's portrait as a sweet concoction made from a collection of her thoughts about Cézanne's paintings.

And then there is the color of sound: "there where the grass can grow nearly four times yearly" contains the words "grass" and "grow," whose visualization as "green" is supported by their changing vocals. The rhyme "nearly"—"yearly" realizes the acoustic materiality of the words in a harmonious repetition, "sweet airs," to quote Caliban (and indeed, the latent word "ear" is realized in both "nearly" and "yearly"). And with this latter strategy as a cue, the reader can continue to play with words and colors and discover anagrams in the last sentence, for the letters that make up the words "grass," "grow," "nearly," and "yearly" can be rearranged to form the words "green" and "yellow"—but also "orange" and "grey."

Literary portraits must work around the problem that they lack the perceptual concreteness of portrait paintings. Some authors stress physiognomic details as clues to the interiority of the portrayed person (relying on physiognomic theories such as Lavater's or on conventional semiotics of the face). More often, literary portraits are organized anecdotally: on the basis of a personal encounter of the portraitist with the portrayed person, the portraitist recollects impressions of the other's face, posture, and demeanor, then moves on to observations

2
Paul Cézanne,
Mont Sainte-Victoire,
ca. 1902–1906.
Watercolor and pencil
on paper, 16 ¾ × 21 ⅜ in.
(42.5 × 54.2 cm).
The Museum of
Modern Art, New York.
Fractional gift of
Mr. and Mrs. David
Rockefeller (the donors
retaining a life interest
in the remainder).

of the other's behavior and speech, and integrates such evidence into a general judgment of character or perhaps treats these things as clues to the invisible interiority of the portrayed person. The subjective factor is crucial for any literary portrait, as it testifies to the impact of the portrayed person's presence on another subject and the way this presence is given meaning. What is thus at stake in a literary portrait is the encounter itself—which is communicated to others by one of the two persons involved who reveals his or her prejudices, perceptual acumen, impressionability, naïve admiration, or hostility in the process. The literary portrait thus prevents the reader from making the conventional shortcut from text to referential reality. Instead, the reader is aware of witnessing one person representing the impression and impact of another person. The subject matter of a literary portrait is not the portrayed subject but an intersubjective relation between the portrayed subject and the portraitist; but since it is the portraitist who attempts to read the character of the other person, the primary subject of a literary portrait is indeed the portraitist (who may, however, prefer to efface herself).

Gertrude Stein's Portrait of Cézanne

Stein never met Cézanne. Her portrait concentrates on Cézanne's paintings and her responses to them. The portrait refers to Cézanne's paintings as Stein first saw them and as she later learned to see them, and it is mindful of Cézanne's aesthetic principles (as she constructed them), while at the same time presenting Stein's own aesthetic principles, which she developed as a consequence of her "looking and looking" at Cézanne's paintings. The portrait is thus a homage to Cézanne—but also a profession of Stein's artistic self-confidence. It is constructed to render her surprise at the initial encounter with Cézanne's paintings, to present her understanding of this surprise, to demonstrate the consequences of this understanding for her own work, and to emphasize the difference of the artistic media. The reader is to tentatively fill the lacunae—to register the figural aspects of words, to make rhymes and rhythmical patterns audible, to observe repetitions, and to discover anagrams for words signifying different colors— in order to realize Stein's indebtedness to Cézanne's picturing, but also so as to recognize her moving beyond the limit of picturing as an artistic goal for literature.

1 Cf. Gertrude Stein, *The Autobiography of Alice B. Toklas* (1933; Harmondsworth, UK: Penguin, 1986), 35.

2 In later years, Gertrude and Leo Stein gave different accounts about who made the first purchase and when it was made. See note 34 below. One of Stein's early Portraits, "Monsieur Vollard et Cézanne" (1912) commemorates the purchase; Cf. Stein, *The Autobiography of Alice B Toklas*, 35. The portrait is reprinted in Stein, *Portraits and Prayers* (New York: Random House, 1934) 37–39.

3 For the collection, cf. Janet Bishop, Cécile Debray, and Rebecca Rabinow, eds., *The Steins Collect* (New Haven, CT: Yale University Press, 2011).

4 Cf. Leo Stein's letter to Mabel Dodge, quoted in James R. Mellon, *Charmed Circle: Gertrude Stein & Company* (Boston: Houghton Mifflin, 1974), 63–64.

5 Cf. Stein, *Autobiography of Alice B. Toklas*, 39. Stein's admiration for Cézanne has often been commented on; cf., e.g., Jayne L. Walker, *The Making of a Modernist* (Amherst: University of Massachusetts Press, 1984); or Tamar Darb, "To Kill the Nineteenth Century: Sex and Spectatorship with Gertrude and Pablo," in *Picasso's "Les Desmoiselles d'Avignon,"* ed. Christopher Green (Cambridge: Cambridge University Press, 2001), 55–76.

6 Robert Bartlett Haas, "A Transatlantic Interview," in *A Primer for the Gradual Understanding of Gertrude Stein* (Los Angeles: Black Sparrow Press, 1971), 11–35 (quote on pp. 15–16). Stein characterized Picasso's cubist painting in exactly the same terms as Cézanne's painting, namely, as a composition in which "each thing was as important as any other thing." Gertrude Stein, *Picasso* (1938; New York: Dover, 1984, 12). In a recently published collection of essays on Cézanne's reception in the arts and sciences, Stein is not mentioned: cf. Torsten Hoffmann, ed., *Lehrer ohne Lehre: Zur Rezeption Paul Cézannes in Künsten, Wissenschaften und Kultur, 1906–2006* (Munich: Fink, 2008).

7 Théodore Duret quoted in Richard Shiff, "Sensation, Movement, Cézanne," in *Classic Cézanne*, ed. Terence Maloon (Sydney: Art Gallery of New South Wales, 1998), 22.

8 I would like to thank Monika Wagner (Hamburg), Martin Wagner (Hamburg), and Karin Gludovatz (Berlin) for their advice on Cézanne.

9 Yve-Alain Bois characterized Cézanne's brushstrokes as a "musical form of notation." "Cézanne: Words and Deeds," *October* 84 (1998), 31–43 (quote on p. 39).

10 Richard Shiff, "Cézanne's Physicality: The Politics of Touch," in *The Language of Art History*, ed. Salim Kemal and Ivan Gaskell (Cambridge: Cambridge University Press, 1991), 129–82 (esp. 152ff.). Shiff also discusses the implicit political allegory of "collaboration, reciprocity and social bonding" of Cézanne's paintings but concludes that the "literalness of Cézanne's art" resists "the distancing act of interpretation" (168–69).

11 Ibid., 142.

12 Cf. Richard Shiff, *Cézanne and the End of Impressionism* (Chicago: University of Chicago Press, 1984), 123.

13 Jules Borély, "Cézanne at Aix," in *Conversations with Cézanne*, ed. Michael Doran, trans. Julie Lawrence Cochran (Berkeley: University of California Press, 2001), 19–24 (Cézanne quoted on p. 23).

14 Shiff, *Cézanne and the End of Impressionism*, 213.

15 Cf. William Rubin, "Cézannisme and the Beginning of Cubism," in *Cézanne: The Late Work*, ed. William Rubin (New York: The Museum of Modern Art, 1977), 151–202 (quoted material on p. 189).

16 Maurice Merleau-Ponty, "Cézanne's Doubt" [1945], in *Symbolic Anthropology*, ed. Janet L. Dolgin, David S. Kemnitzer, David M. Schneider (New York: Columbia University Press, 1977), 91–105 (quoted material on pp. 95–96).

17 Jonathan Crary, *Suspensions of Perception: Attention, Spectacle, and Modern Culture* (Cambridge, MA: Harvard University Press, 1999), 298.

18 Cf. my analysis of "The Good Anna" in "A New Kind of Realism: Flaubert and Stein," *Comparative Literature* 61, 4 (2009): 388–99.

19 Unpublished notebook, Yale Collection of American Literature (YCAL).

20 Cézanne had called himself a primitive, and contemporary critics such as Gustave Geffroy, Maurice Denis, and Georges Lecomte defended Cézanne's

primitivism on the grounds of the intensity of his sensations, or, conversely, on the grounds of the naïveté of his conceptualization. As a deviation from academic conventions, Cézanne's primitivism made sense to both the impressionists and the symbolists. Cf. Shiff, *Cézanne and the End of Impressionism*, 168–73.

21 William Shakespeare, *The Tempest*, 3.2.147–50.

22 Cf. Walter Pater, "The School of Giorgione," *The Renaissance* (1910; Chicago: Academy, 1977), 130–54 (quote on p. 135). The essay was originally published in 1877.

23 Pater, preface to *The Renaissance*, xvii–xxv (quote on p. xviii).

24 Cf. my analysis in "*Tender Buttons*: Stein et ses portraits des choses (1914)," in *Carrefour Stieglitz*, ed. Jay Bochner and Jean Pierre Montier (Rennes: Presses universitaires de Rennes, 2012), 339–48.

25 Stein, "Pictures," in *Lectures in America* (Boston: Beacon Press, 1985), 57–90 (quoted material on pp. 72–73).

26 Cf. Jean-Francois Lyotard, "The Sublime and the Avantgarde," in *The Inhuman*, trans. Geoffrey Bennington and Rachel Bowlby (1988; Cambridge: Polity Press, 1991), 89–107.

27 Stein, "Pictures," 76–77. Stein regarded abstract painting as "pornographic"; cf. Stein, *Everybody's Autobiography* (1937; New York: Vintage, 1973), 127.

28 In the lecture, Stein dropped the first half of the second paragraph of the portrait so that it begins with the sentence "In this way Cézanne nearly did." With this cut, the portrait focuses on Stein's first encounter with Cézanne and thus serves as a companion piece to the lecture.

29 Dorrit Cohn, *Transparent Minds: Narrative Modes for Presenting Consciousness in Fiction* (Princeton, NJ: Princeton University Press, 1978), 94.

30 This argument has an equivalent in Cézanne's paintings, which he constantly reworked by adding more dabs of color. Cézanne's techniques "must have seemed incomplete by their very nature, because the suggestion is that more can always be added," writes

Richard Shiff. "Cézanne's Blur, Approximating Cézanne," in *Framing France: The Representation of Landscape in France, 1870–1914*, ed. Richard Thomson (Manchester: Manchester University Press, 1998), 59–80 (quote on p. 67).

31 Cf. Cézanne to Emile Bernard, Apr. 15, 1904, in *Letters*, ed. John Rewald (New York: Hacker Art Books, 1976), 301.

32 The German Symbolist poet Rilke was particularly eloquent about Cézanne's use of blue: cf. Rainer Maria Rilke, *Briefe über Cézanne* (1952; Frankfurt: M: Insel, 1983), 27, 36, 40, 43, 48. William Rubin calls it "the antinaturalist overall blueness," which he links to "the *stimmung* quality of Symbolist paintings." "Cézannisme," 162.

33 Stein, *Autobiography of Alice B. Toklas*, 36. Leo Stein remembered the purchase of the painting differently: he claimed to have bought the painting by himself (at the suggestion of Bernard Berenson), before he saw Charles Loeser's collection in the summer of 1904; cf. Leo Stein, *Appreciation: Painting, Poetry, and Prose* (1947; Lincoln: University of Nebraska Press, 1996), 155. The different accounts have produced considerable confusion concerning the date of the purchase and the identity of the painting itself. In his introduction to Leo Stein's *Journey Into the Self*, Van Wyck Brooks puts the year of Leo Stein's first Cézanne purchase at 1902 (New York: Crown Publishers, 1950) xi. Jayne L. Walker gives the date as 1904: *The Making of a Modernist*, 2. In her biography *Sister Brother. Gertrude and Leo Stein* (New York: Putnam's, 1996) Brenda Wineapple reconciles the siblings' diverging accounts by having Leo buy *Landscape with Spring House* in the spring of 1903, and Leo and Gertrude buy *The Conduit* in the fall of 1903 (cf. 210–11). But the two titles refer to the same painting.

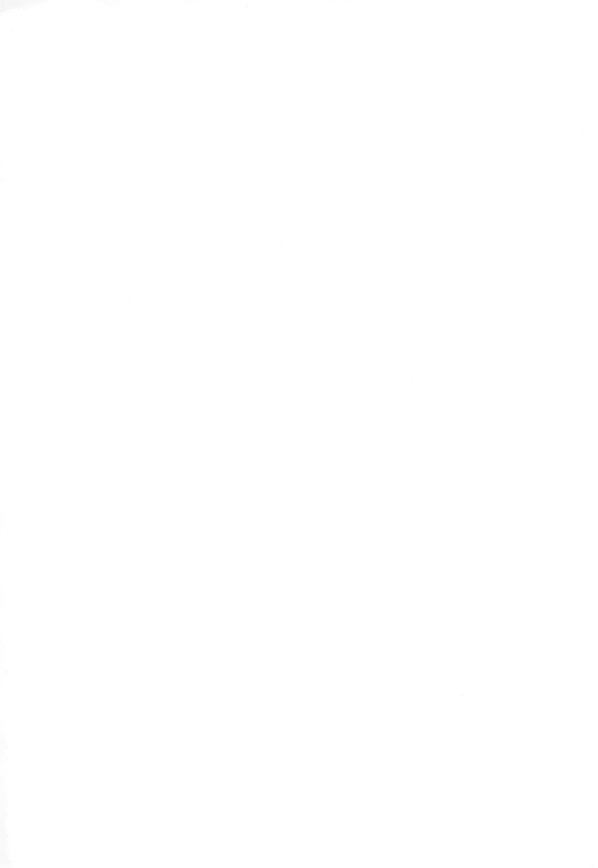

PICTORIAL IS MORE AS THEORY

Robin Kelsey

Pictorialism as Theory

The contours of the category *picture* are neither as obvious nor as firm as they may seem. Tracking them over time betrays subtle historical shifts, oppositions, and particularities of meaning. As America passed from the nineteenth century to the twentieth, the category took on special importance for those extolling the merits of photography. For some, it rationalized shoehorning the new technology as an art alongside painting, drawing, and engraving. For others, it was a means of hailing the radically new relationship that photography had wrought between viewing and being viewed. Although boosters of both kinds often used the term *picture* as though it had a settled meaning, their usage was actually predicated on exploiting its plasticity. As I argue in this essay, some fruitful deformations of the term deserve more attention than they have received.

Understanding these deformations requires a brief return to the long history of *picture* and its kindred French term *tableau*. At critical junctures in the history of the Western tradition, the categories of *picture* and *tableau* have allowed writers to work across artistic boundaries to imagine new aesthetic paradigms. Two cases are especially germane to the present argument. Leon Battista Alberti (1404–1472) entitled his prodigious 1435 commentary on the art of painting *De pictura*. The standard translation of the title as *On Painting* is eminently defensible, but the move from the Latin *pictura* to the English *painting* can obscure the work that Alberti had the Latin term perform.

Robert Macpherson,
*Hall of the Candelabra—
Vatican* (detail, see fig. 1).

176

For Alberti, the value of *pictura* lay precisely in its capacity to transport insights across different arts. As Cecil Grayson observes in the introduction to his authoritative translation of *De pictura*: "In this treatise, and in *De statua*, Alberti is inclined at times to use the term 'pictura' to embrace both painting and sculpture. Certainly for him they had identical objects in imitating Nature; and one of the most important aspects of *De pictura* lies in the assimilation into the art of painting of ideas which he could only have known and seen to have been practiced in sculpture, either in antiquity or among his contemporaries."[1]

The term *pictura* allowed Alberti to bring the practice and theory of painting into a broader cultural scheme.[2] The linchpin of that scheme was linear perspective, a general set of principles designed to interlock representation, beauty, and knowledge.[3] These principles allowed Alberti to encapsulate in the term *pictura* a code of both representation and artistic conduct. As the art historian Jack Greenstein has suggested, Alberti understood *pictura* as demanding that surfaces be built syntactically into a semiotic representation of the substance of things.[4] Across different arts, Alberti made perspective a means of approaching an infinite limit on discrimination and mental ordering.[5] He thus pushed a European tradition of representation toward a new system of correspondence between pictorial signifiers and what they signify. *Pictura*, in short, was less an object category than a semiotic function and a polestar of aesthetic virtue.

The other germane case is that of Denis Diderot (1713–1784) and the French term *tableau*.[6] In his writings from the 1750s and 1760s on art, Diderot used *tableau* to fashion principles that could permit traffic between theater and painting. He was the principal negotiator of what Michael Fried has called the "comprehensive rapprochement between the aims of painting and drama" that occurred in France in the second half of the eighteenth century.[7] In works such as *Entretiens sur "Le Fils naturel"* (1757) and *Discours sur la poésie dramatique* (1758), Diderot urges playwrights to curb their use of coups de théâtre — surprising plot twists or revelations — and rely more on tableaux. Diderot's concept of the *tableau* exalts the display of figures expressively arranged. According to him, the *tableau* must have a seemingly accidental quality, as though its visual properties stem purely from an internal causal chain and not from any consideration of the spectator. "Think no more of the spectator than you would if he did not exist," Diderot advises actors. "Imagine a great wall at the edge of the stage, separating you from the parterre; perform as if the curtain never rises."[8] Bolstered by this imagined fourth wall, the concept of

the *tableau* distilled and privileged the expressive power of sight to fashion a compositional unity.

Diderot employed the term *tableau* to improve painting as well as theater. He thought that the reliance of painting on stale theatrical conventions had led to stilted and inexpressive dispositions of bodies. Seeking to nurture a more refined and compelling visual intelligence in both arts, Diderot shifted emphasis from plot and language to the communicative possibilities of figures artfully orchestrated. As Alberti had used *pictura*, Diderot used *tableau* to reconfigure relations among the arts and to promote a new aesthetic paradigm. Both paradigms exalted the potential for figure groups to bear visual meaning.[9]

A crucial aspect of these categorical moves was their suppression of the viewer as a bodily presence. Alberti's perspectival scheme used geometry to imagine the viewer as the point of an unreal eye. Around it a figure could be drawn, but such illustration was literally beside the point. Diderot suppressed the viewer differently by imagining a wall or curtain excluding the viewer from the space of representation. In both cases, the unity of the fiction — as *pictura* or as *tableau* — required a disavowal of the viewer's corporeal existence. This disavowal established a radical asymmetry between the viewer and the viewed. Bodies viewed, even if configured under the pretense of being unseen, were systematically given over to sight, to the meaning that an inspired disposition of surfaces could convey. The viewer, by contrast, was hidden within a fiction of invisibility. The extreme reduction or buffering of the viewer rendered the viewer universal, even as that universality was reserved and constructed for a privileged few. The viewer was not in the picture, and thus these paradigms were conducive to hiding the social relations that formed him (or her, in the rare case in which such a possibility was entertained).

In return for this bodily suppression, viewers received two important promises. One was a more compelling visual experience. For Diderot, this suppression permitted the fully realized tableau to provide — as Fried has put it — "an external, 'objective' equivalent to [Diderot's] own sense of himself as an integral yet continuously changing being."[10] By accepting disregard, the viewer gained the hope of encountering a unity that shared the marvelous conjunction of mutability and constancy, the internal and infinite logic, that marked the soul. Viewers went unattended, but by attending to the meticulous care with which the painting had been lavished, they could experience an objective counterpart to their own investment with self-sufficiency and grace. A second important promise was an imaginative respite

from the trials of visibility. Even as the gallery was a place in which to be seen by others, the objects within it offered a sanctuary from the vulnerability that this condition entailed. Pictures framed viewing in a reassuring structure of asymmetry, whereby their dedication to visibility came with a promise not to invoke the viewer's own. The experience of a painting was structurally so private that the viewer became an absolute secret. The experience was less like looking through a window than like looking through a keyhole. This was the beautiful regression of pictures. Even as the picture gallery remained a place of public concourse and sociability, a path of retreat into a structure of radical privacy was assured. The fact that this privacy was reserved for a particular class made it a bonding form of privilege.

During the eighteenth century, *picture* and *tableau* were, of course, only two of a bevy of terms that regulated the fine arts. The rise of bourgeois art markets and the burgeoning of art academies contributed to a growing emphasis on other categories, particularly genre and medium. In 1707, the artist and theorist Gérard de Lairesse laid out the different genres of painting with unprecedented clarity in *Groot schilderboek* (published in English in 1738 as *The Art of Painting in All Its Branches*).[11] Later in the eighteenth century, aestheticians such as Gotthold Ephraim Lessing and Johann Gottfried von Herder analyzed the material qualities of different art forms or media, and raised the question of how those qualities ought to govern criteria for artistic success.[12] The analytic divisions of genre and medium tended to diminish the force of the broader terms *picture* and *tableau*.

The institutional emphasis on the categories of *genre* and *medium* did much to shape the reception of photography after it made its sensational debut in 1839. As a matter of course in the nineteenth century, paintings were grouped with paintings, engravings with engravings, and landscapes with landscapes, as a glance at most any contemporaneous exhibition catalogue from western Europe or North America will confirm. Under these overlapping protocols, terming a photograph a *picture* was insufficient to locate it within the institutions and discourses of art.

It should come as no surprise, therefore, that influential early writing on photography in both England and France often refers to the products of photography as *drawings* (or *dessins*), not *pictures* or *tableaux*. The painter Paul Delaroche, in an 1839 report on the daguerreotype submitted to the Chamber of Deputies, refers to the "drawings obtained by this means."[13] A report of the Académie des beaux-arts from the same year refers to Hippolyte Bayard's photographs on paper

as "drawings."[14] Across the channel, William Henry Fox Talbot (1800–1877), one of the inventors of photography, refers in his early writings on the subject to "photogenic drawings." The term *drawing* located photography within an art discourse organized around medium.

To be sure, writers in this early moment also used *picture* to describe the photograph. The term appears frequently in Talbot's early correspondence and publications about photography, and other writers followed suit. Robert Hunt, for example, the author of the first photography manual in English, refers to "the photographic picture."[15] Nonetheless, early writers on photography did not refer to photographs as *pictures* with the regularity or presumption that later writers would exhibit. A preference for the term *drawing* persisted for some time. Reporting on the Salon of 1850, the critic Francis Wey writes that Gustave Le Gray, "one of the most talented practitioners of the new process of photography," has sent to the jury "nine drawings on paper, representing landscapes, portraits from life and from paintings."[16] Consistent with the conventions of his day, Wey used medium and genre to organize his discussion of the visual arts.

But shoehorning photography into such categories was an awkward business. Soon after referring to Le Gray's entries to the 1850 Salon as "drawings," Wey notes the difficulty that the jury had in classifying them, given that they "belonged in no direct way to the practice of drawing."[17] The Salon jury initially placed the works in the lithography section, but later they were classified as scientific works and dropped altogether from the definitive edition of the Salon handbook.[18] As this anecdote would suggest, early writers on photography struggled to find an adequate term for putting photographs into relation with other forms of representation.

By the late 1850s, the use of *picture* to refer to a photograph had become more customary in the English photographic press. In her canonical 1857 essay on photography, Lady Elizabeth Eastlake (1809–1893) uses the term twelve times to refer to photography or photographic reproduction and the word *drawing* only once. This new comfort with the term *picture* was by no means always accompanied by a willingness to assimilate photography into the fine arts. On the contrary, Eastlake—to stick with that example—was vociferously fending off such an assimilation. The situation in France was different. The word *tableau* was generally reserved for the traditional pictorial arts and for the self-sufficient easel painting in particular. It was associated with the highest forms of these arts, which entailed the representation of historical or literary scenes. In his review of the 1859 Salon, Charles Baudelaire

uses the term *image*, not *tableau*, to refer to photographs. In some ways, the bifurcation of *image* and *tableau* made the subordination of photography to traditional arts a cleaner affair in France than in England.[19]

The concession in the English press to the use of *picture* to describe a photograph weakened the case against photography as art. In his excellent book *The Making of English Photography: Allegories*, Steve Edwards claims that many Victorians accepted the photograph as a document but rejected it as a picture. The limitation of this argument is precisely that, as a matter of usage, they did not. Edwards writes: "Lady Eastlake was asserting, it seems to me, that photography was not just different from painting but also, crucially, that it was less than art. This 'new medium' was not a picture but a document produced by the automatic impress of nature."[20] Eastlake was indeed arguing that photography was less than art, but she certainly thought it produced *pictures*, as her use of that term demonstrates. This may seem like nitpicking, and Edwards himself acknowledges that the historical "opposition" he perceives between the document and the picture "is not always stated in these terms."[21] But refashioning historical nomenclature is a dicey matter. The fact that Eastlake clearly believed that both painting and photography produced pictures cut back the ground of her denigration of photography and invited pressure to explain why one picture was art while another was not.[22]

The potential of *picture* to unite photography with traditional modes of representation quickly made it a key term in the photographic press. Boosters of photography used it to insist that painting and photography delivered a similar product, rendering the choice of medium an arbitrary or inconsequential affair. "Our Picture" was what the editors of the *Philadelphia Photographer* entitled their regular feature singling out an individual photograph for reproduction and praise. The British photographer and critic Alfred H. Wall (n.d.–1906), who used the term *picture* frequently, went so far as to claim that the true medium of art was vision itself, a position that the pictorialist Peter Henry Emerson and others took up.[23] According to Wall, once the mind had perceived beauty or poetry in nature, what remained was merely translation, which could be accomplished by various means, including painting or photography. Those embracing such a scheme questioned whether the status of art should hinge on the particular process by which a picture is produced. In 1865, the Philadelphia photographer and painter John Moran wrote: "But it is the power of seeing and deciding what shall be done, on which will depend the value and importance of any work, whether canvas or negative."[24]

1

Robert Macpherson,
*Hall of the Candelabra—
Vatican*, 1860s.
Albumen silver print,
13 ¾ × 12 ⅜ in. (34.9 ×
31.4 cm). The J. Paul
Getty Museum, Los
Angeles, 84.XM.502.25.

The effort of these boosters to establish *picture* as a definitive category capacious enough to include photography led them to reaffirm broad principles of representation such as those that Alberti and Diderot had proffered. In the latter half of the nineteenth century, several photography advocates placed particular emphasis on linear perspective as a unifying requirement of pictorial art. Despite modernist transgressions in pictorial construction, that requirement remained largely intact, and photography was deliberately engineered to satisfy it. The crafting of lenses and cameras ensured that the resulting images

would abide by the rules of correct perspective, rendering photography, in a technical sense, an Albertian machine (fig. 1).[25]

Photography enthusiasts usually made their appeals to Albertian principles in a more contemporary name. As the art historian Paul Sternberger has noted, several American writers on photography in the latter half of the nineteenth century, including Moran, Enoch Root, and Edward L. Wilson urged their fellow practitioners to consult John Burnet's *Practical Essays on Art* (1822–1837).[26] Written just prior to the arrival of photography, Burnet's essays harken back to Alberti's watershed commentary by emphasizing the importance of mastering

2
Oscar Rejlander,
*Photomontage of
Man with Vest and
St. Peter's Basilica*, ca.
1860. Albumen print,
6 ½ × 4 ½ in. (16.5 ×
11.5 cm). George
Eastman House,
Rochester, New York,
1972:0249:0001.

Robin Kelsey

perspective and its geometric tenets, constructed around "the eye" of the spectator.[27] Although written for painters, Burnet's advice, which puts linear perspective at the center of the pictorial enterprise and stresses accuracy and correctness of representation, provided rich material for those arguing that photography satisfied the basic demands of pictorial art.

In England, several leading photographers of the Victorian era, including Oskar Rejlander (1813–1875), Henry Peach Robinson (1830–1901), and Julia Margaret Cameron (1815–1879), placed more emphasis, as Diderot had, on theater. This strategy had much to recommend it. One of the primary reservations about the aesthetic potentials of photography was its excessive reliance on reality, and one of the great strengths of theater was its capacity to transform real bodies into art. By arranging figures into tableaux, these practitioners of photography exploited the evocative power of gesture, pose, and composition. Rejlander and Robinson famously used composite printing to fashion pictures from discrete parts, enabling them to claim that they were exercising aesthetic judgment and synthesis, as academic standards required (fig. 2). In these various ways, loosely affiliated groups of ardent photography supporters appealed to the broad principles subtending *picture* and *tableau* to overcome the categorical barrier of medium.

Not all early writers seeking to elevate the photographic picture, however, stressed its conformity to venerable principles. A discerning few instead hailed its radical newness. Although photography had been technically engineered to deliver representations abiding by linear perspective, and although the resulting representations could incorporate the priorities of the tableau, these observers realized that photography as a social practice was nonetheless disrupting old regimes. In some respects, the work of these farsighted commentators is well known. Many scholars have examined the history of discourse on such matters as photographic transience, fragmentation, and indexicality. But in other respects the most farsighted early writing on photography has escaped our grasp. In particular, early commentary on the new relationship that photography forged between the makers and receivers of representations has received too little attention. This commentary, which envisioned the concept of the picture afresh, is crucial to understanding modern picture theory and its history.

Appreciating the implications of this commentary requires recognizing that the aesthetic paradigms that Alberti and Diderot proffered had a material basis. In particular, the suppression of the viewer in both paradigms was predicated on a social distinction or

boundary. Those who enjoyed an afternoon in a picture gallery or an evening at a theater were, with few exceptions, not engaged in producing works of art intended for either venue. Viewers of pictures or tableaux were exempt from the social limits or obligations of producers. This division underwrote the imaginative asymmetry between the viewing and the viewed that *picture* and *tableau* presumed. The viewer could be excluded from the work of art because he or she was excluded from the labor of art. This exclusion made visibility relatively easy to regulate and structural anonymity before a painting or sculpture the rule. It enabled the preservation of a class of people who could imagine themselves immune to the unwanted repercussions of being visible.

Photography and the burgeoning middle class that embraced it, however, quickly closed this divide. By 1900, members of this new class, availing themselves of handheld cameras and industrial film processing, had made a routine of depicting others and serving as subjects of depiction in turn. The makers and viewers of everyday pictures had collapsed into the same population. Even in the early years of photography, some astute thinkers, including the inventors Talbot and Louis-Jacques-Mandé Daguerre (1787–1851), had anticipated this outcome. Although early photographic processes were too difficult for all but the most dedicated to master, restricting production to a small class of experts, Talbot and Daguerre had both envisioned a technology that would enable the unskilled to make pictures.[28] George Eastman fulfilled technically what had been the idea of photography from the start. Before photography, skill had been a means of maintaining the social divide between the makers and users of pictures or tableaux. A skillful touch had been the burden of the producers of art, while appreciating its exercise (the greatest mark of skill often being the rendering of its exercise difficult to trace) had been the preserve of those who had no particular need of skill.

Nowhere was the vision of photography as a widely practiced and reciprocal medium received more enthusiastically than in the United States, and no one welcomed it more presciently than the American abolitionist and orator Frederick Douglass (1818–1895) (fig. 3). Recent scholarship on Douglass and photography has flourished, and Marcy Dinius in particular has demonstrated how the peculiar qualities of the daguerreotype enabled Douglass to associate its popularity with social progress.[29] The fact that the daguerreotype appears as positive or negative depending on the viewing angle, turning light skin dark and dark skin light, seemed to bear the promise of a more empathetic national conscience. So, too, did the fact that the viewer of a

3
Frederick Douglass,
ca. 1855. Daguerreotype,
2 ¾ × 2 ³⁄₁₆ in. (7 × 5.6 cm).
The Metropolitan
Museum of Art, New
York. The Rubel
Collection, Partial and
Promised Gift of
William Rubel, 2001,
2001.756.

daguerreotype caught glimpses of his own face mingling with that of
the depicted. As Dinius notes, Douglass found in the daguerreotype
not only an affordable means of obtaining self-portraits but also a logic
of reciprocity and inversion that seemed both to display the structure
of racism and to provide a means for its mitigation.

For Douglass, the emergence of the daguerreotype confirmed
that the principal social function of pictures is to foster a more capacious
and honest self-consciousness. In his writings, this aim supplements
or displaces the provision of traditional aesthetic pleasure as the main
service of pictorial art. The picture for him becomes a site of negotia-
tion between self and society. He writes: "A man is ashamed of seeming
to be vain of his personal appearance and yet who ever stood before a
glass preparing to sit or stand for a picture — without a consciousness
of some such vanity?" [30] The indifference of photography was an
agent of social leveling that challenged the authority of the privileged
classes over representation. One could not count on the camera, as

one could on the commissioned portrait painter, to flatter vanity and to acknowledge status. During the Civil War, the importance and timeliness of honest self-reckoning was so great that Douglass interspersed his public orations on abolition and freedom with lectures on pictures.

Although Dinius and others have done a fine job explaining the historical importance that Douglass accorded the daguerreotype, one dimension of his thinking about pictures bears more study. We can bring this dimension into view by attending to a neglected passage in "Pictures and Progress," a lecture manuscript from the early 1860s written in Douglass's hand and residing in the Library of Congress.[31] In the manuscript, Douglass acknowledges his discomfort with lecturing on pictures while young men are dying in droves to save or break the Union in the name of freedom.[32] He admits that under the circumstances it is "almost an impertinence to ask . . . attention to a lecture on pictures," referring elsewhere in his introduction to "this seeming transgression." [33] In his defense, he claims that the intensity of the war and its coverage might justify a momentary and well-considered digression. "One hour's relief from this intense, oppressive and heart aching attention to the issues involved in the war," he writes, "may be a service to all." [34]

Having labored to justify his choice of topic, Douglass then relates a curious but unexpectedly vital anecdote. He writes:

> *Wishing to convince me of his entire freedom from the low and vulgar prejudice of color which prevails in this country, a friend of mine once took my arm in New York saying as he did so—Frederick, I am not ashamed to walk with you down Broadway. It never once occurred to him that I might for any reason be ashamed to walk with him down Broadway. He managed to remind me that mine was a despised and hated color—and his was the orthodox and Constitutional one—at the same time he seemed endeavoring to make me forget both.*
>
> *Pardon me if I shall be betrayed into a similar blunder tonight and shall be found discoursing on negroes when I should be speaking of pictures.*[35]

The anecdote enacts a reversal. Whereas in the preceding paragraphs Douglass exhibits considerable self-consciousness about talking about pictures when he should, according to circumstances

and expectations, be talking about the plight of the negro, in this passage he asks for forgiveness if he ends up speaking about the negro and not about pictures. This reversal suggests a deep conceptual bond between pictures and social justice. Each topic may slip unexpectedly into the other. Once again, the daguerreotype, with its structure of inversion and reversal (including the lateral reversal of left to right), exemplifies this relation.

The anecdote that Douglass relates enables him to take the paradigm of *picture* in another direction as well. He suggests that pictures are about shame, about being made to feel out of place. When he notes that it never occurred to his friend that Douglass "might for any reason be ashamed to walk with him," he implies that his friend has failed to imagine himself in the picture from Douglass's perspective. This is evidently a fundamental reason that Douglass understood social justice and pictures in the age of photography to be entwined. Getting the picture, as he understood it, required the capacity to imagine oneself as an object for another subject. It required a willingness to accord others a point of view and to acknowledge that one could not presume to belong in the picture so defined.

This interpretation puts a different spin on the many accounts of Douglass's celebration of the daguerreotype as a means of allowing "men of all conditions and classes" to "see themselves as others see them." [36] Writers have tended to assume that Douglass was celebrating the egalitarian empowerment that photography delivered, its success in—to use Dinius's words—"making a full experience of subjectivity available to all." [37] But Douglass's use of the anecdote and his words about shame and vanity suggest that his enthusiasm for the daguerreotype stemmed also from its insistence on a shared vulnerability. In the age of photographic pictures, those accustomed to experiencing an asymmetrical and privileged mode of looking would face a new regime. The daguerreotype promised to make the experience of being caught in the presence of others universal, and the universality of that experience would yield, Douglass hoped, the social empathy for which he longed.

In this regard, Douglass anticipated later psychoanalytic thought linking the emergence of photography to a more analytically reflexive approach to the position of the subject. As Marshall McLuhan has written, "The age of Jung and Freud is, above all, the age of the photograph, the age of the full gamut of self-critical attitudes." [38] The self-consciousness and reciprocity promised by photography receives a particularly compelling articulation in the

work of the psychoanalytic theorist Jacques Lacan (1901–1981). In his seminars, Lacan defines *picture* as "the function in which the subject has to map himself as such."[39] This definition inverts the traditional understanding of the picture as enabling the observer to stand outside of visibility and to occupy a dislocated point. It insists that the picture define for the subject a position *as* a subject, a task that requires the subject to become an object. It is in this sense that Douglass's friend failed to picture himself.

It is worth teasing out the relationship between what Douglass and Lacan had to say about pictures. In his discussion of the gaze, Lacan brings up Alberti and Diderot in quick succession. To Alberti, he attributes an epochal articulation of laws of perspective establishing vision as a privileged domain ruled from the geometrical point of the Cartesian subject. To Diderot, he attributes the insight that the geometrical system of perspective could be understood by a blind man, revealing that the system is about the mapping of space, not sight. Indeed, Lacan suggests that it is precisely the suppression of visibility and its uncontrollable intrusions that undergirds the paradigm of perspective. Lacan accordingly faults the Albertian tradition for making the subject a disembodied point of origin. "I am not simply that punctiform being located at the geometrical point from which the perspective is grasped," he says.[40] The figure at the keyhole cannot rule out the possibility that he or she is being watched. "I see only from one point," Lacan remarks, "but in my existence I am looked at from all sides."[41]

Lacan understands that Alberti's reduction of the viewer to a point was a power play, a means of keeping the privileged viewer in control and out of sight. The threat combatted is that of the gaze, the operation by which the subject "is caught, manipulated, captured, in the field of vision."[42] The impulse to stay out of sight thus extends to other species, a fact that for Lacan explains the prevalence of mimicry in nature. According to Lacan, "Mimicry is no doubt the equivalent of the function of which, in man, is exercised in painting."[43] In establishing the terms of painting in the Western tradition, Alberti and Diderot had sought to permit a form of viewing free from the hazards of being trapped in an unmasterable field of vision.

The promise of painting to hide the subject, however, is never completely fulfilled. Even in front of a Dutch or Flemish landscape without figures, Lacan says, you will feel, "in the end," the gaze.[44] What is required, therefore, is a tacit understanding, a trust that art will keep the secret of visibility safe. In front of a painting, according

to Lacan, this implicit contract entails an invitation to lay down the gaze, as "one lays down one's weapons."[45] A traditional painting offers an Apollonian moment of respite, and in return the viewer is expected to pacify his or her looking. This social contract allows the viewer of a painting to occupy a sanctuary within the visual field. This payoff requires proceeding "as if." Like an indulgent parent with a child trying to hide behind a small object, the social practice of painting pretends that the viewer cannot be seen.

Lacan associates the gaze with photography. The gaze, he says, is the "instrument through which light is embodied and through which . . . I am *photo-graphed*."[46] Lacan uses the phrase in an etymological sense, but his logic betrays the imbrication of the gaze and photography as a social practice. To be photographed is to be located, pictured, seized, perhaps unwittingly, perhaps awkwardly, in a visual field. The photographic camera is a kind of trawling net of light, capturing everything along the surfaces before it. Because photography is a democratic medium that erases the boundary between the makers and viewers of depictions, everyone finds herself or himself caught willy-nilly in the nets of others. Subtending Lacan's understanding of the gaze is thus a new sociology of photography that had dismantled the traditional pictorial scheme and rendered every viewing subject prey to disabling disclosure. Douglass's friend, by not understanding himself to be subject to that sociology, to a net that Douglass might drag through the light, had failed to don a self-critical attitude required by his time.

Lacan's discussion of being *photo-graphed*, in other words, has a historical precondition that he neglects. Although photography in technical conception is an Albertian machine, its social structure counters the Albertian paradigm. The photographic apparatus invites the photographer to indulge in the fantasy of being a point-like eye taking in the world as if through a keyhole, but the social reality of photography contravenes this fantasy. Within that reality, every subject occupies a visual field in which the possibility of being caught by another always looms. The probability that an actual camera is aimed at the subject is less the issue than the historical shift that photography has effected regarding the immutable condition of being vulnerable to the gaze. The discovery that matter left to its own automatic ways could manifest how the subject might look to others altered the human condition. Even as the photographer photographs, he or she is *photo-graphed*.

It may seem that the historical arrival of photography is not a necessary prerequisite to this state of affairs. After all, as long as there have been human subjects, coming under the gaze of another has been possible. On the one hand, this is true, and for this reason Lacan can connect the gaze to mimicry in nature and regard it as fundamental to human subjectivity. On the other hand, photography, by making the gaze into a picture, fundamentally altered its operation within psychic and social registers. The gaze no longer remained under the subject's imaginative command, and its downstream effects were uncontrollable. When Douglass notes the anxiety that the soon-to-be portrait sitter experiences while gazing into a mirror, he is invoking not only the worry that the photograph might match the image in the mirror but also the worry that it might not. This lack of control over images of the self only worsened as photographic technology shrank and accelerated. The Kodak snapshot was a potentially endlessly circulating caricature, a random exercise in grotesquerie, that laid bare the subject's lack of self-mastery.

For these reasons, something like what Fried calls, following Diderot, theatricality—that is, the acknowledgment of the body of the observer—became in the age of photography a historical necessity. In that age, the class of viewers of pictures could no longer be distinguished from the class of producers. Imagining the viewer as a geometric point or as behind a curtain became a fantasy without a social basis. Although writers have often suggested that photography drove painting to abstraction by taking over the task of representation, the abandonment of illusionistic space by painters doubtless also stemmed from photography's destruction of the social conditions of unreciprocated viewing. A laying down of the gaze was no longer possible. Illusionistic space could only remind the subject of his or her unavoidable role as an accidental or unwanted intrusion in pictures for others. This historical reasoning puts the emergence of cinema in a different light. Its development during the final abandonment of illusionism in painting appears to be a desperate effort to renew the traditional pictorial contract. If the presence of the body in an encompassing visual field could not be denied in the age of photography, then at least that body could be shrouded in darkness.

We can clarify the relationship between the writings of Lacan and Douglass on pictures by considering the anecdote that Lacan uses to convey his understanding of what a picture is. The story he tells runs as follows:

Robin Kelsey

I was in my early twenties or thereabouts—and at that time, of course, being a young intellectual, I wanted desperately to get away, see something different, throw myself into something practical, something physical, in the country say, or at the sea. One day, I was on a small boat, with a few people from a family of fishermen in a small port. At that time, Brittany was not industrialized as it is now. There were no trawlers. The fisherman went out in his frail craft at his own risk. It was this risk, this danger, that I loved to share. But it wasn't all danger and excite-ment—there were also fine days. One day, then, as we were waiting for the moment to pull in the nets, an individual known as Petit-Jean, that's what we called him—like all his family, he died very young from tuberculosis, which at that time was a constant threat to the whole of that social class—this Petit-Jean pointed out to me something float-ing on the surface of the waves. It was a small can, a sardine can. It floated there in the sun, a witness to the canning industry, which we, in fact, were supposed to supply. It glittered in the sun. And Petit-Jean said to me— You see that can? Do you see it? Well, it doesn't see you!

He found this incident highly amusing—I less so. I thought about it. Why did I find it less amusing than he? It's an interesting question.

To begin with, if what Petit-Jean said to me, namely, that the can did not see me, had any meaning, it was because in a sense, it was looking at me, all the same. It was looking at me at the level of the point of light, the point at which everything that looks at me is situated— and I am not speaking metaphorically.[47]

Lacan then writes:

The point of this little story, as it had occurred to my partner, the fact that he found it so funny and I less so, derives from the fact that, if I am told a story like that one, it is because I, at that moment—as I appeared to those fellows who were earning their livings with great difficulty, in the struggle with what for them was a pitiless nature—looked like nothing on earth. In short, I was rather out of place in the picture. And it was because

I felt this that I was not terribly amused at hearing myself addressed in this humorous, ironical way.[48]

To account for the picture, Lacan and Douglass offer similar anecdotes, featuring asymmetries encountered while socializing across racial or class lines. Whereas Douglass walks with a Euro-American friend down Broadway, Lacan fishes with a hardscrabble fishing family in Brittany. In both cases, the asymmetry erupts in an ostensibly convivial moment of everyday conversation. When Douglass's friend says that he is not embarrassed to walk down Broadway together, the words mean something entirely different to Douglass than they do to his friend. When Petit-Jean cracks his joke about the sardine can, it is funny to him but not to Lacan. In both cases, the communication is an act of picturing, a sorting of perspectives, a determination of who belongs within a picture and who does not.

Douglass and Lacan approach the condition of "looked-at-ness" in the age of photography from different social positions. Whereas Douglass, as a member of an oppressed class in the 1860s, celebrates that in the age of photography all must account for how they look to others, Lacan, as a member of a privileged class in the 1960s, considers the difficult consequences of this exposure for those unaccustomed to it.

Lacan's understanding of the gaze, it is worth recalling, emerged from an engagement with Jean-Paul Sartre's *Being and Nothingness*, first published in France in 1943. In that work, Sartre defines the Other as "the one who looks at me."[49] While acknowledging that the look of the Other usually manifests itself as two directed eyes, Sartre notes that it can arrive just as well "when there is a rustling of branches, or the sound of a footstep followed by silence, or the slight opening of a shutter, or a light movement of a curtain."[50] For Sartre, such signs operate less as evidence of fact than as reminders of possibility. "What I apprehend immediately when I hear branches crackling behind me is not that *there* is someone *there*," he writes. "It is that I am vulnerable, that I have a body which can be hurt, that I occupy a place and that I can not in any case escape from the space in which I am without defense—in short, that I *am seen*."[51]

In 1943, this emphasis on the vulnerability of the subject to the look of others has obvious historical moorings (fig. 4). As an active participant in the French Resistance in occupied Paris, Sartre understood the perils of visibility. One of Lacan's many insights was his realization that this vulnerability, as a general matter, had historically found alleviation in the norms of painting. I consider in this essay

4

Glenn Ernest Grohe, *He's Watching You*, ca. 1942. Poster, 12 1/10 × 16 1/25 in. (30.75 × 40.75 cm). National Archives and Record Administration, Still Pictures Branch, College Park, Maryland, ARC identifier 7387549, local identifier 208-AOP-119.

the possibility that this historical function came into view because photography had more or less nullified it. Before photography, the access of the elite to fantasies of remaining unviewed while viewing seemed a normal condition. The historical turn that photography delivered surfaces in the language of twentieth-century theorizations of the subject. Whereas Lacan discusses being *photo-graphed* from all sides, Sartre describes the "pure interiority" of the Other as it appears to the subject as "something comparable to a sensitized plate in the closed compartment of a camera." [52] For both writers, photography had become essential to understanding subjectivity.

At times, practitioners of photography have made picturing, in this psychosocial sense, a focus of their work. A particularly complex

Robin Kelsey

case involves Alfred Stieglitz (1864–1946) and his famous photograph *The Steerage*, made in 1907 (fig. 5). Decades later, in 1942, a year before *Being and Nothingness* appeared, a short account by Stieglitz was published entitled "How *The Steerage* Happened." By then, *The Steerage* had come to represent for Stieglitz and for his critics an apotheosis of his aesthetic sensibility and ambition. In his account, which was evidently based on years of offering similar versions orally, Stieglitz traces his production of the photograph to an experience of class alienation.[53] His retelling of that experience recalls Douglass's understanding of photography as a means of locating the self within a riven social field. Stieglitz writes:

> *Early in June, 1907, my small family and I sailed for Europe. My wife insisted upon going on the Kaiser Wilhelm II — the fashionable ship of the North German Lloyd at the time. Our first destination was Paris. How I hated the atmosphere of the first class on that ship. One couldn't escape the nouveaux riches.*
>
> *I sat in my steamer chair the first days out — sat with closed eyes. In this way I avoided seeing faces that would give me the cold shivers, yet those voices and that English — ye gods!*
>
> *On the third day out I finally couldn't stand it any longer. I had to get away from that company. I went as far forward on the deck as I could. The sea wasn't particularly rough. The sky was clear. The ship was driving into the wind — a rather brisk wind.*
>
> *As I came to the end of the deck I stood alone, looking down. There were men and women and children on the lower deck of the steerage. There was a narrow stairway leading up to the upper deck of the steerage, a small deck right at the bow of the steamer. . . .*
>
> *On the upper deck, looking over the railing, there was a young man with a straw hat. The shape of the hat was round. He was watching the men and women and children on the lower steerage deck. Only men were on the upper deck. The whole scene fascinated me. I longed to escape from my surroundings and join those people.*
>
> *A round straw hat, the funnel leading out, the stairway leaning right, the white drawbridge with its railings made of circular chains — white suspenders crossing on*

the back of a man in the steerage below, round shapes of iron machinery, a mast cutting into the sky, making a triangular shape. I stood spellbound for a while, looking and looking. Could I photograph what I felt, looking and looking and still looking? I saw shapes related to each other. I saw a picture of shapes and underlying that the feeling I had about life. And as I was deciding, should I try to put down this seemingly new vision that held me, — people, the common people, the feeling of ship and ocean and sky and the feeling of release that I was away from the mob called the rich, — Rembrandt came into my mind and I wondered would he have felt as I was feeling.

Spontaneously, I raced to the main stairway of the steamer, chased down to my cabin, got my Graflex, raced back again all out of breath, wondering whether the man with the straw hat had moved or not. If he had, the picture I had seen would no longer be. The relationship of shapes as I wanted them would have been disturbed and the picture lost.

But there was the man with the straw hat. He hadn't moved. The man with the crossed white suspenders showing his back, he too, talking to a man, hadn't moved, and the woman with the child on her lap, sitting on the floor, hadn't moved. Seemingly no one had changed position.

I had but one plate holder with one unexposed plate. Would I get what I saw, what I felt? Finally I released the shutter. My heart thumping. I had never heard my heart thump before. Had I gotten my picture? I knew if I had, another milestone in photography would have been reached, related to the milestone of my Car Horses, made in 1892 [known generally as The Terminal], and my Hand of Man made in 1902, which had opened up a new era of photography, of seeing. In a sense it would go beyond them, for here would be a picture based on related shapes and on the deepest human feeling, a step in my own evolution, a spontaneous discovery.

I took my camera to my stateroom and as I returned to my steamer chair my wife said, "I had sent a steward to look for you. I wondered where you were. I was nervous when he came back and said he couldn't find you." I told her where I had been.

Robin Kelsey

*She said, "You speak as if you were far away in a
distant world," and I said I was.*

*"How you seem to hate these people in first class." No,
I didn't hate them, but I merely felt completely out of place.*

*As soon as we were installed in Paris I went to the
Eastman Kodak Company to find out whether they had a
dark room in which I could develop the plate. They had
none. They gave me an address of a photographer. I went
there. The photographer led me to a huge dark room, many
feet long and many feet wide, perfectly appointed.*

*He said, "Make yourself at home. Have you a
developer? Here's a fixing bath—it's fresh."*

*I had brought a bottle of my own developer. I started
developing. What tense minutes! Had I succeeded, had
I failed? That is, was the exposure correct? Had I moved
while exposing? If the negative turned out to be anything
but perfect, my picture would be a failure. . . .*

*The first person to whom I showed The Steerage
was my friend and co-worker Joseph T. Keiley. "But you
have two pictures there, Stieglitz, an upper one and a
lower one," he said.*

*I said nothing. I realized he didn't see the picture I'd
made. Thenceforth I hesitated to show the proofs to anyone,
but finally in 1910 I showed them to [Paul] Haviland and
Max Weber and [Marius] de Zayas and other artists of
that type. They truly saw the picture, and when it appeared
in Camera Work it created a stir wherever seen, and the
eleven by fourteen gravure created still a greater stir.*[54]

Few accounts of the making of a photograph are more elaborate,
psychologically inflected, or self-aggrandizing. Jason Francisco has
called it "a shameless piece of self-hagiography."[55]

In the quoted passage, Stieglitz uses the term *picture* in multiple
ways. He initially uses it to mean a promising momentary configura-
tion of things in the world. As he races back to get his camera, he fears
that "the picture" that he had seen would "no longer be." He then
uses it to mean a pictorial outcome he has foreseen. "Had I gotten my
picture?" he asks. Shifting again, he uses the term to mean the actual
outcome of his work. "If the negative turned out to be anything but
perfect," he writes, "my picture would be a failure." Finally, he shifts to
using the term to mean the aesthetic experience that people of

requisite sensibility could find in that outcome. Keiley failed to see "the picture I'd made," Stieglitz informs us, whereas Haviland and Weber and de Zayas "truly saw the picture." For leading photographers of aesthetic ambition, the plasticity of the term *picture* was crucial. It gave the intimate and intricate interplay that photography fostered between work and world a positive aesthetic value. A picture had to be both found and made, and its materials were both forms (e.g., an oval) and things (e.g., a hat). It was both a physical object and an aesthetic experience.

Stieglitz associates making the photograph with feeling "completely out of place." The history of photography is rife with examples of practices or work driven by conditions of alienation. From the colonial subject returning to the imperial center and reimagining its nationalist mythologies (e.g., Julia Margaret Cameron, Peter Henry Emerson) to the wandering émigré who explores the friction of estrangement (e.g., Robert Frank, Lisette Model, André Kertész), much of the history of photographic aesthetics could be written through the concept of displacement. Indeed, one might say that in the age of photography this concept and that of the picture are inseparable. When Lacan frames his discussion of the picture by linking the concept of being *"photo-graphed"* to the story of his estranging response to the joke of Petit-Jean, he encapsu-lates this insight.

But what kind of alienation does Stieglitz offer us? In his text, a smug and indulgent one. His account of his voyage is precisely the kind of modernist fantasy that Lacan lampoons in his fishing anecdote. Like the young Lacan of the anecdote, Stieglitz wishes to escape his social stratum and participate in what he imagines are the more genuine and uncorrupted ways of the working class. Like the young Lacan, he associates this participation with the bracing fresh-ness of the sea. But whereas Lacan, through the joke of Petit-Jean, comes to realize that he has entered a picture in which he does not fit, that his fantasy is nothing more than that, that he will encounter no dangerous wild fish but only the glint of a sardine can, Stieglitz has no such moment of disillusioning social contact. He stays on his deck, removed from the steerage by a gap, keeping the working class at a distant focus, and thus never putting his longing to "join those people" to the test. He comes back to his wife triumphant, believing himself to have reached a "distant world" when he had never left the comfort-able confines of his class. The dialogue between the stories of Lacan and Stieglitz extends to the objects that they sought or found. A fish,

a sardine tin, and a photographic plate are all smooth and glinting entities emerging from the darkness. But whereas the tin is the negative of the fish, the photographic negative is matter transformed into art. Negative in hand, Stieglitz returns from the sea with the great catch that the young Lacan never makes.

The stale modernism of Stieglitz's account borders on comedy. Allan Sekula, in his essay "On the Invention of Photographic Meaning," skewers Stieglitz for the flimsy and uncritical terms of his imagined liberation. He writes of this origin story:

> As I see it, this text is pure symbolist autobiography. Even a superficial reading reveals the extent to which Stieglitz invented himself in symbolist clichés. An ideological division is made; Stieglitz proposes two worlds: a world that entraps and a world that liberates. The first world is populated by his wife and the nouveaux-riches, the second by "the common people." The photograph is taken at the intersection of the two worlds, looking out, as it were. The gangplank stands as a barrier between Stieglitz and the scene. The photographer marks a young man in a straw hat as a spectator, suggesting this figure as an embodiment of Stieglitz as Subject. The possibility of escape resides in a mystical identification with the Other: "I longed to escape from my surroundings and join those people." I am reminded of Baudelaire's brief fling as a republican editorialist during the 1848 revolution. The symbolist avenues away from the bourgeoisie are clearly defined: identification with the imaginary aristocracy, identification with Christianity, identification with Rosicrucianism, identification with Satanism, identification with the imaginary proletariat, identification with imaginary Tahitians, and so on. But the final Symbolist hideout is in the Imagination. Stieglitz comes back to his wife with a glass negative from the other world.[56]

Sekula's critical analysis is characteristically trenchant. Stieglitz, by holding his identification with the working class at a distance that his photographic imagination permits, offers us an indulgent and superficial form of deliverance.

End of story? Not quite. To begin with, there is something more complicated in Stieglitz's formulation than Sekula acknowledges.

Consider again this passage:

> *On the upper deck, looking over the railing, there was a*
> *young man with a straw hat. The shape of the hat was*
> *round. He was watching the men and women and children*
> *on the lower steerage deck. Only men were on the upper*
> *deck. The whole scene fascinated me. I longed to escape*
> *from my surroundings and join those people.*

Stieglitz claims that he wishes to join "those people," yet his wish is channeled—as Sekula observes—through his identification with the man in the straw hat. That man, the protagonist of the picture, is himself an alienated subject, separated, as Stieglitz is, from the familial order, looking on others from a distance. Stieglitz's identification may be delusional, but he does not identify with "the imaginary proletariat" writ large. He identifies with a subject imagined to be alienated within his class as Stieglitz is alienated within his own. To be sure, ideology is at work: any implication that being alienated within the one class is like being alienated within the other runs roughshod over vital differences. At the same time, the very assertion that the condition of being alienated, which Stieglitz associates with a rich and sensitive subjectivity, is available to working-class subjects is historically not without its progressive dimension.

The formula works to complex effect in the photograph itself. [57] The straw hat is the most magnetic element in the picture, drawing and holding the attention of the viewer like nothing else. This fosters a sense of identification with the figure despite the fact that the vehicle of that identification—the hat—hides the figure's face. This puts *The Steerage* alongside other photographs by Stieglitz, most famously *The Terminal*, in which identification with a member of the working class proceeds paradoxically via a blockage. Whether delivered via a hat-wearing head or a turned figure, this blockage both licenses an imaginary identification with the figure and suggests that the object of that identification remains unknowable as a subject. Whether one ought to interpret this use of blockage as a way to maintain a safe distance and preserve the mystery of the Other, or instead as a respectful acknowledgment of the limits of identification, cannot be resolved readily.

The structure of *The Steerage* adds yet another level of complexity. After spending time contemplating the man with the straw hat, it comes as a surprise to note that the figure standing immediately to his

right, a figure bearing a mustache and a dark cap, looks directly at the camera. At this distance, the man's expression is hard to read, but it seems cool if not hostile. Close observation reveals that several other men in the upper steerage appear to be looking toward the camera as well. It is notable that the figures that Stieglitz imagines abstractly as forms—the man with the straw hat and the man wearing suspenders on the level below—direct their looks elsewhere. Their objectification is facilitated by, perhaps even predicated on, their averted gaze. By not confronting Stieglitz and his camera with a demand to register as fellow human subjects, they fall prey to formalist appropriation and romantic identification. Because their averted gazes are accompanied by the formal attractions of sunlit hat and suspenders, even the viewer unaware of Stieglitz's account of the making of the photograph establishes a relationship with these figures first, rendering the confrontational looks coming from those around them an uncomfortable surprise.

This structure leaves us with a curious contradiction between text and image. Although Stieglitz's account of making *The Steerage* is a modernist fantasy of the kind that Lacan lampoons with his story of fishing with Petit-Jean, the structures of story and photograph are actually similar. Both begin with a romantic identification between a privileged intellectual and one or more members of the working class but proceed to a jolting recognition of a returned and threatening gaze. Neither Lacan nor Stieglitz belonged where they were. Whereas the joke of Petit-Jean reveals to the young Lacan a lack of belonging, the returned gazes of several inconspicuous passengers reveal to the viewer of *The Steerage* a similar state. Like the glinting sardine can, the secondary figures in the photograph, although they do not see us, look at us all the same. That look catches us by surprise, locating us in a picture we did not expect, drawing us into the shame of voyeuristic desire. As Douglass understood decades earlier, photography was about positioning oneself in a riven society.

For these reasons, we should augment or amend Sekula's account of Stieglitz. Sekula argues that the "final Symbolist hideout" is in the imagination, and we can certainly find ample support for that proposition in what Stieglitz wrote. But for Lacan the imagination is no safe hideout from being *photo-graphed*. "The gaze I encounter," Lacan says, "is not a seen gaze, but a gaze imagined by me in the field of the Other." [58] While looking through the keyhole, a rustle of leaves or a glint of a can may remind us that we are in a picture for which we are not the point, perhaps one in which we appear as a stain.

The imagination is precisely where those reminders give rise to the gaze. In *The Steerage*, the man in the straw hat establishes the pictorial keyhole, that secret formalist grasp of an aesthetic opportunity. The other eyes looking upon us are not a seen gaze—these bits of silver gelatin, or carbon black, or halftone ink, or glowing pixels do not see—but precisely for this reason they invoke the gaze Lacan imagines. Invited to enjoy the pleasures of Stieglitz's identification across class lines, we find ourselves caught in unwelcoming looks meant for him. The formalist arrangement is punctured by this unexpected confrontation, which reveals the imagination of the photograph to be no hideout at all.

This brief account of the concept of *picture* in the age of photography has implications for recent mobilizations of the term. The artist Jeff Wall (1946–), in his much reproduced and discussed essay "'Marks of Indifference': Aspects of Photography in, or as, Conceptual Art," offers a different story. He defines the "Western Picture" as "that tableau, that independently beautiful depiction and composition that derives from the institutionalization of perspective and dramatic figuration at the origins of modern Western art." [59] Because Wall seeks to draw the authority of painting into the medium of photography, his succinct appeal to the paradigms set forth by Alberti and Diderot— paradigms designed precisely to allow for invigorating traffic between different arts—makes complete sense. Wall introduces his definition by way of asserting that a "new version" of the Western Picture appears in photography's "post-Pictorialist phase," which he says could be termed its "post-Stieglitzian phase." This new version of the picture, he says, found value in reportorial images emphasizing immediacy, instantaneity, and evanescence. By subjecting this new version of the picture to trenchant critique, conceptual artists, according to Wall, matured photography as a modernist medium, enabling it finally to take its place among the arts. As a new mode of tableau, photography thus carried out the "restoration" of the concept of "the Picture." [60]

The differences between Wall's account and mine are stark. Whereas Wall suggests that the notion of the picture remained essentially intact until the documentary turn of the 1920s and 1930s, I argue that photography had by then already transformed that notion by establishing a new relationship between makers and viewers. As Douglass articulated, picturing was now a social process predicated on a universal visibility within pictures for others. This new set of conditions was precisely what Alberti and Diderot had sought to foreclose. As we have seen, the viewer of *The Steerage* becomes keenly aware that

6
Cindy Sherman,
Untitled Film Still #35,
1979. Gelatin silver
print, 10 × 8 in. (25.4 ×
20.3 cm). Edition of 10.

he or she is not occupying a geometric point or the position of an anonymous viewer in darkness. By moving "as far forward" as he could, Stieglitz surrendered the privilege of invisibility that the fictions of Alberti and Diderot had reserved for his class. From the vantage of this account, Wall's insistence on a restoration of "the Picture" willfully ignores the social preconditions of any such development.[61]

We can track the effects of this disregard by attending to Wall's work *Mimic* of 1982. This light-box mounted image depicts an encounter across the social divides of race and class, thus partaking of the catalyst of alienation or displacement described above. The encounter is replete with signs of vision. The man who looks of European descent uses his middle finger to pull his eye into a narrower form, mimicking the physiognomy of the Asian-looking man. The eye is both aggressive agent and plastic object. But even as the eye is so invoked, the gaze is tamed. As Walter Benn Michaels has noted, the work quotes the idiom

of so-called street photography while emptying the camera of the bodily comportment associated with that genre.[62] The work is a scene made for the pleasure of a viewer not subject to the operation of the vision depicted within it. It revisits what Wall deems a new version of the Western Picture while returning the viewer to the comfortable place behind the imaginary curtain of the tableau. In doing so, it eschews any acknowledgment that photography has rendered that curtain a social impossibility, a relic from another era. Indeed, by working with actors, Wall reestablished the social divide between viewers and viewed that photography in its everyday mode had put to rout.[63]

If pursued, this brief new history of the concept of the picture could link up constructively with other pathways in critical literature. For example, it could raise questions concerning the popularization of the home movie camera in the 1950s and the interest in cinematic forms of subjectivity in art of subsequent decades. From the "screen tests" of Andy Warhol (1928–1987) to the film stills of Cindy Sherman (1954–), artists during the 1960s and 1970s questioned how the subject would bear up as an object of the gaze when tokens of that gaze could circulate as moving images (fig. 6). In the context of this history, the commonality of the early work of Wall and Sherman is largely a red herring. Although the work of both is about the construction of a theatrical scene, Wall sealed off the viewer and alluded to historical forms in hopes of restoring an older notion of the picture while Sherman critically participated in new circulations between the viewer and the viewed. Her work affirms a strange and resourceful mastery over the still image, even as her imagery invokes the unavoidable new condition of the subject as an object of motion pictures.

This history can also be grafted onto accounts of the relationship between photography and performance art. Douglass, both in his writings and in his extensive service as a subject of photographic portraiture, associated the picture in the age of photography with a self-consciousness before the camera. In his formulation, the performance of the portrait sitter is as much a part of the picture as is the resulting photograph. In early performance art, as Carrie Lambert-Beatty has demonstrated in the case of Yvonne Rainier, photography was by no means merely an afterthought or convenient mode of documentation.[64] Photography was inscribed within the practice from the beginning. As a social form, picturing in the age of photography locates both viewers and viewed, while insisting on a self-critical assessment of their relative positions. Photography thus engenders a performative subject.

Robin Kelsey

The rise of surveillance, of course, refracts this history to a
substantial degree. Over the course of the twentieth century, the gaze
took on an institutional cast. Just as corporations came to be deemed
persons for many legal purposes, the power of looking was increasingly
accorded to institutional entities. The sense of looked-at-ness thus
spread from the scenario of the individual within a social group to the
tracking of the individual within geopolitical spaces. The issue of
belonging largely gave way to the issue of social control, and less anxiety
was attached to being a stain and more to being a profile of data or a
target of violence. With thermal cameras and other devices, the
catching of the individual in a cone of detection extended beyond the
visible. By now the subject has become a confusing mix of individu-
ated bodily presence, unit of continually reassembled data, and
interactive network node. Much contemporary art and criticism has
grappled with these new conditions.

This history also opens onto broad questions concerning what
happens to aesthetic experience when the privilege of the keyhole can
no longer be reconciled with serious art, when the endless efforts to
recuperate the authority of painting through large color photography
result mostly in tedium, and when perhaps the only sure way toward

rapture, as Jeff Koons has suggested in his work, is to drive viewers into insignificance through a spectacular display of big capital pandering to their infantile desires (fig. 7). Self-fashioning before the reflective surfaces of Koons's sculptures seems less vain than in vain, as if the daguerreotype had morphed into something beyond human measure. In the meantime, the hopeful vision that Douglass proffered for the age of photography remains woefully unfulfilled. Millions of African Americans sit before the camera, not to perform the anxious but possible selfhood that he imagined, but rather to mark through an instrument of legitimated violence their abjection yet again. For those free of that particular subjugation, the alienation that concerned Sartre and Lacan has taken a backseat to the effects of a coerced enrollment in a surveillance apparatus that never lets anyone out of its site (pun intended). A question driving much of the best of recent art is, how can we imagine *that* picture?

1 Cecil Grayson, introduction to *On Painting and Sculpture: The Latin Texts of "De pictura" and "De statua,"* by Leon Battista Alberti, ed. and trans. Cecil Grayson (London: Phaidon, 1972), 10.

2 As the architectural historian Mark Jarzombek has put it, Alberti was seeking to "unite literary and cultural phenomena." Mark Jarzombek, "The Structural Problematic of Leon Battista Alberti's *De pictura,*" *Renaissance Studies* 4, 3 (Sept. 1990): 277.

3 On linear perspective as an integrated cultural scheme, see Erwin Panofsky, *Perspective as Symbolic Form,* trans. Christopher S. Wood (New York: Zone Books, 1991).

4 Jack M. Greenstein, "On Alberti's 'Sign': Vision and Composition in Quattrocento Painting," *Art Bulletin* 79, 4 (1997): 669–98.

5 As Greenstein has put it, "A signal character-istic of [Alberti's] commentary is that the rules of art apply equally to works of different scale, format, medium, subject, and use." Ibid., 670.

6 Like many art historians, I have come to know Diderot's thoughts on the tableau primarily through the writings of Michael Fried. See, for example, Michael Fried, "Toward a Supreme Fiction: Genre and Beholder in the Art Criticism of Diderot and His Contemporaries," *New Literary History* 6, 3 (Spring 1975): 543–85.

7 Ibid., 552.

8 Diderot quoted in Julie Stone Peters, *Theatre of the Book, 1480–1880: Print, Text, and Performance in Europe* (Oxford: Oxford University Press, 2003), 270.

9 As Fried has said of Diderot and "the Albertian tradition" generally, "the human body in action was the best picture of the human soul; and the rep-resentation of action and passion was therefore felt to provide, if not quite a sure means of reaching the soul of the beholder, at any rate a pictorial resource of potentially enormous efficacy which the painter could neglect only at his peril." Michael Fried, *Absorption and Theatricality: Painting and Beholder in the Age of Diderot* (Berkeley: University of California Press, 1980), 75.

10 Ibid., 91.

11 Gérard de Lairesse, *The Art of Painting in All Its Branches,* trans. John Frederick Fritsch (London, 1738).

12 See Gotthold Ephraim Lessing, *Laokoon oder Über die Grenzen der Mahlerei und Poesie* (Berlin: C. F. Voss, 1766), or various later translations; Johann Gottfried von Herder, *Selected Writings on Aesthetics,* ed. and trans. Gregory Moore (Princeton, NJ: Princeton University Press, 2006).

13 Paul Delaroche quoted in Beaumont Newhall and Robert Doty, "The Value of Photography to the Artist, 1839," *Image* 11, 6 (1962): 26.

14 Académie des beaux-arts quoted in J.-C. Gautrand, *Hippolyte Bayard: Naissance de l'image photographique* (Amiens: Trois Cailloux, 1986), 193–95, cited in Henri Zerner, "Gustave Le Gray, Heliographer-Artist," in *Gustave Le Gray: 1820–1884,* ed. Sylvie Aubenas (Los Angeles: J. Paul Getty Museum, 2002), 216.

15 Robert Hunt, *A Manual of Photography,* 3d ed. (London: J. J. Griffin and Co., 1853), 300.

16 Francis Wey, "De l'influence de l'héliographie sur les beaux-arts," *La Lumière,* no. 1 (1851): 2–3, quoted in Zerner, "Gustave Le Gray," 209.

17 Ibid.

18 Ibid.

19 The dichotomy of *image* and *tableau* would become important in the emergence of abstract painting. See Hubert Damisch, "L'image et le tableau," in *Fenêtre jaune cadmium* (Paris: Seuil, 1984), 49–120.

20 Steve Edwards, *The Making of English Photography: Allegories* (University Park, PA: Penn State Press, 2006), 161.

21 Ibid., 153.

22 Although it is marginal to the present argument, Victorians were not at all apt to use the term *document* to describe photographs. In this respect, Edwards's argument, to which I am much indebted, troubles me as well.

23 "Before entering upon the question of Literal or Art-Photography, I will explain my views of Art, which,

summed up in a few words, consist of a *faithful* translation of the beauty and poetry of Nature, as rendered to the perception of the human mind through the medium of the *sense of vision*; and, whether embodied upon canvas by the 'artist' proper, by the mechanical aids at his command, or by the 'artist-photographer' upon a chemically-prepared plate, with much less mechanical labour, through the means at his disposal, yet both are dependent upon extraneous assistance—'mechanical'—whether manipulatory or otherwise." [Alfred H. Wall?], "Art-Photography," *Photographic News* 5, 133 (Mar. 22, 1861): 134. On Emerson, see Robin Kelsey, *Photography and the Art of Chance* (Cambridge, MA: Harvard University Press, 2015), 129–30.

24 John Moran, "The Relation of Photography to the Fine Arts," *Philadelphia Photographer* 2, 15 (Mar. 1865): 3.

25 As A. D. Coleman has written, "Photography institutionalizes Renaissance perspective, reifying scientifically and mechanistically that acquired way of perceiving which William Ivins called 'the rationalization of sight.'" A. D. Coleman, "The Directorial Mode: Notes toward a Definition," in *Light Readings: A Photography Critic's Writings, 1968–1978* (Oxford: Oxford University Press, 1979), 248. See also Joel Snyder and Neil Walsh Allen, "Photography, Vision, and Representation," *Critical Inquiry* 2, 1 (Autumn 1975): 89–90.

26 See Paul Sternberger, *Between Amateur and Aesthete* (Albuquerque: University of New Mexico Press, 2001), 1–5. Wilson published a compilation of the essays in 1888. See John Burnet, *Practical Essays on Art* (New York: Edward L. Wilson, 1888).

27 Burnet wrote: "Though the varieties of painting are endless, yet the properties of which these varieties are composed are, as in music, few in number." John Burnet, *An Essay on the Education of the Eye with Reference to Painting*, 4th ed. (London: Henry Sotheran, 1880), vii. As the titles of the sections of the essay ("Measurement," "Form," "Perspective," "Lines," "Diminution," "Angles," etc.) would indicate, these properties, according to Burnet, are principally Albertian and geometric.

28 Daguerre wrote: "Everyone can use the daguerreotype to make views of his chateau or country house." L. Daguerre, "Daguerréotype," prospectus, ca. Mar. 1838, reprinted in F. Reynaud,

ed., *Paris et le Daguerréotype* (Paris: Paris-Musées, 1989), 22 ("Chacun, à l'aide du daguerréotype, fera la vue de son château ou de sa maison de campagne").

29 Marcy J. Dinius, "Seeing a Slave as a Man: Frederick Douglass, Racial Progress, and Daguerreian Portraiture," in *The Camera and the Press: American Visual and Print Culture in the Age of the Daguerreotype* (Philadelphia: University of Pennsylvania Press, 2012), 192–232. For another account of the imbrication of pictures and social progress in Douglass's work, *see* John Stauffer, "Frederick Douglass and the Aesthetics of Freedom," *Raritan* 25, 1 (Summer 2005): 114–36. See also the essays in *Pictures and Progress: Early Photography and the Making of African-American Identity*, ed. Maurice O. Wallace and Shawn Michelle Smith (Durham, NC: Duke University Press, 2012).

30 Frederick Douglass, "Pictures and Progress," undated lecture manuscript, p. 9, Frederick Douglass Papers, Library of Congress, 9.

31 Ibid. Other versions of the lecture exist.

32 As James McPherson has observed, the same words—or lyrics—concerning freedom were cherished and exalted by both sides of the war. See James McPherson, *Battle Cry of Freedom: The Civil War Era* (New York: Oxford University Press, 1988).

33 Douglass, "Pictures and Progress," 1.

34 Ibid., 4.

35 Ibid., 5–6.

36 Douglass quoted, for example, in Dinius, *Camera and the Press*, 208.

37 Dinius, *Camera and the Press*, 209.

38 Marshall McLuhan, *Understanding Media: The Extensions of Man* (Cambridge, MA: MIT Press, 1994), 197.

39 Jacques Lacan, *The Four Fundamental Concepts of Psycho-Analysis*, 100.

40 Ibid., 96.

41 Ibid., 72.

42 Ibid., 92.

43 Ibid., 109.

44 Ibid., 101.

45 Ibid.

46 Ibid., 106.

47 Ibid., 95.

48 Ibid., 95–96.

49 Jean-Paul Sartre, *Being and Nothingness*, trans. Hazel Estella Barnes (New York: Simon and Schuster, 1992), 345.

50 Ibid., 346.

51 Ibid., 347.

52 Ibid., 385.

53 On the history of Stieglitz's accounts of the making of *The Steerage*, see Elizabeth Anne McCauley, "The Making of a Modernist Myth," in *The Steerage and Alfred Stieglitz*, by Jason Francisco and Elizabeth Anne McCauley (Berkeley: University of California Press, 2012), 18–19.

54 Alfred Stieglitz, "How *The Steerage* Happened," in "Alfred Stieglitz: Four Happenings," *Twice a Year: A Book of Literature, the Arts, and Civil Liberties*, nos. 8–9 (Spring–Summer and Fall–Winter 1942): 127–31.

55 Jason Francisco, "The Prismatic Fragment," in Francisco and McCauley, *The Steerage and Alfred Stieglitz*, 77.

56 Allan Sekula, "On the Invention of Photographic Meaning," in *Thinking Photography*, ed. Victor Burgin (London: MacMillan Press, 1982), 99–100.

57 One weakness of much Foucault-era photographic criticism is an excessive estimation of the framing powers of discourse, a word that never loses its verbal connotations despite efforts to extend its reach. Before taking Stieglitz to task for his tired Symbolist moves, Sekula argues that "the photograph, as it stands alone, presents merely the *possibility* of meaning. Only by its embeddedness in a concrete discourse situation can the photograph yield a clear semantic outcome." Ibid., 91. This is certainly true, but if we infer from this proposition that photographs are wholly governed by the textual framing of them, we have gone astray. Like a painting or song, a photograph forever remains open to new inspection, which may deliver new meanings and inflect the discourse surrounding it in new ways. A photograph never operates independently of discourse, but it is not merely a passive and plastic outcome of discourse either. This is particularly important in the case of Stieglitz, who produced some extraordinary photographs despite being a pompous and often unconvincing writer.

58 Lacan, *Four Fundamental Concepts*, 84.

59 Jeff Wall, "'Marks of Indifference': Aspects of Photography in, or as, Conceptual Art" [1995], reproduced in Douglas Fogle, *The Last Picture Show: Artists Using Photography, 1960–1982* (Minneapolis, MN: Walker Art Center, 2003), 33.

60 Ibid., 44.

61 The irony of Wall's assumption that photography did not substantially change the "Western Picture" until after pictorialism is that his enterprise structurally repeats pictorialism. Like the pictorialists, Wall seeks to draw on the authority of painting through imitation. Whereas the pictorialists mainly did so through signs of preparation and labor, either surface based (e.g., brushed gum prints or composite printing) or by way of theatrical staging, Wall hews to the staging option while seeking to match the capacity of painting to yield a large and charismatic presence on the gallery wall.

62 Walter Benn Michaels, "The Politics of a Good Picture: Race, Class, and Form in Jeff Wall's *Mimic*," *PMLA* 125, 1 (Jan, 2010): 180–81.

63 Needless to say, many artists today continue to follow Wall in using the large color photographic format in an effort to restore the tableau. Other artists use that format to carry out the project that Douglass forecast, using portraiture to insist that people of all forms and formations take a place before the camera. This normal art—to riff on Thomas Kuhn's notion of normal science—does tedious if necessary cultural work.

64 Carrie Lambert-Beatty, *Being Watched: Yvonne Rainier and the 1960s* (Cambridge, MA: MIT Press, 2008).

Contributors

Rachael Z. DeLue

is associate professor in the Art & Archaeology Department at
Princeton University. She specializes in the history of American art
and visual culture, with particular focus on landscape representation,
intersections between art and science, and the visual culture of
race and race relations in the United States. She is currently at work
on a study of Charles Darwin's diagram of evolution in *On the
Origin of Species* as well as a book about impossible images. Her
publications include *George Inness and the Science of Landscape*
(University of Chicago Press, 2004), *Landscape Theory* (Routledge,
2008), coedited with James Elkins, and *Arthur Dove: Always
Connect* (University of Chicago Press, 2016).

Michael Gaudio

is associate professor in the Department of Art History at the University
of Minnesota. He specializes in the visual arts of early modern Europe
and the Atlantic world, particularly the visual arts in relation to early
modern science, religion, and cultural encounter. He is the author
of *Engraving the Savage: The New World and Techniques of Civilization*
(University of Minnesota Press, 2008) and is currently completing a
study of the handmade Bible concordances created by the seventeenth-
century English Protestant community at Little Gidding, England.
Other publications consider landscape painting in nineteenth-century
America and the history of scientific illustration.

Ulla Haselstein

is chair of the Literature Department of the John F. Kennedy
Institute of North American Studies at Freie Universität, Berlin.
Her research focuses on literary theory and American literary
modernism and postmodernism. She is currently completing a book
on Gertrude Stein. Her most recent book publications in English
are several coedited volumes, among them *The Cultural Career of
Coolness: Discourses and Practices of Affect Control in European
Antiquity, the United States, and Japan* (Lexington Books, 2013),
The Pathos of Authenticity: American Passions of the Real (Winter,
2010), and *The Power and Politics of the Aesthetic in American
Culture* (Winter, 2007).

Matthew C. Hunter

is assistant professor in the Department of Art History and Communication Studies at McGill University. His research focuses on art and architecture of the long eighteenth century, with special attention to intersections among art, science, and technology. His publications include *Wicked Intelligence: Visual Art and the Science of Experiment in Restoration London* (University of Chicago Press, 2013) and *The Clever Object* (Wiley, 2013), coedited with Francesco Lucchini. He is currently writing a book on Joshua Reynolds's experimental chemistry and the longer history of temporally evolving chemical objects in the British Enlightenment.

Elizabeth W. Hutchinson

is associate professor in the Department of Art History and Archaeology at Barnard College–Columbia University. Her areas of specialization include North American art through the First World War and feminist and cultural theory. She is particularly interested in the relationship between the visual culture of a variety of North American groups and its viewers and the ongoing impact of the colonial history of the Americas. She is the author of *The Indian Craze: Primitivism, Modernism, and Transculturation in American Art, 1890-1915* (Duke University Press, 2009), and her current research focuses on the issue of sovereignty over land and self-representation, considering among other things portraits of Native Americans from the colonial period to the twentieth century.

Robin Kelsey

is the Shirley Carter Burden Professor of Photography in the Department of History of Art & Architecture at Harvard University. A specialist in the histories of photography and American art, he has published on such topics as survey photography, landscape theory, ecology and historical interpretation, and the nexus of art and law, and he is currently researching a book about photography in Cold War America. He is the author of *Archive Style: Photographs and Illustrations for U.S. Surveys, 1850–1890* (University of California Press, 2007) and *Photography and the Art of Chance* (Harvard University Press, 2015).

Photography Credits

Every effort has been made to trace ownership of visual material used in this volume. Errors and omissions will be corrected in subsequent printings provided notification is sent to the publisher.

Art Institute of Chicago
Photography © The Art Institute of Chicago: 13 (bottom)

Bancroft Library
Courtesy of the Bancroft Library, University of California, Berkeley: 118, 122, 142

The Barnes Foundation
Image © The Barnes Foundation: 167

The British Museum
© Trustees of the British Museum: 18, 63, 70

The Clark Art Institute
Images © Sterling and Francine Clark Art Institute, Williamstown, Massachusetts, USA (photos by Michael Agee): 13 (center), 17, 37

Cooper Hewitt, Smithsonian Design Museum
Art Resource, NY. Photo: Matt Flynn © Smithsonian Institution: 12

Davison Art Center
Open Access Image from the Davison Art Center, Wesleyan University: 89

The Fitzwilliam Museum
© Fitzwilliam Museum, Cambridge: 46

George Eastman Museum
Courtesy of George Eastman House, International Museum of Photography and Film: 184

Hamburger Kunsthalle
bpk, Berlin / Hamburger Kunsthalle / Elke Walford / Art Resource, NY: 119

The Huntington Library, Art Collections, and Botanical Gardens
© The Huntington Art Collections, San Marino, California: 53, 54, 57, 74

The J. Paul Getty Trust
Digital image courtesy of the Getty's Open Content Program: 183

Metro Pictures
Courtesy of Cindy Sherman and Metro Pictures, New York: 205

The Metropolitan Museum of Art
© www.metmuseum.org: 124
Image copyright © The Metropolitan Museum of Art, Image source: Art Resource, NY: 187, 196

Museum of Fine Arts, Boston
Photograph © 2016 Museum of Fine Arts, Boston: 14, 141

The Museum of Modern Art
Digital Image © The Museum of Modern Art/ Licensed by SCALA/Art Resource, NY: 169

National Portrait Gallery
© National Portrait Gallery, London: 64

Pennsylvania Academy of the Fine Arts
Courtesy of the Pennsylvania Academy of the Fine Arts, Philadelphia, Joseph E. Temple Fund: 15

Portland Museum of Art
Image courtesy Portland Museum of Art, Maine / Meyersphoto.com: 36

Stanford University Libraries
Courtesy of Department of Special Collections and University Archives, Stanford University Libraries: 106

Tate
© Tate, London 2015: 49

Van Abbemuseum
Image by Peter Cox, Eindhoven, The Netherlands; Courtesy of Collection Van Abbemuseum, Eindhoven, The Netherlands: 51

Yale University Art Gallery
Image © Yale University Art Gallery: 117

Courtesy Geographicus Rare Antique Maps: 133, 138
© Jeff Koons. Courtesy of Gagosian Gallery: 207
© FRANK STELLA / SODRAC (2015): 51
Alfred Stieglitz © ARS, NY: 196
Courtesy United States Coast Guard Historian: 114, 127

A Note on the Type

This publication is typeset entirely in typefaces designed by the American designer and writer William A. Dwiggins (1880–1956). His practice encompassed a broad range of activities in printed communication, including book design, advertising, illustration, type design, lettering, and calligraphy. Dwiggins is widely credited with coining the term "graphic design" in a 1922 *Boston Evening Transcript* article titled "New Kind of Printing Calls for New Design."

Deco (W.A. Dwiggins, 1930)
A digitization of abstract geometric lettering originally designed by Dwiggins for the cover of Paul Hollister's *American Alphabets* (New York: Harper Brothers, 1930).

Metro (W.A. Dwiggins, 1929–1930)
Originally called Metroblack, Metro is a modern sans serif series designed for Mergenthaler Linotype, an American type corporation founded in 1886, as a critical response to contemporaneous European competitors Futura, Gill Sans, and Kabel. Toshi Omagari's 2013 restoration, Metro Nova, has been used for this publication.

Electra (W.A. Dwiggins, 1935–1949)
An original serif typeface without any discernible historical model, designed by Dwiggins for Mergenthaler Linotype to reflect the modern machine age. Electra was widely used by American publishers during the mid-twentieth century, with highly readable yet idiosyncratic letterforms notable for their weighted lowercase serifs and unusual flat curves. The type combines a warm, human character with a fluid, electric quality. In Dwiggins's words: "sparks, energy— high-speed steel—metal shavings off a lathe."

About the Foundation

This volume, the first in the series of the Terra Foundation Essays, was conceived to provide an international forum for the thorough and sustained exploration of fundamental ideas and concepts that have shaped American art and culture over time.

For over thirty years, the Terra Foundation for American Art has been committed to supporting innovative programs and initiatives designed to engage audiences around the globe in a lively dialogue on the visual arts of the United States. This series offers a novel platform for international exchange, complementing the foundation's existing programs.

The Terra Foundation for American Art is dedicated to fostering exploration, understanding, and enjoyment of the visual arts of the United States for national and international audiences. Recognizing the importance of experiencing original works of art, the foundation provides opportunities for interaction and study, beginning with the presentation and growth of its own art collection in Chicago. To further cross-cultural dialogue on American art, the foundation supports and collaborates on innovative exhibitions, research, and educational programs. Implicit in such activities is the belief that art has the potential both to distinguish cultures and to unite them.

For information on grants, programs, and publications at the Terra Foundation for American Art, visit terraamericanart.org.

TERRA
FOUNDATION FOR AMERICAN ART

Terra Foundation Essays

Scale (2016)
Edited by Jennifer L. Roberts
With essays by Glenn Adamson and Joshua G. Stein,
Wendy Bellion, Wouter Davidts, Darcy Grimaldo Grigsby,
Christopher P. Heuer, and Jason Weems

Circulation (2017)
Edited by François Brunet
With essays by Thierry Gervais, Tom Gunning,
JoAnne Mancini, Frank Mehring, and Hélène Valance

Experience (2017)
Edited by Alexander Nemerov
With essays by Michael Amico, Lucy Mackintosh,
Jennifer Jane Marshall, Xiao Situ, and Robert Slifkin

Intermedia (2018)
Edited by Ursula A. Frohne

Color (2018)
Edited by Darby English

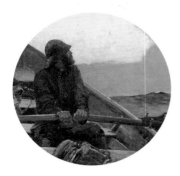

TERRA
FOUNDATION FOR AMERICAN ART
terraamericanart.org

978-0-932171-57-3 90000